THE ART OF PERSPECTIVE

THE ART OF PERSPECTIVE

THE ULTIMATE GUIDE FOR ARTISTS IN EVERY MEDIUM

PHIL METZGER

NORTH LIGHT BOOKS
CINCINNATI, OHIO
www.artistsnetwork.com

fw
F+W PUBLICATIONS, INC.

North Light Books, an imprint of F+W Publications, Inc., 4700 East Galbraith Road, Cincinnati, Ohio, 45236. (800) 289-0963. First Edition.

Other fine North Light Books are available from your local bookstore, art supply store or direct from the publisher.

11 10 09 08 07 5 4 3 2 1

DISTRIBUTED IN CANADA BY FRASER DIRECT
100 Armstrong Avenue
Georgetown, ON, Canada L7G 5S4
Tel: (905) 877-4411

DISTRIBUTED IN THE U.K. AND EUROPE BY DAVID & CHARLES
Brunel House, Newton Abbot, Devon, TQ12 4PU, England
Tel: (+44) 1626 323200, Fax: (+44) 1626 323319
Email: postmaster@davidandcharles.co.uk

DISTRIBUTED IN AUSTRALIA BY CAPRICORN LINK
P.O. Box 704, S. Windsor NSW, 2756 Australia
Tel: (02) 4577-3555

Library of Congress Cataloging in Publication Data
Metzger, Philip W.
 The art of perspective : the ultimate guide for artists in every medium / Phil Metzger. -- 1st ed.
 p. cm.
 Includes bibliographical references and index.
 ISBN-13: 978-1-58180-855-1 (pbk. : alk. paper)
 ISBN-10: 1-58180-855-0 (pbk. : alk. paper)
 1. Perspective. 2. Drawing--Technique. 3. Painting--Technique. I. Title.
NC750.M485 2007
701'.82--dc22 2006032029

All art is by the author except where stated otherwise.
Edited by Mona Michael and Amy Jeynes
Designed by Wendy Dunning
Page layout by Terri Woesner
Production coordinated by Jennifer Wagner

ABOUT THE AUTHOR

Phil Metzger has been painting and selling his artwork for over thirty years. His work is included in thousands of private and public collections and has earned him honors in national and regional exhibitions. He teaches watercolor and perspective drawing and has written many popular North Light books including *Perspective Without Pain*, *Enliven Your Paintings With Light*, *Pencil Magic*, *Watercolor Basics: Perspective Secrets*, *The North Light Artist's Guide to Materials and Techniques* and *The Artist's Illustrated Encyclopedia*.

METRIC CONVERSION CHART

To convert	to	multiply by
Inches	Centimeters	2.54
Centimeters	Inches	0.4
Feet	Centimeters	30.5
Centimeters	Feet	0.03
Yards	Meters	0.9
Meters	Yards	1.1

DEDICATION
To Shirley Porter

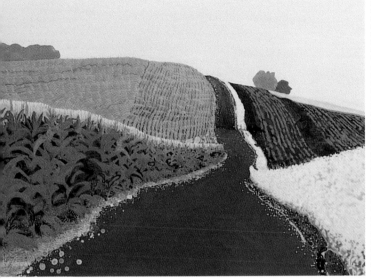

THE LONG AND WINDING ROAD
Shirley Porter
Acrylic gouache on illustration board
30" × 40" (76.2cm × 101.6cm)

A NOTE FROM THE AUTHOR

A few decades ago I had a cushy job managing programmers at IBM. After a while I thought there might be something I'd rather do, so I quit to become a painter. Mind you, I knew almost nothing about painting—no training at all, just a little puttering around—but off I went. My family were very supportive, except for my mother who would have cut me out of her will if she'd had one. So I spent the next twenty years or so at shows, mostly outdoors, freezing in Maine, roasting in Chicago, enduring Texas and getting destroyed by a mini-hurricane in Boca Raton. During those years, I came home flying high from many shows, dragging from others. My partner, Shirley Porter, and I wore out a van and two trucks. We framed and matted late at night getting ready to hit the road the next day for a show, often in some town we'd never heard of. Selling art is an exhilarating but exhausting business.

Then, in the late eighties, someone from North Light Books called and asked if I would like to write them a little book on perspective. They figured I must be an expert (ha!) because I had written a short review of some other people's books on perspective. As it happens, I had already written a couple books on another subject—managing programmers. Those books had sold extremely well and I liked the work. So I was happy to write a perspective book for North Light. That book, in black-and-white, was called *Perspective Without Pain*; it has sold wonderfully well and is still going strong, but it came time for a full-color book, the one you're now reading.

I love my hermit-like relationship with my computer and my paints and my camera, but I do miss all those friends on the art circuit. I make up for that loss by substituting family and dogs and the lovely people who attend my art classes. My family supports me and the dogs and students tolerate me and my lame jokes, so it all seems to work out pretty well.

This will be my last book on this subject. I have several other books in mind, not art-related, that I hope to get somebody to publish. As for this one, I tried hard to get it just right. I hope you like the results.

ACKNOWLEDGMENTS

To draw the many linear perspective diagrams in this book I relied heavily on Adobe Photoshop and Adobe Illustrator software. I learned how to use these programs thanks to my partner, Shirley Porter, who uses them daily in her work as a graphic designer. It seemed every other page I'd call out: "Shirley, how do I . . .?" The alternative would have been to plow through the manuals and learn the slow, hard way. Thanks to Shirley I was spared that agony and I finished the book on time (just barely!) The other Shirley-support for which I'm thankful is her careful reading and proofing of the entire manuscript.

The first editor assigned to this book was Mona Michael; when she left North Light Books partway through the project, the task was turned over to Amy Jeynes. Thanks to the intelligence and professionalism of both these editors, and thanks to the striking design by Wendy Dunning, I can honestly say I'm proud of the result. My thanks, too, to Terri Woesner, who laid out the pages; Nancy Harward, the copy editor; Mary Davisson, the proofreader; Jennifer Wagner, who coordinated the book's printing; and editorial director Jamie Markle, who was responsible for getting this book off the ground.

TABLE OF CONTENTS

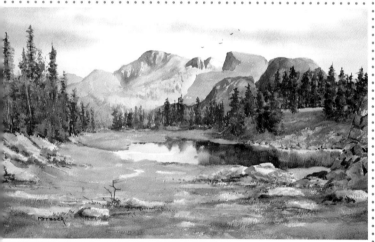

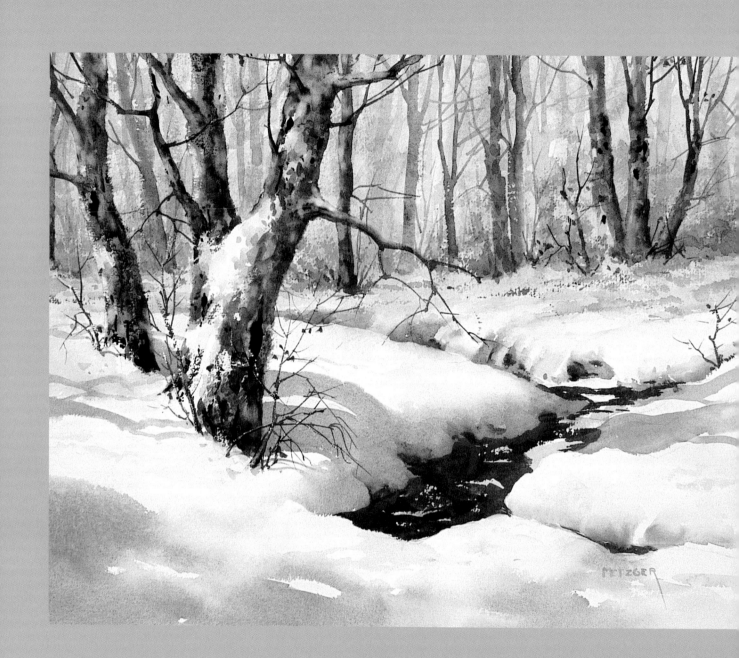

WHAT IS PERSPECTIVE?

If you draw or paint realistic pictures, you use perspective to create an illusion of depth on your flat, two-dimensional paper or canvas. There are lots of perspective techniques you can use, but the aim of all of them is simply to mimic the way we see. When you paint a distant mountain blue, for example, you're painting it the way you see it; when you draw a road narrowing in the distance, again you're drawing it the way you see it.

Some perspective techniques are natural and intuitive; we'll cover them in Part 1. Another technique, linear perspective, is slightly less intuitive; it's the subject of Part 2. In Part 3, we'll look at some more advanced examples of linear perspective.

All these perspective techniques will help you draw or paint a solid, believable, beautiful picture. Used properly, they're guaranteed to add depth and reality to your work. But don't use them blindly; forcing the "rules" of perspective onto your picture may produce a result that is stiff, formulaic and sterile, like a poem forced to rhyme no matter what.

DEFINITION

PERSPECTIVE: *The art of drawing three-dimensional scenes convincingly on a two-dimensional surface.*

NEW SNOW
Watercolor on Arches 300-lb. (640gsm) cold-pressed paper
18" × 24" (45.7cm × 61cm)

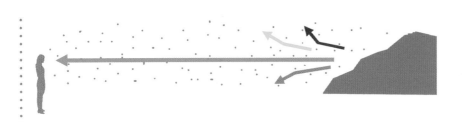

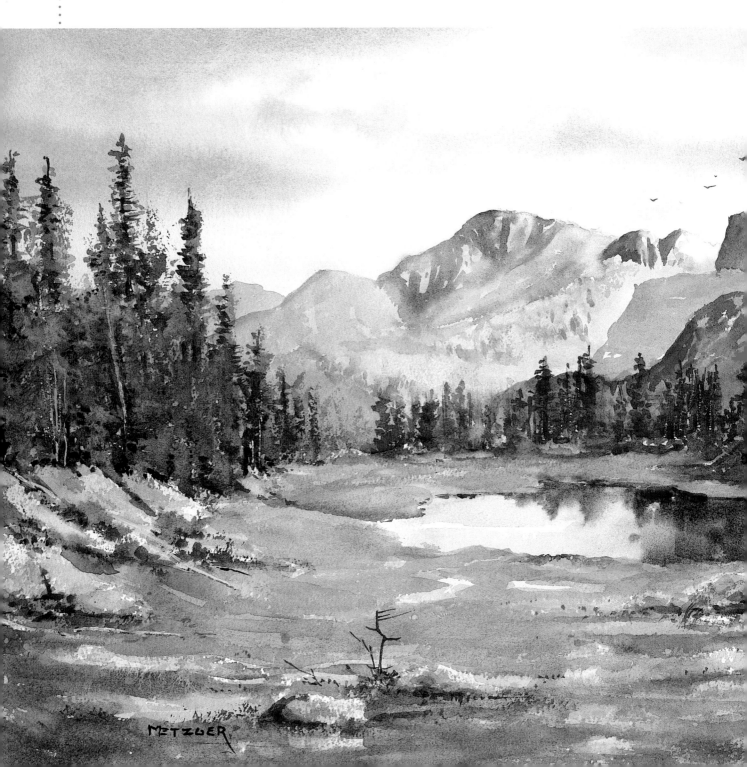

METZGER

PART 1

NATURAL PERSPECTIVE

Draw and Paint What You See

ROCKY MOUNTAIN POOL
Watercolor on Arches 300-lb. (640gsm) cold-pressed paper
18" × 28" (45.7cm × 71.1cm)
From a photo: www. istockphoto.com/Ashok Rodrigues

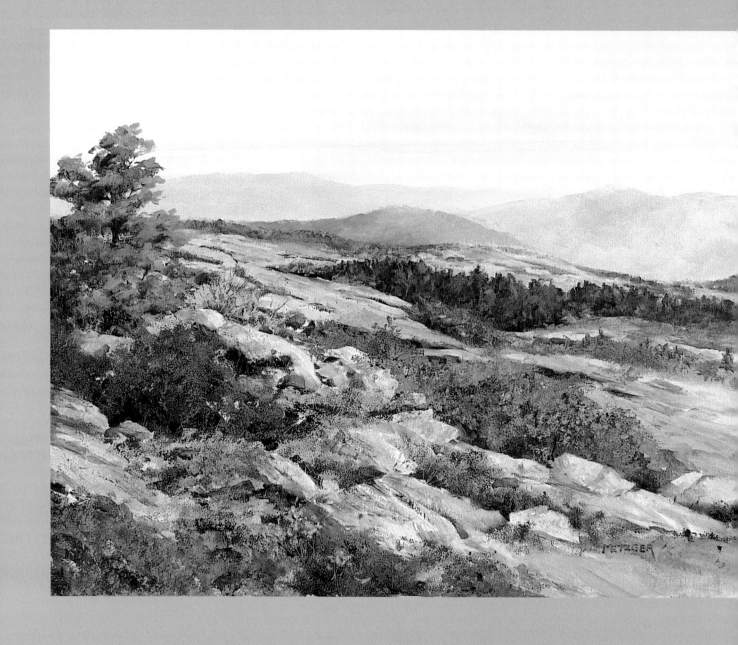

ATMOSPHERIC PERSPECTIVE

If you've ever taken a summer drive through hilly country you've probably noticed that those green distant hills look pretty blue. Or if it's fall, a distant hill may appear bluish-purple even though you know darn well it's really yellow, red and brown. What you're seeing is something called atmospheric perspective, or aerial perspective. The layer of air between you and the hill causes a shift in color. The air contains impurities such as smoke particles, water droplets and pollen that prevent some of the light from the hill from reaching your eyes. The impurities act as a filter, letting the cooler, bluish colors through and blocking a lot of the warmer reds and yellows. In addition to blocking some colors, the atmosphere also cuts down the total amount of light that reaches your eye, so the distant hills look paler than they really are.

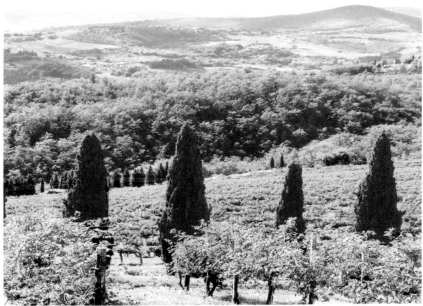

Photo courtesy of Jeffrey Metzger

**Atmospheric Perspective:
A Living Example**

In this photo of the Chianti region of Italy, the shift from strong, warm colors in the foreground to fainter, cooler colors in the distance is an example of atmospheric perspective.

MAINE
Oil and alkyd on canvas
18" x 24" (45.7cm x 61cm)

DISTANT HILLS

When you look at any distant object—a hill, a city skyline, a barn—it does not look the same as it would up close. The air between you and the object acts like a veil or filter that inhibits the passage of light from the object to your eyes. The dirtier the air, the greater the filtering effect. It happens that shorter light waves (those at the blue end of the spectrum) reach us more easily than longer waves (those at the red end of the spectrum).

TWO KINDS OF CHANGE

Particles in the atmosphere inhibit certain colors of light from passing through, as we've seen; they also reduce the total amount of light that gets through. So in addition to a color shift there is a value shift; that is, distant objects look paler than they really are. To mimic this effect, you should normally paint a distant hill a pale blue rather than a strong, dark blue.

TIP

The golden rule of painting realistically is to trust your eye and paint what you see.

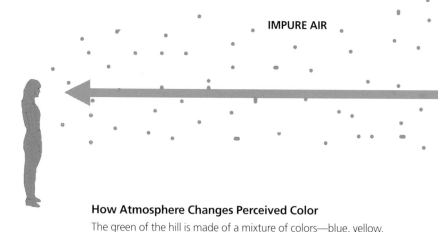

IMPURE AIR

How Atmosphere Changes Perceived Color
The green of the hill is made of a mixture of colors—blue, yellow, red and more. The short blue light waves pass easily through the atmosphere, but other colors get partially blocked and dispersed by the particles in the air.

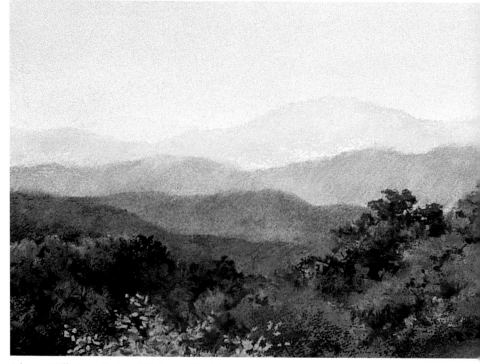

Distant Hills Usually Look Pale and Bluish
These mountains provide a textbook example of atmospheric perspective. The farther away each hill is, the bluer and paler it looks. Because the air around these mountains contains significant pollution, there is an abrupt change from the colorful foliage in the foreground to the bluish hills in the distance. The clearer the air, the more gradual the transitions of color and value.

BLUE RIDGE MOUNTAINS
Pastel with watercolor underpainting on Whatman watercolor board
12" × 16" (30.5cm × 40.6cm)

THE EXCEPTIONS

Painting distant objects bluish and pale is a good rule of thumb, but don't be slavish about this. Thank goodness there are always exceptions in nature. Here are some examples.

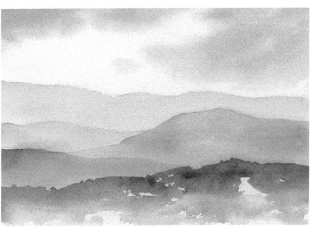

Autumn Foliage Can Change the Rules
In fall, the hills are covered with reds, yellows and browns. Those colors are so dominant that from a distance the hills that might in another season seem blue now look reddish blue, or purple.

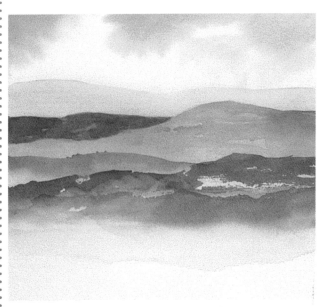

Nature Sometimes Does the Unexpected
One of the distant hills appears darker, not lighter, than the nearer hills. This may occur because a cloud is casting a shadow over that hill. Another reason may be that that particular hill is densely covered with evergreen trees, making it much darker than those covered with deciduous trees, grasses or snow.

CHOOSING YOUR MEDIUM

Perspective techniques work no matter what medium you use, but sometimes your choice of mediums can simplify life a little. For instance, if you want soft edges you might choose watercolor or pastel rather than acrylic. For the painting on the opposite page, I chose pastel, making it easier to create soft edges and to vary the tones of the distant mountains.

For this painting I used mounted cold-pressed watercolor paper as my support because I like its slightly irregular texture better than the monotonous texture of many standard pastel papers. But the watercolor paper is white, so unless the paper is first coated with color, lots of tiny white specks will show through. To get around that, I first did a rough, broad underpainting in watercolor, as shown here, covering the white of the paper. Knowing I would need lots of small darks in the foreground to give form to the foliage, I underpainted that area with dark watercolor.

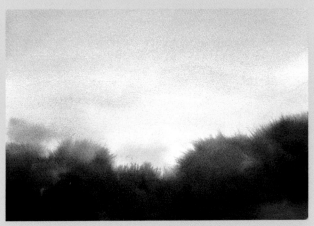

Watercolor underpainting for *Blue Ridge Mountains*.

DISTANT BUILDINGS

The effect of distance on hills or mountains is hard to miss. Even though they're far away, they're big and they grab our attention. With smaller objects, such as buildings, the effect of distance is not so dramatic, but it's still important. Almost any building will appear slightly dulled in color (grayer) and lighter in value as it recedes. Other qualities change, too, such as the crispness of edges and the amount of visible detail (the subjects of the next chapter). Sometimes you see colors and values in distant objects that seem not to obey the rules because atmospheric conditions, such as the time of day and the color of the sky, alter what you see.

CLOSE **MEDIUM DISTANCE** **FAR AWAY**

CITY AIR VS. COUNTRY AIR

Atmospheric perspective in city or village scenes is often more exaggerated than in open country scenes because city air may be much more polluted than country air. Sometimes haze or smog can be so dense that it severely limits how far you can see at all. It may not be much fun to breathe that stuff, but painting it can certainly help create distance and mood.

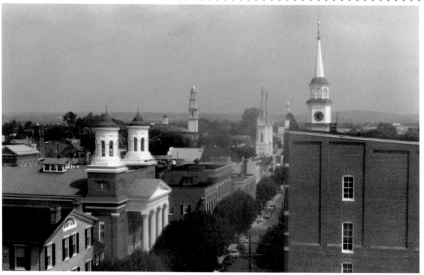

Typical City Smog
The hills in the distance are hazy and bluish. But even over much shorter distances—from the foreground buildings to the buildings a little farther away—you see a definite increase in haziness and loss of color intensity. Notice that the white towers in the distance are grayed due to the particles in the atmosphere.

The Effect of Atmospheric Perspective on a White Building

At left are some possible effects of atmospheric perspective on three buildings: red, yellow and white. This is a day when the air has its normal content of dust and water droplets; if the air were perfectly clear (a rarity for most of us), the changes in color and value might be barely noticeable.

But the white building isn't behaving! In the distance it appears darker than up close, which seems to go against the rules. However, if you think about it, up close the white is already as bright and vibrant as it can get and it can't get any lighter in the distance. But, like other colors, it can and does get *grayer*.

Dense Fog

Here the air is dense with water droplets (fog), and the atmospheric perspective is pronounced. Nothing is visible in the far distance; the red brick building in the middle distance is deeply shrouded and the white building right behind it is almost lost. Scenes like this give the artist a great opportunity for drama.

WHAT IS VALUE?

Value *is the relative lightness or darkness of a color. Other terms for value are* tone *and* shade. *White is the lightest, or highest, value and black is the darkest, or lowest. In the design of realistic drawings or paintings, skillful use of values is extremely important, not only for suggesting distance and defining form, but for providing visual excitement. For example, placing strong dark blue or red or black next to bright white creates a contrast that demands the viewer's attention. An effective design technique is to draw or paint big areas of a picture in middle values, reserving strong value contrasts—sparks—for parts of the picture where you want to grab the viewer's interest. When planning a composition, consider employing just a few values—often three are enough—to nail down the key areas of the design. Then, as you paint, you can introduce as many in-between values as you need.*

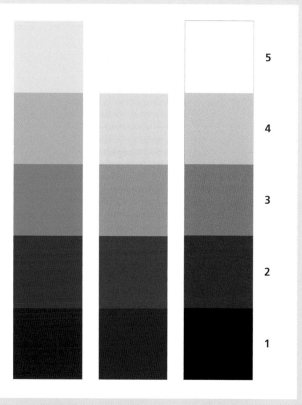

Three simple scales of values from 1 (black or darkest) to 5 (white or brightest).

STAGING: RECEDING WOODS

To get atmospheric effects, I often begin a painting with a pale, fuzzy lay-in followed by a series of increasingly stronger, more distinct layers. Building a picture in this way, in stages, allows you to feel your way forward. You can use this approach in any medium, but it's particularly useful in transparent watercolor, as shown in this demonstration.

MATERIALS

WATERCOLORS
Alizarin Crimson, Burnt Sienna,
Cadmium Yellow Light, Cobalt Blue

PAPER
140-lb. (300gsm) cold-pressed paper,
11" × 15" (27.9cm × 38.1cm)

BRUSHES
All synthetic: 2-inch (51mm) flat,
1-inch (25mm) flat, no. 12 round,
no. 6 rigger

OTHER
Soft pencil

1 **Draw the Major Shapes, Then Paint the First Washes**
Using a soft pencil, draw faint outlines of major shapes on your watercolor paper, such as the foreground tree and stream, and indicate the edge of the background woods. The less you draw at this stage, the freer you'll be to "draw" with your brush later on. Thoroughly soak the paper and pour off excess water. With a large brush, paint big splotches of very pale yellow, red and blue all over the paper. While the paper is still wet, paint pale blue trees in the background woods area. Now allow the surface of the paper to dry thoroughly.

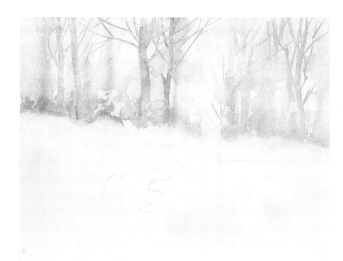

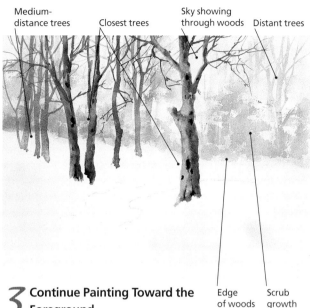

Medium-distance trees Closest trees Sky showing through woods Distant trees

Edge of woods Scrub growth

2 Paint the Next Stage of Trees

Paint the next stage of woods right over the soft background, using stronger, warmer blues than before. The trees you paint at this stage are closer to the viewer, so they should be darker and hard-edged, not quite so cool in color, but still with very little detail. Now you have two stages of woods: fuzzy, distant trees and slightly sharper, closer ones.

3 Continue Painting Toward the Foreground

Now paint the trees in the middle-ground, and finally, those in the foreground. You can move back and forth from middle trees to foreground trees, and even go back into the distant ones until you feel you have a good progression from fuzzy distant woods to the stronger foreground. As you paint the nearby trees, make them warmer in color and more detailed.

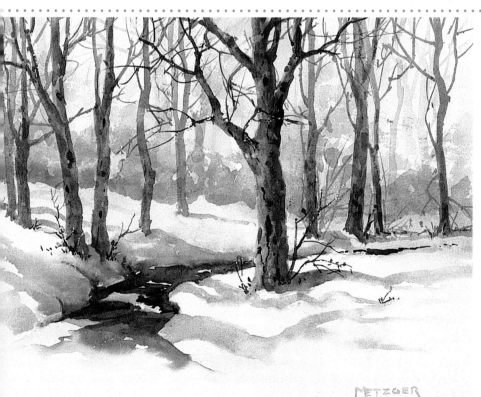

4 Finish

Paint the stream, the sloping banks, the cast shadows and the tree details. Let the stream fade at the bottom of the picture or, if you wish, continue the stream all the way into the foreground. Inspect your work by looking at it in a mirror; seeing it reversed makes it easier to spot odd shapes, poor values and other weaknesses.

WOODS STREAM
Watercolor on Arches 140-lb. (300gsm) cold-pressed paper
11" × 15" (27.9cm × 38.1cm)

USING COMPLEMENTARY COLORS

An important technique for creating atmospheric perspective in a painting is graying, or muting, colors in the distance. You can do this by painting a distant object its *local color* and then glazing over the local color with diluted black or gray. Or you can mix black, white or gray with the local color before applying it. But those methods usually won't give you the most pleasing results; such color mixes can be dull and uninteresting. It's usually more effective to tone down (gray) a color by mixing it with some of its complement.

To understand complements, let's briefly revisit an old standby, the color wheel. In its simplest form, the color wheel arranges the three primary pigment colors—red, yellow and blue—equally distant around a circle. Those three colors are called primaries because, theoretically, you can use them to mix any other color except white. Between pairs of primaries are the *secondary* colors: orange, green and purple. Colors directly opposite one another on the wheel are called *complements*. Green is the complement of red, red is the complement of green, purple is the complement of yellow, yellow is the complement of purple, and so on.

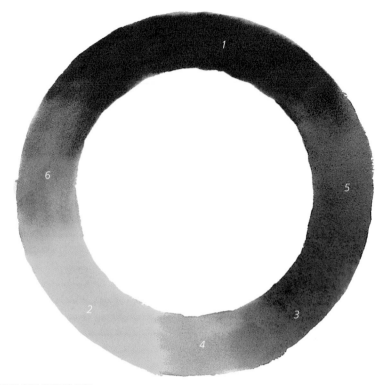

THE COLOR WHEEL
1. Primary (Red) 2. Primary (Yellow) 3. Primary (Blue) 4. Secondary (Green) 5. Secondary (Purple) 6. Secondary (Orange)

Red and green *Orange and blue* *Yellow and purple*

Mixing Complements
Any primary color mixed with its complement gives a range of grays. The colors used here are: Alizarin Crimson + Phthalocyanine Green; Phthalocyanine Blue + orange mixed from Alizarin Crimson and Aureolin; and Aureolin + purple mixed from Cobalt Blue and Alizarin Crimson.

HOW COMPLEMENTS WORK

The nifty thing about complements is this: If you add to a color a little of its complement, you get a grayed version of the color and the grayed version is almost always more lively than if you had simply mixed the color with black.

Complementary colors are useful in suggesting atmospheric perspective. Add just a touch of red to that distant green hill color and presto!—you've pushed the hill back a mile or two. But there's a little more to it than that (wouldn't you know?) The results you get depend on exactly which color pigments you mix; for example, Alizarin Crimson + Phthalocyanine Green will give you one set of grays, but substituting Cadmium Red (or any other red) for Alizarin will give you a different set of grays. And to make matters worse, your medium can make a difference. For instance, Cobalt Blue + Cadmium Orange oils will yield a different set of grays than Cobalt Blue + Cadmium Orange watercolors. But don't be put off by those issues. The truth is, whatever medium you're currently working in, you'll quickly get used to what works with what.

DEFINITION

LOCAL COLOR:
The actual color of an object unaffected by conditions such as atmospheric haze or unusual lighting.

TRY THIS

On a piece of white mat board, paper or canvas, lay out six blobs of color: red, yellow and blue (the primaries) across the top row, and under them, green, purple and orange (the secondaries). Use whatever medium you like; watercolor is quick and easy. Using a clean brush or a painting knife, carefully mix a primary with its complement. Vary the amounts of each to see what variety of grays you get. Notice how a little too much of one color or the other can give you muck instead of a delicate gray!

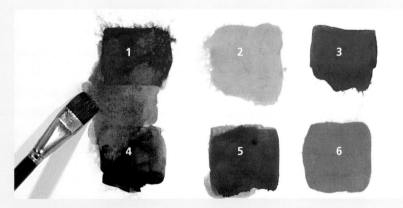

Mixing Complements
Here I've laid out watercolor paint and have begun mixing two of my colors.

1, 2, 3: primaries
4, 5, 6: complements

ADVANCING AND RECEDING COLORS

We've seen that, as a rule, distant objects appear bluish and those same objects seen up close are generally warmer in color. We can stretch that observation a bit and come up with this handy guideline: *Warm colors advance, cool colors recede.* Why that should be so is a matter of human perception; when you paint objects in the foreground in warm tones and objects in the distance in cool ones, you're mimicking the way we see.

**Warm Colors Advance;
Cool Ones Recede**
The warmest, "hottest" colors seem to come forward and yell at you while the cooler ones quietly recede.

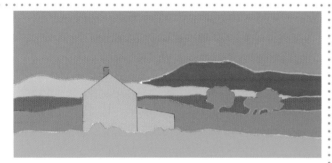

An Experiment in Rule Reversal
In this sketch, there isn't much depth because the warm colors are in back and the cool ones are up front.

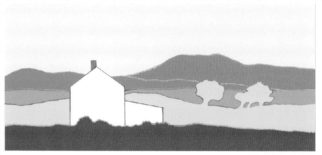

**A Warmer Foreground Is
More Convincing**
By warming the foreground and cooling the distance, we improve the apparent sense of depth.

TRY THIS

Trace this sketch and try your own color combinations to see which ones seem best to create a sense of distance.

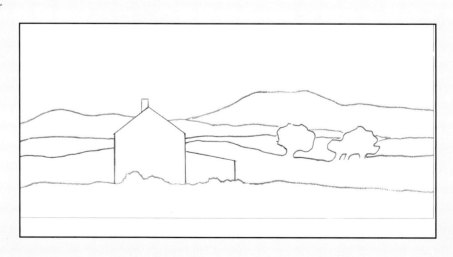

ABOUT THOSE RULES

You're an artist. You may break the rules anytime it suits you—isn't that handy? The "rule" that warm colors should be up front and cools in the rear works well enough most of the time, but often— very often—I hope you'll be tempted to turn things upside down. Never be a slave to the rules!

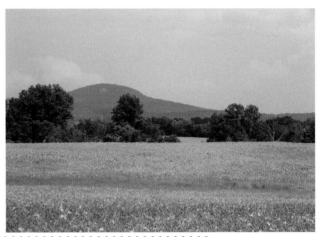

A Perfect Warm-to-Cool Scene
This scene is most obedient: warm as can be up front, nice and cool in the distance. It's made to order for a painting.

Sometimes You Can Break the Rule
This painting reverses the warm-to-cool rule: it's cool up front and hot in the distance. It works because of the use of linear perspective and other perspective techniques: the road leading into the picture, fence posts that diminish in size as they recede into the distance, overlapping objects, more detail in the foreground than in the distance. We'll learn more about those techniques in the following chapters.

CHARLIE'S PLACE
Watercolor on Arches 140-lb. (300gsm) cold-pressed paper
18" × 24" (45.7cm × 61cm)

WARM AND COOL

We use the terms warm *and* cool *because of associations with familiar things. Warm conjures up red, yellow and orange things, such as the sun or fire; cool suggests bluish stuff, such as ice.*

SUMMARY

- Objects far away appear paler than objects close to you because the layer of air between you and distant objects acts as a filter, blocking some of the light from reaching you.

- Objects far away appear cooler than objects close to you because the atmosphere allows blue light to pass more freely than warmer-colored light.

- To make a painting mimic reality, paint distant objects paler and cooler than close objects. That's a rule.

- Break any rule.

- Consider switching mediums to get particular effects. Sometimes it's easier and more effective to express something, such as a soft edge, in one medium than in another.

- To gray a color, mix it with some of its complement.

IMPURE AIR

Red and green *Orange and blue* *Yellow and purple*

Tree overlaps distant rocks and hills

Pale blue mountain far away

Dark hill pushes pale hill back

Treeline overlaps distant rocks

Rocks and shrubs more detailed in foreground

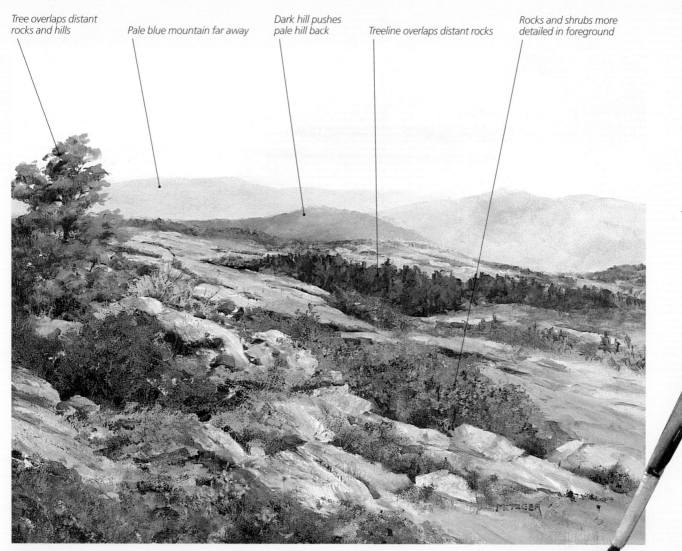

Atmospheric Perspective . . . and Other Kinds

Atmospheric perspective is clearly at work here, but so are other techniques we'll discuss later, including sharper edges and more detail in the foreground, overlapping of objects and value contrasts.

MAINE
Oil and alkyd on canvas
18" × 24" (45.7cm × 61cm)

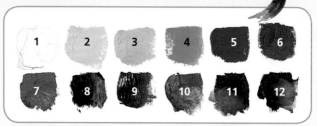

Palette

1 Titanium White
2 Cadmium Yellow Light
3 Cadmium Yellow Medium
4 Cadmium Orange
5 Cadmium Red Deep
6 Alizarin Crimson
7 Raw Sienna
8 Raw Umber
9 Burnt Sienna
10 Cobalt Blue
11 Phthalocyanine Blue
12 Phthalocyanine Green

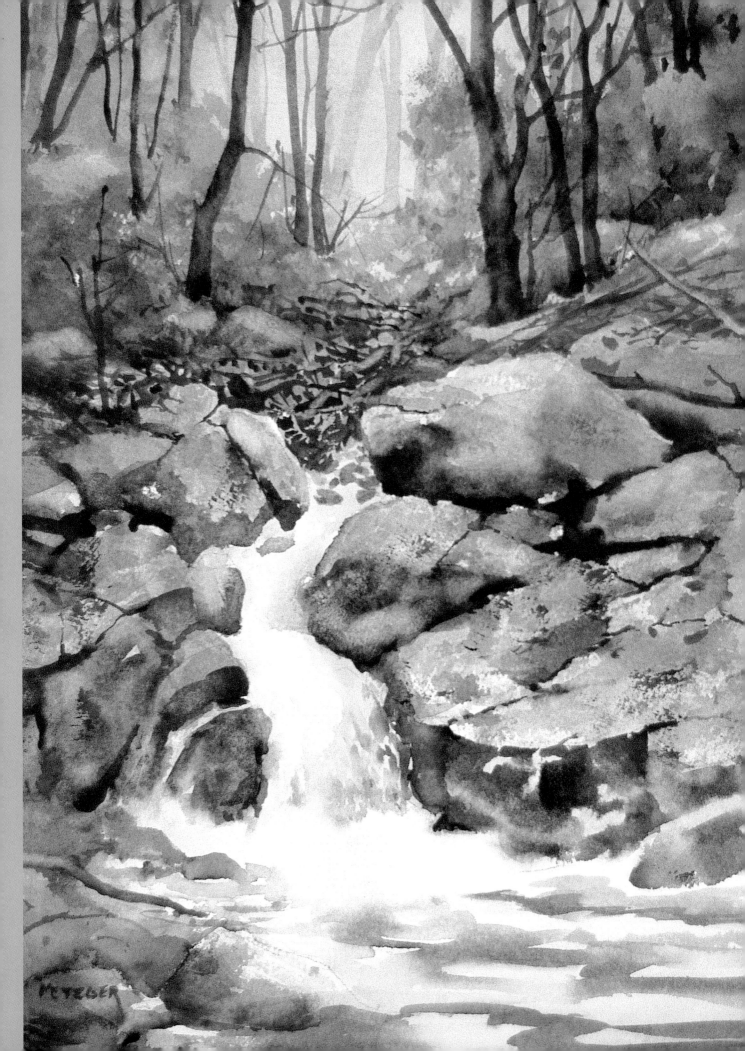

DETAIL AND EDGES

Like a camera, our eyes can focus on only one plane at a time. If we're looking intently at some distant object, nearby objects are out of focus; if we focus on a nearby object, the distance is blurry. That's the way we see, so it makes sense to paint or draw that way.

Think of a scene as having a foreground, a middle ground and a background. In most (but not all) pictures, the center of interest—the place the artist wants the viewer to see most clearly—is either in the foreground or the middle ground. Whichever you choose, that's where you should show the most detail and the sharpest edges. If you show the same amount of detail and the same sharp edges all over the picture, at all distances, you'll lose some depth.

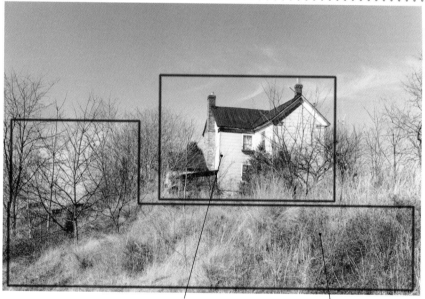

Choose the Focus That Suits Your Needs

In this photo, the focus of the camera is on the house. If you were to paint this scene, you could change the focus to the foreground—it's up to you. If you focus on the house, put your details and sharp edges there and leave the foreground looser, softer. If the foreground is your focus, make it detailed and keep the house a little vague.

FOCUS HERE **OR HERE**

WATERFALL
Watercolor on Arches 140-lb. (300gsm) cold-pressed paper
14" × 10" (35.6cm × 25.4cm)
Collection of Ted Staley

WHERE'S YOUR FOCUS?

I've painted the house from the previous page in three ways—the first two with the house in focus and then with the foreground in focus. In each case, there is a feeling of depth because I've sharpened one plane and blurred the other; it's the contrast between the two planes that gives the illusion of distance. In the examples where the house is in focus, I've played down the foreground first by painting that area vaguely, and then by fading it at the edges (vignetting). Whichever plane you choose to focus on, you have several options for creating that sense of distance.

ANOTHER EXAMPLE

All day, every day, you practice focusing at varying distances. As you read this, you're focusing at a distance of perhaps a foot or so. When you glance out the window to see what the dogs are fussing about, you change your focus to ten or twenty or thirty feet without even thinking about it. Speaking of dogs, at the bottom of the next page is a painting of a nearby park where I often walk my dogs. The tree in front, an oak, is in focus; just behind it is another tree a bit out of focus and still farther back, several more that are even fuzzier.

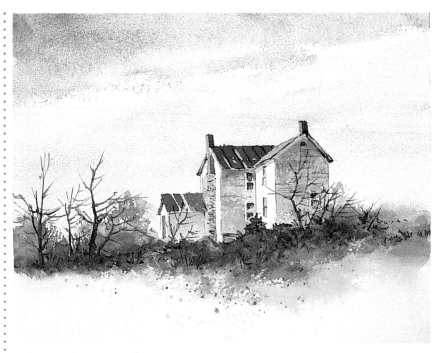

Vignetted Foreground
The vignetted foreground places the focus on the house.

TRY THIS

Hold a pencil or pen at arm's length. Focus on it so you see it clearly. Without shifting your focus (no cheating) notice an object across the room, maybe a chair or a bookcase. If you're really focusing on your pen, that other object will look fuzzy. Now, still holding the pen at arm's length, focus on the chair or bookcase. That object will now be clear and the pen will be fuzzy. When you draw or paint realistically, your job is to mimic the way you see. Painters such as Grandma Moses paint as though everything is in one plane, with no depth at all.

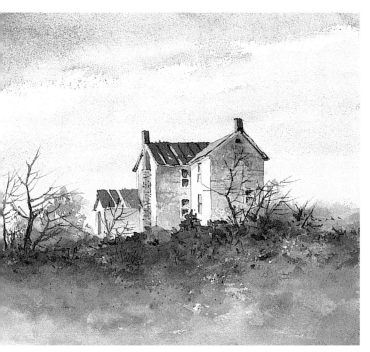

Full Foreground
A loosely painted foreground also places the focus on the house.

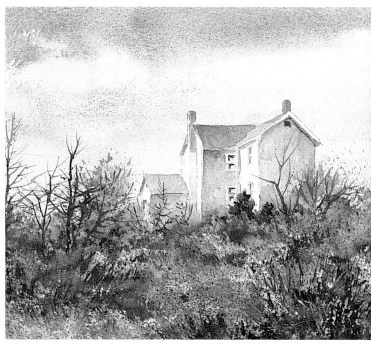

Detailed Foreground
Here the house is understated and the emphasis is on the foreground.

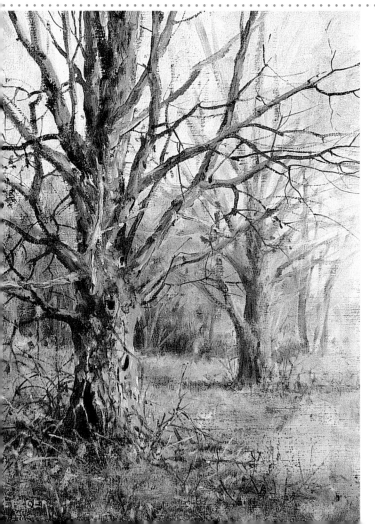

Sometimes You Need to Exaggerate
If you were standing alongside me looking at this scene and comparing the actual scene with my painting, you'd quickly notice that I had lied a little. The second tree back would not actually appear quite as vague as I painted it, and the same would be true of the more distant trees. But to nail down the illusion of depth on my canvas I intentionally exaggerated what I was seeing. You just can't trust a painter.

TREES IN THE PARK
Oil on canvas
14" × 11" (35.6cm × 27.9cm)

29

CHOOSE THE MEDIUM TO SUIT YOUR GOAL

If you're intent on describing lots of detail and using sharp edges in your drawing or painting, your choice of mediums can be important. I think you can render fine detail more easily in, say, pencil than in pastel and easier in egg tempera than in watercolor, which is why I chose egg tempera for the painting at right. An added benefit of egg tempera is that you can build up many layers of transparent or translucent glazes that give a painting a certain glow lacking with mediums such as watercolor.

ABOUT EGG TEMPERA PAINTING

Artists have used eggs as a binder for their pigments for hundreds of years, even before the use of oils. The traditional way of painting in egg tempera is to use small brushes to create layers of tiny strokes. (Andrew Wyeth must be an exceedingly patient man.) I prefer much bolder, faster strokes, using big brushes, tiny brushes, sponges, occasionally a painting knife—whatever will lay down paint. You can't work in broad washes, as with watercolor, because the paint dries too rapidly.

Usually egg tempera painters mix powdered pigments with water to form a paste and then mix the paste (a little at a time because the mixture will dry quickly on your palette) with egg medium. Mixing the pastes is time-consuming, so you may substitute tube watercolor paint for the pastes (as I did in this painting). The egg medium is usually ordinary hen's egg yolks combined with just enough water to make

a creamy mixture. You can use an eyedropper or a soda straw to deposit a little medium at a time onto your palette. For a painting surface, the preferred choice is hardboard (such as Masonite) coated with finely sanded true gesso, which provides a beautifully receptive surface; other choices are hardboard coated with acrylic gesso, or various watercolor boards and illustration boards.

For much more about egg tempera painting, see my books The North Light Artist's Guide to Materials and Techniques *and* The Artist's Illustrated Encyclopedia.

Egg Tempera for Detail

Although most of the subject of this picture lies in one plane, the picture still feels three-dimensional, thanks to three important perspective techniques. (1) The strip at the right shows trees that are some distance back from the face of the building; that distance is implied by the lack of detail in the trees and by the bit of sunlit lawn that helps push the trees back. (2) Value contrasts (see chapter four) draw the eye into the otherwise flat building surface: cracks and holes in the masonry surface, broken windowpanes, small cast shadows. The dark trees next to the sunlit building vigorously separate the building from the trees. (3) The joints in the sidewalk are an example of linear perspective (see chapter five), which draws the eye into the picture.

I had finished this painting and left it leaning against the wall. I returned a few minutes later to find Charlie, my beagle who eats everything and anything, happily licking a hole in the painting! I had him checked by the vet because the paint he ate was mostly toxic cadmiums and cobalts. Charlie was fine, but I spent hours repainting.

THE DOG ATE MY PAINTING
Egg tempera on watercolor board
11" × 25" (27.9cm × 63.5cm)

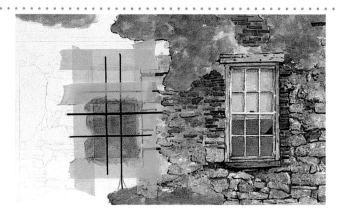

Masking Tips

It's inadvisable to use any kind of tape over an already painted egg tempera surface; it might leave a cloudy residue or even remove the paint. But you can mask freely on the bare paper.

Here I've masked with both drafting tape and Letraline tape. The wide, buff-colored drafting tape is less sticky than masking tape, so there's less danger that it will tear the surface of the paper when you remove it. Handy Letraline tapes come in a variety of widths, including the narrow black tape you see here separating the windowpanes.

CAPTURING DETAIL WITH PENCIL

Among the mediums that make it easy to capture detail and sharp edges is the simple drawing pencil. It's made of a rod—called the lead, even though it contains no actual lead—of dense material that's mostly graphite (a form of pure carbon) and clay. The higher the proportion of graphite to clay, the softer and darker the lead will be. Most manufacturers offer a range of leads from hard (designated by the letter H) to soft, or black, designated by B. A 6H lead is very hard and 6B is very soft, with at least ten grades in between plus a middle grade usually called HB.

You can use a pencil in a variety of ways, from soft passages made with the broad side of the lead to sharp marks made with the point. Draw on any surface that suits you, but if you're interested in permanence, choose an acid-free rag paper that won't become yellow and brittle over time.

MATERIALS

PENCILS
Graphite pencils: 2H, HB, 2B and 4B

PAPER
2-ply bristol (acid-free), 10" × 13" (25.4cm × 33cm)

OTHER
Index cards
Pink Pearl eraser
Mirror

TIP

Never mask a graphite picture by using tape over an area that already has some graphite on it because when you remove the tape it will lift a lot of the graphite. The same applies, of course, to any similar medium, including charcoal and pastel.

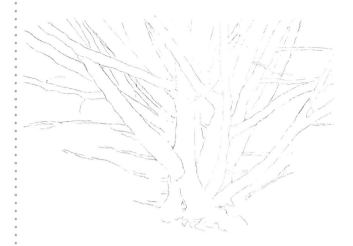

1 Lightly outline the main shapes in your drawing to make sure your overall design looks satisfactory before you invest a lot of time rendering the subject. Use a soft pencil, such as HB or 2B, rather than a hard lead that might score your paper and make erasures difficult. Draw your outline more faintly than you see here; I've made it darker to be sure it would show up in this book.

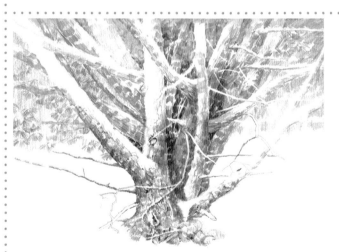

4 Begin the background woods lightly with 2H and HB pencils. From now on, keep adjusting detail and values between the tree and its background. The idea is to keep the background quiet so it feels distant when compared with the much more detailed foreground; i.e., the tree. Try to preserve white areas where they make sense; if you lose them, the picture may lose its spark.

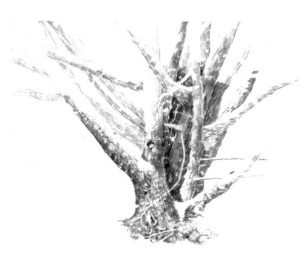

2 Begin in any area you wish and quickly establish some strong value contrasts. You could work lightly all over the picture first, if that suits you; I like getting some action going early. Using first a light pencil such as 2H, and then HB and 2B, lay in "patches" of hatched strokes. Use 2B and 4B for darks. The idea in hatching is to retain lots of tiny white areas between strokes for a lively visual effect.

3 After establishing an interesting center, work outward, still using combinations of hatched strokes. Using an erasing template, begin forming the little white twigs. Make your own erasing templates by cutting a variety of thin grooves out of an index card with an art knife. Hold the card firmly over the drawing and erase the exposed area using the sharp edge of an eraser, such as a Pink Pearl.

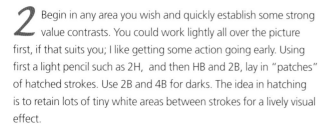

5 Take your time finishing. Pause often to look at your picture upside down and also in a mirror; these techniques help you spot awkward shapes and other problems you won't always see looking at the picture straight on.

In this picture, detail is everything. Try to place a detail, such as a dark spot or a white twig, in an area where it will show up well. The best "action" you can get is to place a white area next to a black one. Don't hesitate to erase, but make sure you erase cleanly. Always use a template or the edge of an index card.

NEEDWOOD PINE
Graphite pencil (2H, HB, 2B, 4B) on acid-free 2-ply Canson Bristol
10" × 13" (25.4cm × 33cm)

EVEN STILL LIFES NEED DEPTH

Even though most still lifes are not very deep, perspective is important; without it, your picture may look flat (lots of still, not much life). Using details and edges effectively will help you achieve a sense of depth, as will some of the perspective techniques, such as overlap and spacing, that will be discussed in other chapters.

Your still life will have a background, even if it's only the white of the paper or canvas. The small distance between objects and background can be as important as the mile of distance between the foreground and background in a landscape. An easy way to get some separation from front to back in a still life is to make the objects detailed and sharp and keep the background soft.

Softness Suggests Distance
Compare the boards in the shelf sticking out at you with the vertical boards in the wall behind the shelf. The forward boards are detailed, but those in the rear, just a couple feet away, are only suggested; keeping them simplified pushes them back. The objects on the shelf are all so detailed that they clearly separate from the fuzzy background wall.

BARN CLUTTER
Watercolor on illustration board
30" × 48" (76cm × 122cm)

Another Example
So far in this simple still life the area behind the fruit is blank. You could leave it that way and there would be a decent feeling of depth. On the next page, you'll see the effect of various filled-in backgrounds.

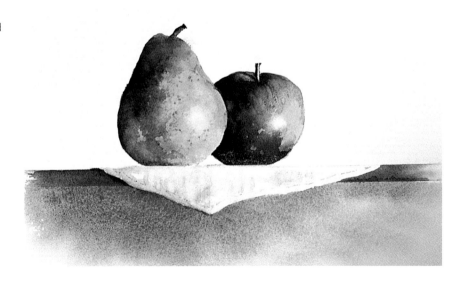

TRY THIS

Suppose you're reasonably satisfied with your painting of some objects in a still life, but you can't decide what to do with the background. Here's a method I use a lot. If I can't decide on the color of a background I cut pieces of paper representing the shape I'm unsure about: in this case, the space behind the pear and the apple. I paint the cutouts in a number of ways, and lay the painted cutouts over the painting to see what looks best. This method is practically foolproof; with patience you'll always find a solution without ruining your

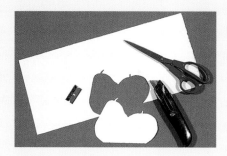

painting. I use it a lot in landscapes to help me decide on the color, or even the shape, of a roof or sky or some other part of the picture.

How to Create a Shape Cutout

The easiest way to make a cutout is to place tracing paper over your picture and trace the shape you want to experiment with. Transfer the shape to a piece of watercolor paper and then cut it out with a sharp knife, razor blade or scissors.

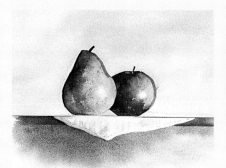

Soft Blue Background

Paint the cutout, dry it, and lay it over your painting. Try a light option first, so you can use the same cutout for the next darker choice. In this version, there's no conflict between the fruit and the wall. There is a good separation and, therefore, a decent illusion of depth. But it's pretty bland.

Reddish Background

You can try a whole range of colors. This one seems to advance too much, so maybe we lose some depth.

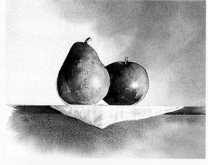

Graded Background

I've rewet the light blue background and added darker blue, graded from light to dark. This looks better.

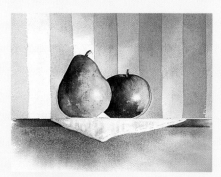

Wallpaper

This is more interesting, but we're getting into dangerous territory. If we're not careful, the background will be so strong it won't feel separated, or distant, from the fruit.

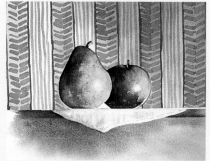

Stronger Wallpaper Pattern

Here's a stronger wallpaper pattern (you can see I'm not much of a wallpaper designer). This is too busy. The strong pattern brings the background too far forward, thus losing perspective.

You can try any number of alternatives—other colors, other patterns, something other than a wall—but try for a separation between the fruit and whatever you stick behind the fruit.

SUMMARY

- **Your eyes focus on only one plane at a time, just like a camera.**

- **Think of your picture as having a foreground, middle ground and background and pick one of them as your area of interest. Put most of your detail and sharp edges there.**

- It doesn't matter which area you choose; what's important is that there be a definite *contrast* from one plane to the other. It's the contrast that suggests separation and depth.

- If you make every area of a picture equally detailed, the picture will probably appear flat and two-dimensional.

- Even over short distances, as in a still life, depth is important. One way to get depth is to keep the backdrop calm so that it definitely remains separate from the foreground objects.

- Sometimes you choose a medium to achieve a particular mood; you may also consider one medium rather than another to help render sharper or softer details and edges.

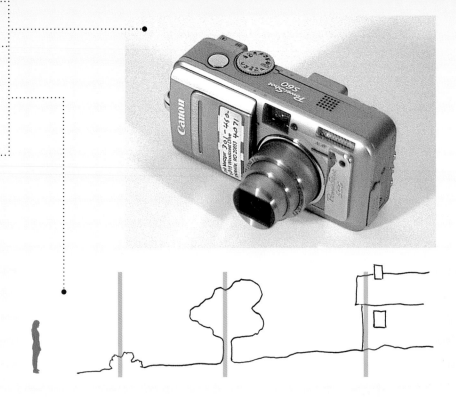

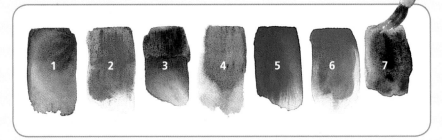

Palette

1 Alizarin Crimson
2 Raw Sienna
3 Raw Umber
4 Burnt Sienna
5 Phthalocyanine Blue
6 Cobalt Blue
7 Phthalocyanine Green

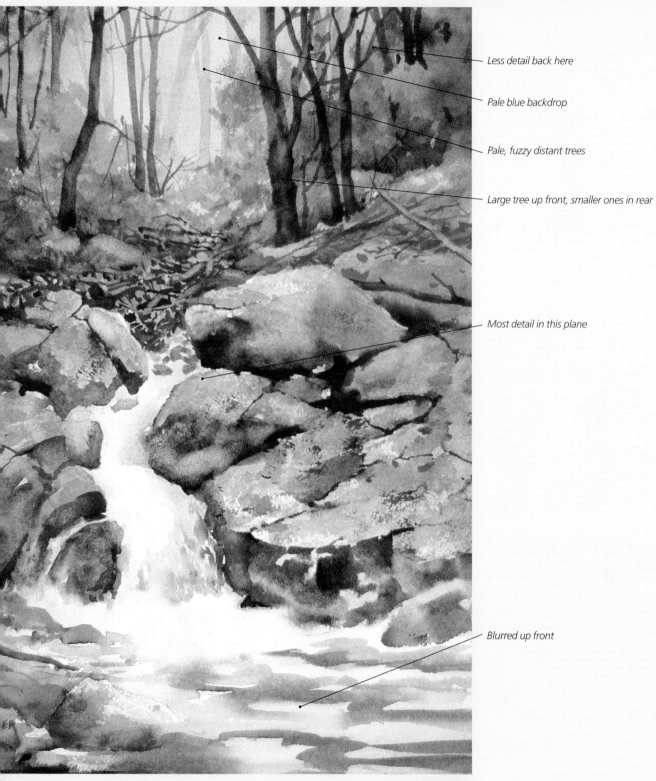

Less detail back here

Pale blue backdrop

Pale, fuzzy distant trees

Large tree up front, smaller ones in rear

Most detail in this plane

Blurred up front

WATERFALL
Watercolor on Arches 140-lb. (300gsm) cold-pressed paper
14" × 10" (35.6cm × 25.4cm)
Collection of Ted Staley

CHAPTER THREE

SIZE, SPACING AND OVERLAP

The men in the illustration on this page may be recruits reporting for duty. We can see that they're all pretty much the same size, even though the figure at the far end is much smaller than the one that appears to be closest to us. As you look down the line there's a gradual diminishing in both the size of the figures and the spaces between them. This is a common sight: we're used to seeing same-size objects in a row and we expect those farthest away to be represented as smaller than those nearby.

Behind the men is a building. We know instinctively the building is farther away from us than the men are. We know this because the building is behind the men. We need not even think about it because we know that if one object overlaps another, the front object is closer to us than the rear one.

These techniques—varying the size and spacing of objects and overlapping them—are simple but powerful means of achieving perspective.

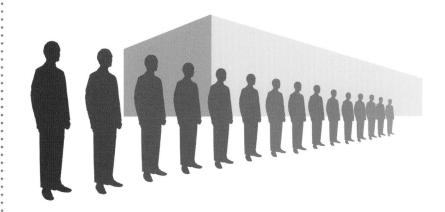

Use Size and Overlap to Create Perspective

The biggest figure looks closest and the smallest, farthest away. The building seems even farther away than the men because it's overlapped by the men. (The gradual lightening of the values also adds perspective.)

OVER THE BRIDGE
Watercolor on Arches 140-lb. (300gsm) cold-pressed paper
22" × 30" (55.9cm × 76.2cm)

HOW WE SEE SIZE AND SPACING

VERTICAL OBJECTS

Let's say you're painting a row of trees that are pretty much the same height and evenly spaced. If you paint them that way, they will march across your picture without suggesting much depth. But if you place yourself at one end of the row and paint them the way you see them from there—nearby trees larger than distant trees—you'll introduce depth into your picture. When you paint that way, all you're doing is imitating the way we see. Wouldn't it seem strange to us if suddenly we saw everything at its actual size rather than seeming to diminish in size in the distance?

TIP

Lots of repeating vertical objects—fenceposts, power poles, trees, cans or books on a shelf—are almost identical and equally spaced. Use your artist's license to mess them up a little, whether painting them broadside or in perspective. Depart from the real scene enough to add bits of interest to your work. Don't be afraid to make the viewer question what you've done (thus catching his interest).

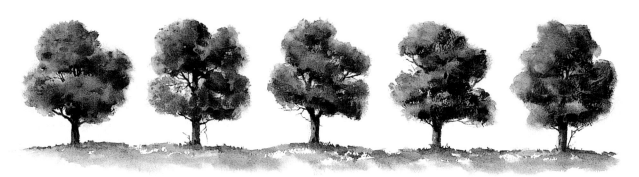

Row of Trees

These trees were planted in a nice, straight line, evenly spaced. Seen (or painted) from this broadside view, they don't suggest much depth.

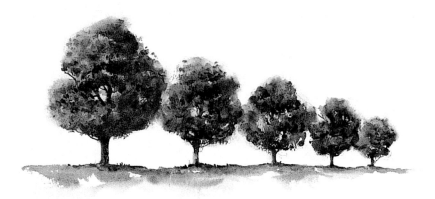

The Same Trees in Perspective

No question, there's more depth here than in the previous painting. You can usually arrange parts of your picture to do your bidding. An exception is when you're painting on commission and the customer wants things just as they are and painted from a particular spot. If you take on that commission, good luck!

HORIZONTAL OBJECTS

Objects that are essentially *parallel to* the ground (rather than perpendicular to it) appear to diminish in size and spacing just as vertical objects do. Depict them the same as you would vertical objects: larger up front, smaller in the distance.

Railroad Tracks in Perspective

The wooden ties that connect railroad tracks are evenly spaced, like rungs on a ladder, but seen in perspective the rungs get smaller and the spaces between them decrease as they recede. Another powerful perspective technique at work here is linear perspective, illustrated by the meeting of the tracks in the distance. As we'll see in later chapters, *size and spacing* perspective and *linear* perspective are closely related.

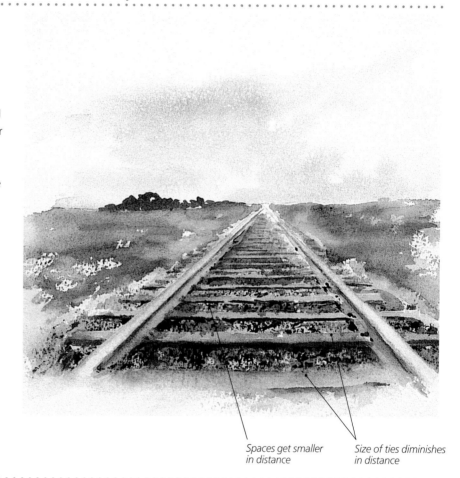

Spaces get smaller in distance Size of ties diminishes in distance

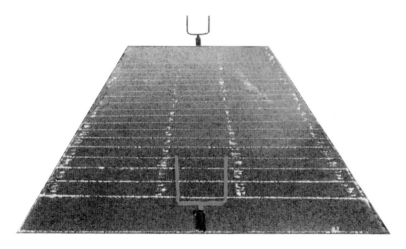

When Equal Spaces Don't Look Equal

An American football field is divided into five-yard spaces, but the five-yard space nearest you seems a whole lot bigger than the ones at the far end of the field.

MAKE SIZE AND SPACING WORK FOR YOU

Here are some examples of how you can rearrange the sizes and positions of elements of your picture to emphasize depth. Often this is easy to do, but at other times you may find yourself straining to make something work. In those cases, it may be that you're doing more harm than good and you'd better leave well-enough alone.

Flat
Faced head on, this brick wall is flat and monotonous.

Orange book

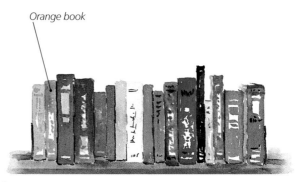

Flat
In this sketch, you see the books straight on and, except for the bit of receding shelf at both ends, there is not much hint of depth.

VALUES AROUND A CORNER

In the brick wall sketch we have a bright (more sunlit) wall adjoining a somewhat darker wall. The value difference between two such walls always seems strongest at the corner—the dark makes the light seem lighter and the light makes the dark seem darker. We'll revisit this idea in the next chapter.

GET UP AND MOVE!

If you often paint from photographs, it's important to make those photos the best you can. It's easy to shoot too much and come home with too little. If you shoot wildly all over the place, when you get home and look over what you've got, you may find that you've wasted most of your shots. When you look through your viewfinder, imagine that scene as a painting. If it doesn't grab you, maybe it's not worth shooting. With a digital camera you can check your shots on the spot and reshoot until you get just what you want.

While you're photographing, try moving around to shoot the scene from different angles. Better yet, shoot from a spot you think will make a good painting and then get some supporting shots that include close-up details that may help you later on.

No Depth Here
This fence is not helping in the depth department!

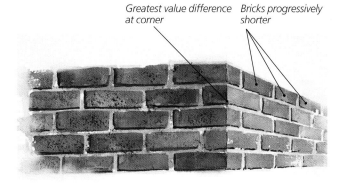

Greatest value difference at corner

Bricks progressively shorter

Better

Move to the right a little so you can see the receding side wall, and the bricks look something like this. As they diminish in size they suggest depth.

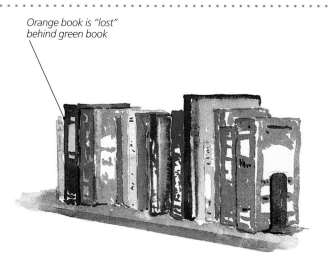

Orange book is "lost" behind green book

Better

By changing your position and looking down the shelf at an angle, you gain depth. When you shift your position, be ready for some surprises; a couple of the books "disappear." That's because they're not all lined up evenly and some that are pushed farther in get lost behind those that project farther out.

And as the books diminish in size, as you would expect, the spaces between them don't diminish because there are no spaces to begin with.

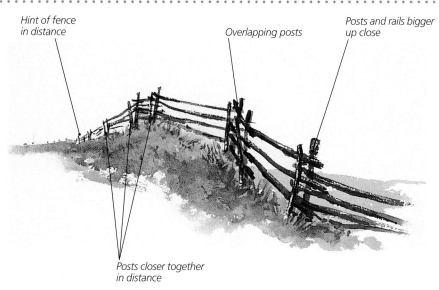

Hint of fence in distance

Overlapping posts

Posts and rails bigger up close

Posts closer together in distance

If It Doesn't Work, Change It

Better, no? Often you can improve a picture not necessarily by moving its pieces, but by moving yourself—that is, painting (or photographing) the scene from a better vantage point.

HOW TO MEASURE

As I was teaching a class I looked over a student's shoulder and saw that she was drawing a cat alongside another furry critter. "Cute rat," I said. She corrected me. "It's a mouse, not a rat!"

Well, you could have fooled me. That mouse looked pretty formidable. What had happened was that she had drawn her cat from one photo and her mouse from another and had not paid attention to their relative sizes. In any realistic picture, you must get sizes right, otherwise realism (and probably any sense of depth) may go out the window.

What's important in a picture is not the true size of an object, but its relative size—that is, how big one object is when compared to another. Getting relative sizes right is easy if you use a simple measuring technique called the thumb-and-pencil method. Here's how it works.

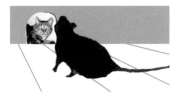

Here kitty kitty…

1 Use a Viewfinder
In the scene before you there's a lot of stuff to choose from. Use a viewfinder (a small rectangle of cardboard with a rectangular hole) to home in on the part of the scene you want to draw.

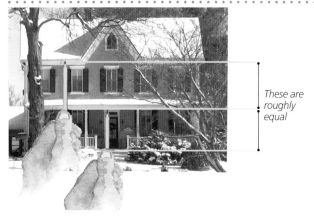

These are roughly equal

4 Measure and Compare Verticals…
"Measure" the distance from the porch floor to the porch roof. To do this, hold a pencil at arm's length, close one eye (only one!) and align the tip of the pencil with the underside of the porch roof. Slide your thumb down the pencil to the level of the porch floor. The length from tip to thumb represents the porch height. Now, still holding the pencil as before, thumb still at the same spot, shift left a little and align the tip of the pencil with the lower edge of the main roof. Now you see your thumb is about at the lower edge of the porch roof. So those two measurements are about the same. Check those two dimensions on the drawing and you'll see that in the drawing those dimensions are nowhere near equal. If you go a step further and measure from the lower edge of the main roof to the top of the roof, you find that dimension is roughly the same as the other two. The drawing is way out of whack!

All three spaces roughly equal

5 … And Horizontals
There are lots of other dimensions you can check. In the drawing, the triangular dormer seems too small compared with the roof. Use the pencil again, this time horizontally, to check the three dimensions shown here and you'll find the middle dimension (the width of the dormer) is about the same as the two flanking it. In the drawing the width of the dormer is much smaller than the other two.

Left edge of garage House rooftop Right edge of house

Bottom of steps

2 Mark Off the Outer Limits

It's a good idea to tape off an inch (25mm) or so around the edges of your paper to save a clean border. Then lightly mark off the outer limits of the larger objects in the scene to make sure you keep the drawing within the limits of the size of your paper. Without these marked limits, it's easy to end up with a drawing that falls off the edges of the paper.

3 Sketch the Main Objects

Faintly sketch the main objects in the scene: the house and garage. A glance at the real subject tells you the drawing is pretty far off, so it's time to take a few measurements.

6 Keep Adjusting

Part of the reason the dormer seems too small is that the roof is too wide. Check the height of the actual house with thumb-and-pencil and compare it with its width. The sketched house is too long. Also compare the length of the garage with the length of the house. The garage is too short. Here's an adjusted sketch (by now we need a new eraser).

COMPARE ANYTHING TO ANYTHING

There are many ways to use rough measurements to get a drawing right:

- Look for dimensions in the subject that are more or less equal and see that they're also equal in your drawing.
- Where there are unequal dimensions, see how many times a smaller dimension fits into a larger one. For example, thumb the fence post in the foreground and see how many times its height "fits" into the height of the house; it looks like about six in this scene.
- Use the measuring technique not only to measure the relative sizes of objects, but to measure the spaces between them, as well; e.g., see how the space between the house and garage compares with the width of a window.

OTHER MEASURING TECHNIQUES

Artists use all kinds of techniques, tools and tricks to get where they want to go, including using a ruler! Objects that appear to be the wrong size can ruin your picture. If you really want your picture to suggest a cat and a mouse having a friendly get-together, better not have the mouse look like a rat!

An ordinary ruler (or a straightedge of any kind) can help nail down those details that are critical to establishing a sense of reality and depth in a picture. Here are just a few ways to use it.

PLUMB LINES

A plumb line is a perfectly vertical line. If you suspend a weight from a string (plumbers call this a *plumb bob*), the string will always hang straight down. If you want to align objects vertically you could use a plumb bob, but for drawing, a simpler tool will do the job: a ruler. Hold it out vertically, close an eye, and check the alignment of elements in the scene you're looking at. Then lay the ruler on your drawing to see whether you've drawn the objects in alignment. Or, of course, if there are objects you *don't* want to line up, use the ruler to make sure they are not aligned.

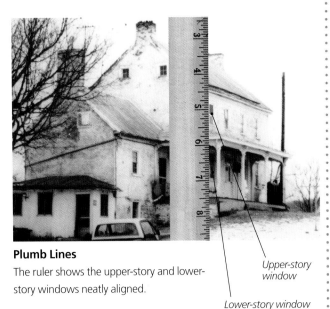

Plumb Lines
The ruler shows the upper-story and lower-story windows neatly aligned.

Upper-story window

Lower-story window

GETTING RELATIVE SIZES RIGHT

In a recent class, we painted pictures of a brick building, working from photographs. In an otherwise beautiful painting, one student lost track of the size of the bricks relative to the size of a window. He made the bricks so small that the window seemed much too large by comparison; the two were not in synch. Because the bricks were so small, they almost felt more distant than the adjoining window. Another student went the opposite way, making her bricks much too large for the setting. A way to avoid such errors is to count how many of one kind of object will fit in the space occupied by another object; for example, how many bricks equal the height of a window pane. Once you make that assessment, you can't go wrong.

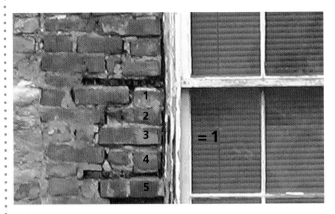

Relative Sizes
Just count 'em up! There are five bricks alongside a single window pane.

HORIZONTAL "PLUMB LINES"

Often you need to check horizontal alignments. You're not necessarily interested in lining things up, but maybe only in seeing how one level, such as a rooftop, relates to another level, such as another rooftop.

Checking on roof levels

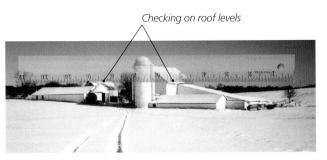

Horizontal "Plumb Lines"
Holding a ruler horizontally allows you to compare the heights of various roof levels.

SIZING THINGS UP

If you draw what you know rather than what your eyes tell you, you're in trouble. You may know that distant child is three feet tall, the same as the child right next to you, but if you draw them the same size in your picture, it will look wrong: no depth. Draw the way your eyes dictate.

Look at this detail of the picture at the beginning of this chapter. Compare the height of the foreground post to the height of the distant barn; they're about equal. You know, of course, that the post is really only about one-eighth or so as high as the barn; that is, you'd have to stack eight posts end on end alongside the barn to reach the barn's rooftop. But if we drew the barn eight times as tall as the post, the scene would not look realistic.

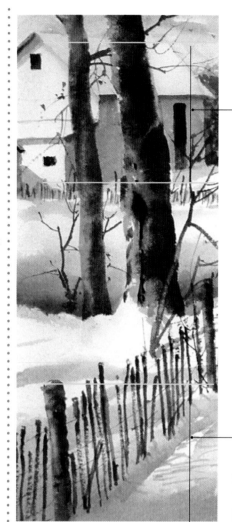

— Barn height

The barn height and the post height appear to be roughly equal!

— Post height

Draw What You See
The post is not really as tall as the barn—you just have to draw it that way.

TRY THIS

To see how distance can affect size relationships, use the thumb-and-pencil method shown on page 44 to measure the height of this paragraph. Keep your thumb in place and look out the window at a neighbor's car. Hold up the pencil and compare the height of the paragraph to the height of the car.

EXAMPLES OF DIMINISHING SIZE AND SPACING

We can't avoid it: all around us we see objects that appear to diminish in size and spacing. We're so accustomed to this type of perspective that we take it for granted, so it feels quite natural to include it in our pictures.

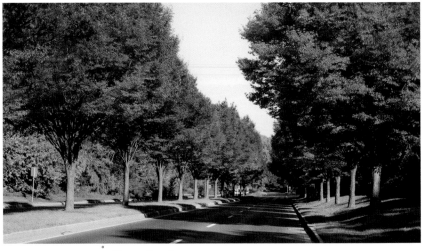

Along the Avenue
Japanese zelkova trees in perfect perspective.

Down the Street
Utility poles that recede into the distance can add a bit of realistic detail and, as shown here, lead the eye into the picture

At the Mall
Both the cars and the columns at the rear diminish in size and spacing.

High in the Sky
Clouds don't always cooperate this well, but when they do, they help draw your eye into the picture.

Windows
Practically everything in this photograph demonstrates size-and-space perspective: the windows, the bricks, the rectangular stripes above and below the windows and even the little trees.

Columns
The columns get smaller and closer together as they recede, and so do the flat sidewalk sections (like railroad ties).

HOW OVERLAP WORKS

If one object overlaps another, the overlapped object automatically seems (and must be) more distant than the overlapping object. That's an obvious, take-for-granted rule of life that provides us with an easy way to suggest depth in a picture. Want to push that building back? Stick a pole or a person or a tree or another building or anything you please in front of it.

How Far Away?
Which is closer, the tree or the house? Can't tell.

OVERLAPPING ON A SMALL SCALE

Overlapping is effective no matter how small the setting. In a still life, you can arrange objects to overlap and partially hide one another; with flowers and vegetation, leaves, petals and stems naturally overlap and provide critical depth even though the distances involved are very short. *Lilies*, at right, demonstrates this well.

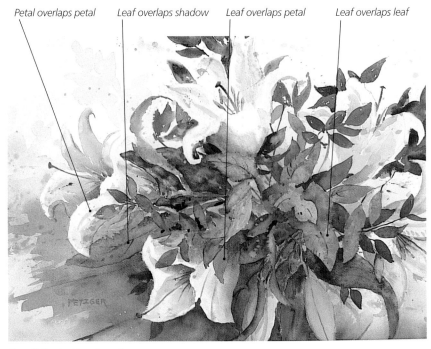

Petal overlaps petal Leaf overlaps shadow Leaf overlaps petal Leaf overlaps leaf

Small-Scale Overlapping
Thanks to small overlapping parts, this floral has a decent amount of depth.

LILIES
Watercolor on Arches 140-lb. (300gsm) cold-pressed paper
14" × 20" (35.6cm × 50.8cm)

Overlap the Tree
The house is clearly in front; the tree is pushed back in space.

Overlap the House
Now the tree is up front and the house is pushed back.

OVERLAPPING ON A LARGE SCALE

In a landscape you can place lots of things in front of lots of other things: a mailbox in front of a house in front of a tree in front of fields in front of woods in front of mountains in front of the sky . . . the sky's the limit! Or you can have just two objects, as in the painting *Winter Boughs*, at right.

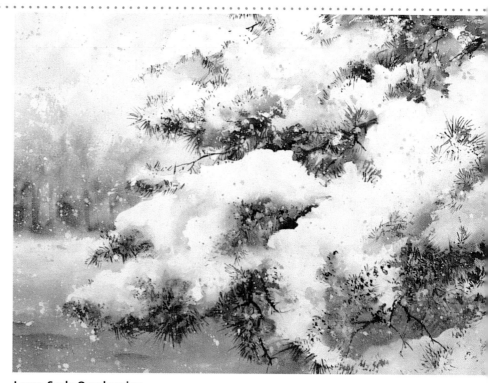

Large-Scale Overlapping
These evergreen boughs are clearly in front of the woods. Of course, as is usually true, there are other perspective techniques at work here, including more detail and sharper edges in the foreground.

WINTER BOUGHS
Watercolor on Arches 140-lb. (300gsm) cold-pressed paper
18" × 24" (45.7cm × 61cm)
Collection of Barbara Weiss

Here are four objects—vase, glass, bottle and bowl—lightly drawn. You have no clue which object is closest to you, which is farthest back. Use overlap to make the objects appear in whatever order you choose. Start by darkening the lines of the object you want to be most forward, then the object you want to be next farther back, and so on until one object is clearly at the rear. Do the same exercise with all four frames below, each time putting the objects in a different order. As a starter, I've begun overlapping the set in the first frame by bringing the bottle forward and placing the vase behind it. As you'll see, by using simple overlap you can greatly affect the sense of depth in the picture.

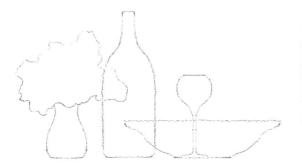 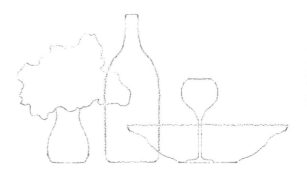

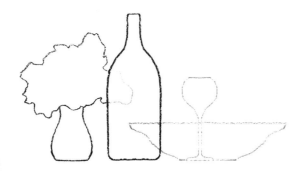 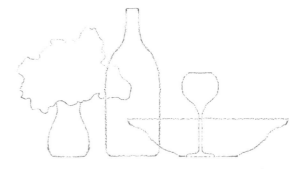

THE IMPORTANCE OF SCALE

Let's go back to the row of trees on page 40; a couple of them are repeated here. Do you have any clue about the size of these trees? They could be ten feet tall or fifty and they would still look pretty much the same. With nothing to indicate scale, these trees could be far away in your picture or nearby. To give the viewer a hint about distance, the trees need something to indicate their size.

An easy way to suggest the size of one object is to put next to it an object whose size everyone knows. For instance, if you put a person or a dog or a car or a fence close to the trees, you'll automatically show how big the trees are. The viewer unconsciously compares the trees to the known object and infers the size of the trees.

For this to work, make sure it's clear that the known object—e.g., the fence—is in the same plane as the trees. It wouldn't help to add the fence if you left the impression that the fence might be way forward or far behind the trees.

How Tall?
No way to tell how tall these trees are. They could be ten feet tall, or fifty.

Add a Person
The person sitting against the tree gives you an idea of the tree's size.

Add a Fence
You know roughly how high a fence is, so its presence alongside the trees tells you the sizes of the trees. But you must make it clear that the fence and trees are in the same plane. Do this by painting them with the same degree of detail and sharpness.

CONNECTIONS BETWEEN OVERLAPPING OBJECTS

When objects overlap, they don't necessarily make a physical connection; one object is simply some distance behind the other. Sometimes, however, there is a physical connection between objects, and you can increase the sense of depth in your composition by plainly showing those connections. Consider a tree. Wherever a branch, big or small, connects to the trunk or to another branch, the joint will be quite evident. The shape of that joint signals, subtly but clearly, which object is forward and which is at the rear.

It's useful to think of a tree as a bunch of cylinders stuck together. How you draw the joint where the cylinders meet will tell the viewer a lot about branch directions.

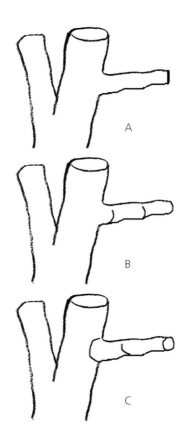

A

B

C

Simple Curves Show Direction
In A, the branch is apparently aiming straight off to the side. In B it's aiming toward the rear, thanks to just a couple of curved lines. In C the branch comes forward, again thanks to some curves.

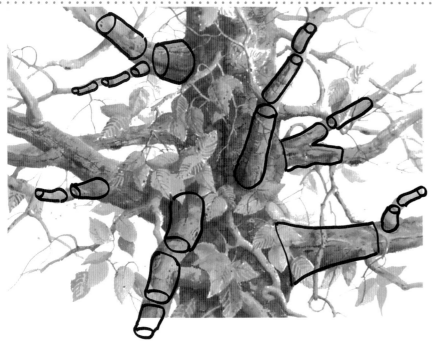

A Tree As a Set of Cylinders
Here are a few of the "cylinders" you might find in the beech tree on the opposite page.

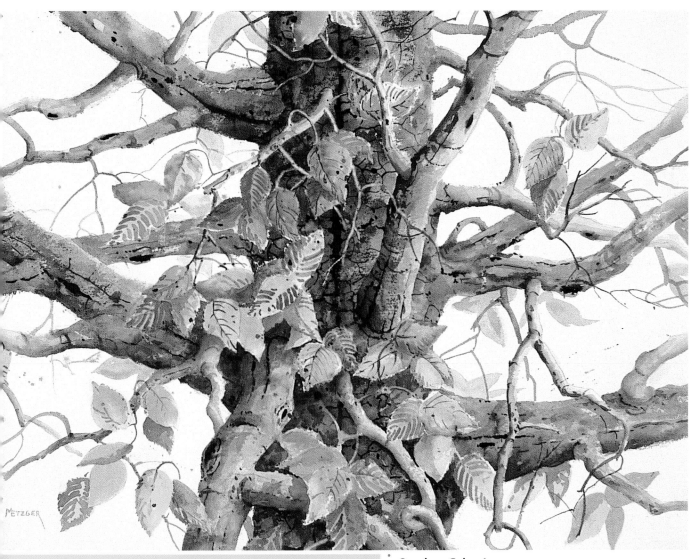

KNOW YOUR SUBJECT

To paint a tree (or anything else) accurately, get to know it intimately. You may have noticed by now that I like trees; I paint them pretty often. It all goes back to my childhood, when my brothers and I went into the woods to cut trees for our firewood. We made a game of it: one of us would climb up in the tree and the others would cut it down. What fun!

Overlaps Galore!

Trees offer many opportunities to use overlap: branches overlap other branches, branches overlap trunks, leaves overlap leaves and so on. In addition, joints help suggest which branches come forward, which go to the side and which to the rear.

AMERICAN BEECH
Watercolor on Strathmore illustration board
22" × 30" (55.9cm × 76.2cm)

SUMMARY

- **As same-size objects appear to get smaller and smaller, we know they must be farther and farther away.**

- Overlapping one object with another pushes one object back and brings the other forward.

- When objects are evenly spaced, the spaces seem to diminish as they recede.

- **You can rearrange the elements of your design so they more effectively show distance.**

- **To convey a realistic sense of distance, it's critical to show the relative sizes of objects accurately.**

- **To get sizes right, compare one object with another using the thumb-and-pencil method.**

- If the scale of an object isn't clear, place a familiar object of known size nearby.

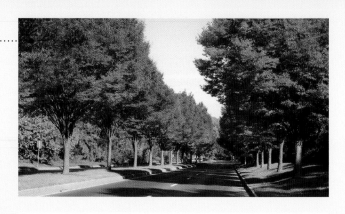

SHADING: *Tree trunks look rounded because of gradual shading*

OVERLAPPING: *Trees in front of barns push barns back*

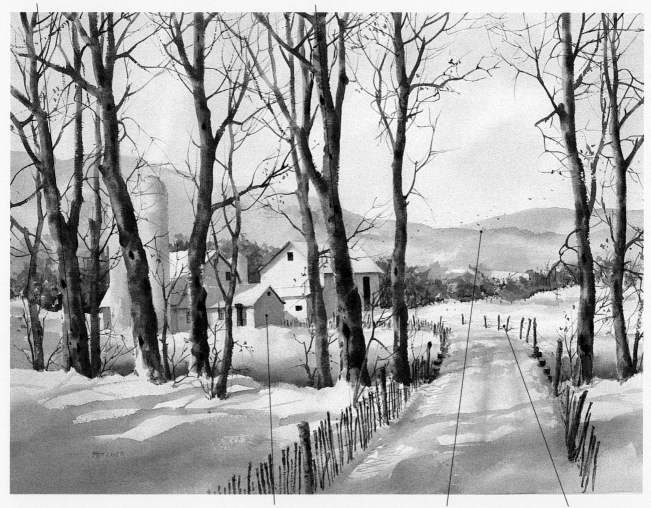

VALUE CHANGE: *Small black accents (doors, windows) suggest you're seeing into buildings*

LINEAR PERSPECTIVE: *Sides of road converge toward distant horizon*

WARM TO COOL: *Trees and fence in foreground are warm; distance is cool*

SHADOWS: *Building looks three-dimensional because one side is sunlit and adjoining side is in shadow*

ATMOSPHERIC PERSPECTIVE: *Distant hills are pale and bluish*

SIZE AND SPACING: *Fence gets smaller in distance*

OVER THE BRIDGE
Watercolor on Arches 140-lb. (300gsm) cold-pressed paper
22" × 30" (55.9cm × 76.2cm)

Palette

1 *Alizarin Crimson*
2 *Cadmium Yellow Light*
3 *Raw Sienna*
4 *Raw Umber*
5 *Burnt Sienna*
6 *Phthalocyanine Blue*
7 *Cobalt Blue*

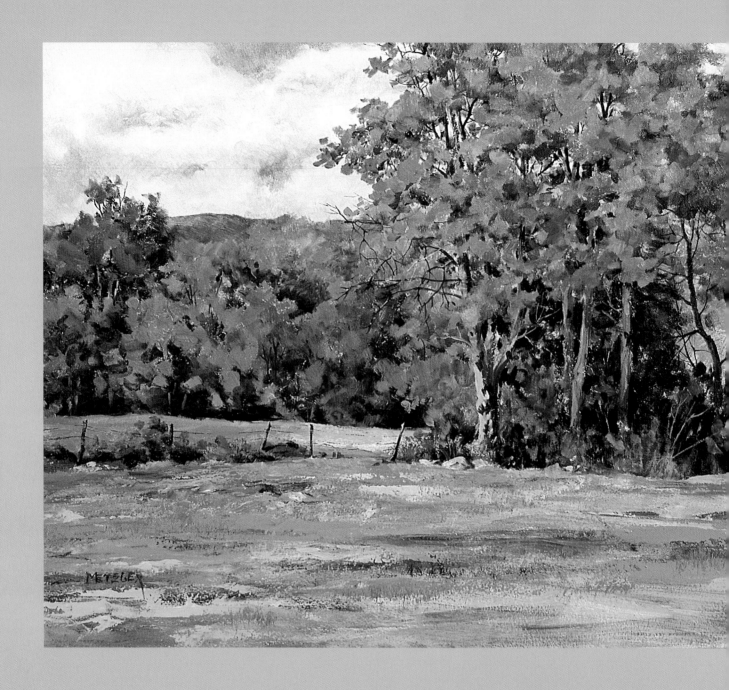

VALUES AND SHADOWS

Sometimes pale values suggest distance, as we saw in the first chapter. But often a dark value suggests depth, as in the case of a dark window or door in a building, or a dark crevice in a brick wall. In either case, it's the contrast in values that does the trick. Put a dark next to a light and it's almost impossible to see the two as equally distant from you.

Pale values, like those distant hills we've discussed, draw you gently into the distance. Dark values reach out and grab you by the throat and say: Look at me! They aggressively pull you in. While a picture surface that's either *all* light or *all* dark may be intriguing and beautiful, it is unlikely to give you much sensation of depth.

The most important instances of value change are *shadows*, areas receiving less light than adjacent areas. Some shadows are bold and dark; some are more gentle. If they're bold and placed next to a brightly lit area, as in the example below, the result is hard to ignore. But if they're quiet they may only nudge you into the distance or subtly pull you around the curve of a face or a tree trunk.

Value Adds Punch

The contrast between the leaves and the dark area is so strong that it's hard to imagine both areas equally distant from you. If you were to replace the dark with a bright area, almost all depth would be lost.

Autumn Leaves
Pastel and watercolor on Arches 300-lb. (640gsm) cold-pressed paper
6½" × 9½" (16.5cm × 24.1cm)

IN THE PARK
Oil on canvas
16" × 20" (40.6cm × 50.8cm)
Collection of Marilyn Keil

A WATERCOLOR ASSIST

To get the rich dark in this sketch I underpainted first with dark watercolor, then colored the leaves with pastel.

KINDS OF SHADOWS

There are two basic kinds of shadows: cast shadows and shading. A *cast shadow* is an area deprived of light because some object is blocking the light coming from the source. *Shading* is the darkened area you see on the unlit or less-lit side of an object. Some shading is soft and gradual, like that on the ball, below, while other shading has more abrupt edges, like the darkened side of a box. Both shading and cast shadows have a role to play in perspective.

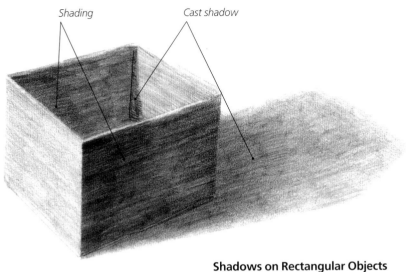

Shading *Cast shadow*

Shadows on Rectangular Objects
When you shade an object you create the illusion of a third dimension, which, in turn, gives the picture depth.

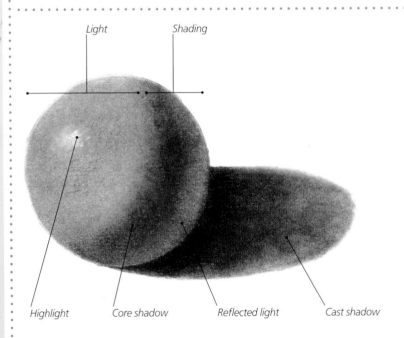

Light *Shading*

Highlight *Core shadow* *Reflected light* *Cast shadow*

Shadows on Rounded Objects
Any three-dimensional object, unless it's totally bathed in light from multiple sources, has a shaded side. The object also causes a cast shadow. Within both the light and shadow areas on the object are nuances called highlights, core shadow, and reflected light.

SHADING

Shading is the darkened side of an object. With a single light source, it's usually clear that one side is lighter and the other side darker, period. If there are multiple light sources, as in some still lifes, shading is not so cut-and-dried; in such cases you have to rely on your observation and paint what you see.

Whether you're painting an apple or a building or something else, the instant you shade a side of an object you introduce dimension and depth. There are usually nuances—the shading is lighter here, darker there—but as long as you show a distinct difference in value between one surface and another, you'll inevitably create some perspective.

Flat
This building is flat as a tortilla.

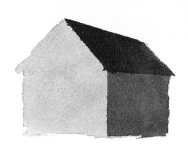

Better
Just a simple wash gives the building solidity.

Flat
Pretty flat—not a convincing apple, is it?

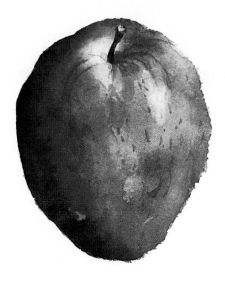

Better
That's more like it. When you draw or paint an apple, try to get the feeling you could wrap your hand around it; if you're painting a barn, try to imagine what's around the corner behind the barn.

SHADING PORTRAITS

Portrait artists take pains to light their subjects to suit their artistic aims (or to suit the sitter's wishes). If light is flooded directly over the subject's face, leaving none of the features in shadow, the result is likely to be flat and uninteresting. To make the head seem round, play off lighted features against darkened features. How much shadow you arrange depends on the mood you're after. For a gentle mood, maybe moderate shadow makes sense, but for a stronger contrast you may need to lose an entire side of the head in deep shadow.

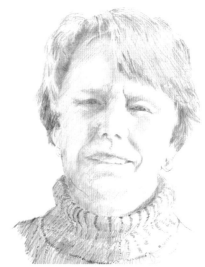

A Fully Lit Face
This pencil sketch is pretty flat, not much depth.

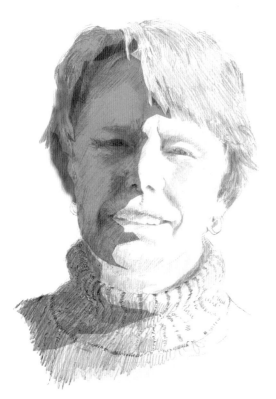

Face Lit From One Side
Here I've used a wash to throw one side of the face into shadow, improving the sense of depth. Although I did this "wash" on a computer, you could easily use pencil or charcoal—or even ink or watercolor provided you first spray the pencil drawing with any type of fixative to prevent smearing.

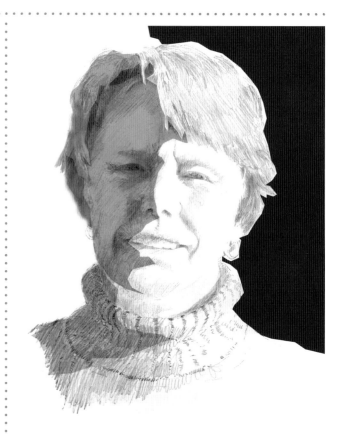

More Value Contrast
Just for fun, I've placed a strong dark behind the lighted side of the head. The contrast between the light and dark areas separates the background from the head, thus adding more depth.

CAST SHADOWS

A cast shadow is an area receiving less light than surrounding areas because something is blocking the light coming from the source. If you take the apple and building sketches on page 61 and add cast shadows, it's clear the shadows add to the illusion of depth.

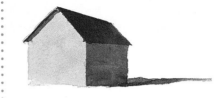

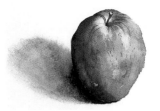

Cast Shadow of a Rectilinear Object
Because the roof overhang casts a small shadow on the face of the building, we know the roof projects outward by some small, but measurable, amount—so there we have bit of depth. The shadow cast on the ground gives the building some connection with the ground, which helps us to see the building as a real object.

Cast Shadow of a Rounded Object
The shadow adds a little more reality so the apple is not hanging in space.

COMBINING SHADING AND CAST SHADOWS

Few realistic pictures have no shadows at all, and few have *only* shading or *only* cast shadows. Usually you have both—as the song goes, you can't have one without the other. Both types of shadows work together to punch depth into a flat picture surface. Try to imagine the tree picture on this page without shadows.

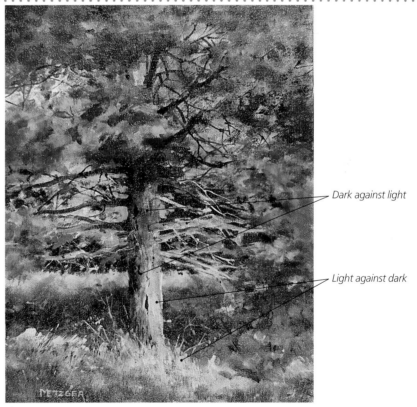

Dark against light

Light against dark

Shading and Cast Shadows Working Together
The tree is all about values—both shading and cast shadows. When you paint a subject like this, look for places where you can play off a light area against a dark, and vice versa.

TREE STUDY
Oil on canvas board
16" × 12" (40.6cm × 30.5cm)

AIMING YOUR SHADOWS

You can put cast shadows to work helping suggest distance by aiming them to suit you. A shadow falling straight across the picture plane does the least to suggest depth; slanting a shadow into the background or bringing it forward helps.

THAT LUCKY OLD SUN

… got nothing to do but roll around heaven all day! Lucky you, you have complete control of the sun. Stick it wherever you want, but be consistent. If the sun is at position X for part of your scene, make sure it's not at position Y for another part.

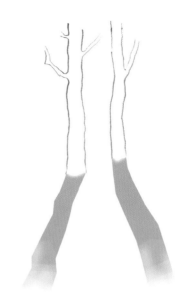

A Backlit Scene
These shadows also lead back into the picture. This is the way shadows would appear in a backlit scene; that is, with the sun in the distance, behind the trees.

Sideways Shadows
Minimal perspective.

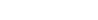

Oblique Shadows
These shadows take your eye back into the picture.

WHAT ABOUT MULTIPLE LIGHT SOURCES?

Often you're confronted with more than a single light source. In a still life you may have one or more room lights as well as light from a window. Such conditions may be complex and hard to figure out without actually setting up a model, but they certainly offer lots of intriguing possibilities as one shadow overlaps another. Another challenging situation is a night scene with multiple street lamps, automobile lights, signs and so on. When confronted with multiple sources, look for places where two or more shadows overlap; that's usually where the shadows will be darkest.

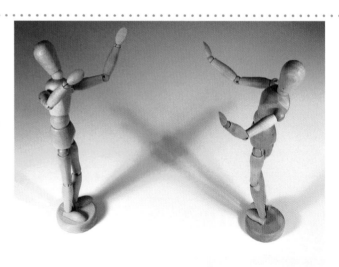

Multiple Light Sources
Old friends meeting under a couple of street lights. In their joy, they're oblivious to how their shadows are overlapping.

64

MODELS HELP MAKE CONVINCING SHADOWS

What's this? I ask a student. *A cast shadow,* he replies. And what's this? *Well, another cast shadow.* How come one goes north and the other goes south? *Hmmmm. I don't know.*

You may be making it up as you go along—painting shadows in a scene, but without any real shadows to guide you—but you really don't have to guess. You can make a model, shine a flashlight on it and see right away how real shadows behave. I implore my students to do this, but with only middling success because they think it's too much work or will take too much time. The truth is, you can model practically anything in minutes and the payoff is big. Let me show you a couple examples of models.

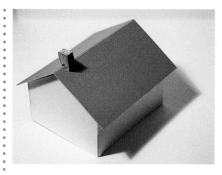

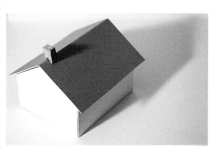

Construct Your Model
This house is made from a cardboard box that I cut off at angles to make the triangular ends (the gables); the roof is a piece of mat board and the chimney, a block of wood (I could have used cardboard). Cost: five minutes and a nicked finger. With the room darkened and the flashlight held high and to the left, you get one set of shadows.

Experiment With the Light
Move the flashlight (the sun, that is) around to get shadows to fall where you want them. Here the sun is lower and more to the front.

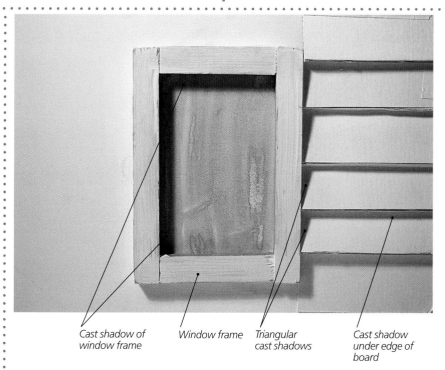

Cast shadow of window frame Window frame Triangular cast shadows Cast shadow under edge of board

Models Reveal Surprises
Here's a model I use in class to show the shadows you get when light shines on beveled, overlapped house siding. It's not intuitively obvious to most of us that we'd get those neat little triangular shapes.

TRY THIS

Suppose you have a shed attached to the side of a building and you want to see how cast shadows would look with the sun (or moon) in a variety of positions. And suppose, too, there is to be a round stovepipe sticking up from the roof of the shed.

Use any upright surface (a room wall or a piece of cardboard) to represent the wall to which the shed will be attached. Cut a three-sided shed out of cardboard and place it against the wall. Cut a rectangle of cardboard and use it as the shed roof (if it slides off, tape it in place), but first punch a hole in the roof with a pencil. Leave the pencil sticking up as the stovepipe. Be sure to make the shed roof big enough that it hangs over the sides of the shed; that way, you'll see the shadows the roof casts on the sides.

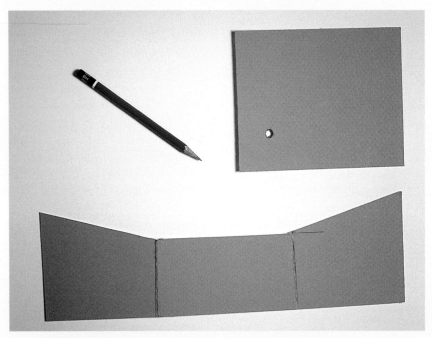

A Few Simple Pieces
Here are the parts for your model building, shed and stovepipe.

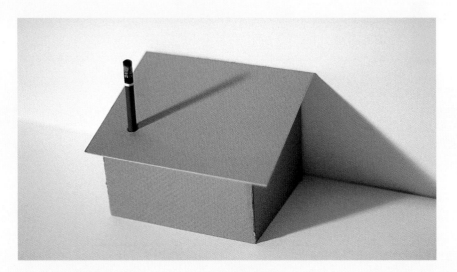

The Finished Model
Here are the pieces assembled. Elapsed time: three minutes, a record. Now all you need do is turn out the lights, switch on your flashlight "sun" and move it around and observe the results. Take special notice of the shadow cast by the pencil "stovepipe" on that slanted roof surface.

VALUE CHANGES ADD DEPTH

No matter what other perspective techniques you use, sharp value contrasts add depth to a picture. There's a sort of push-pull going on as brighter areas tend to come forward and dark areas recede and pull you in.

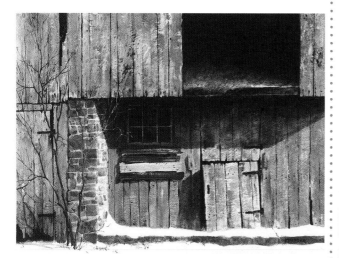

Both Large and Small Darks
Value change gives this picture its depth. The deep shadow inside the upper loft draws your eye in; the cast shadow under the overhang tells you the top part of the barn projects farther out than the lower part; the shadow cast by the lower door says the door is partly open and forward from the door jamb; the dark cracks, holes and indentations in the siding and the stone foundation give those objects a bit of depth; and the sunlit side of the foundation contrasting with the darker face makes the foundation turn the corner.

BARN OVERHANG
Opaque and transparent acrylic on Strathmore illustration board
20" × 24" (50.8cm × 61cm)

VALUE CHANGE, NEAR AND FAR

Value change over short distances is as important as value change in long-range atmospheric perspective. The small dark dots and crevices in a rock or in board siding, for example, tend to punch holes in the rock or siding and let us see a tiny way into it. Without the darks, those surfaces would be smooth and uninteresting, with no depth at all.

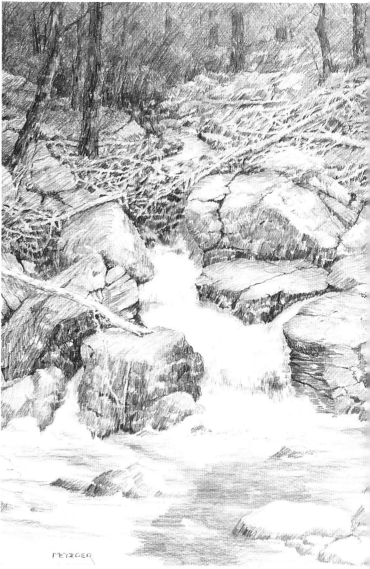

Lots of Small Darks
Working in black, white and gray, without the aid of other color, you have to rely on values to carry a picture. In this drawing there are hundreds of little patches of dark value next to lighter values. I attempted to keep the water bright and not let it get lost in all the busy rocks and driftwood. I suggest doing black-and-white studies (pencil, charcoal, ink, etc.) as a great way to hone your ability to both see and render values.

WATERFALL
2H, HB, 2B and 4B pencils on Strathmore illustration board, plate finish
17" × 12" (43.2cm × 30.5cm)

REFLECTED LIGHT AND COLOR

The play of light and shadow on any object is much more nuanced than you might imagine. The ball on page 60 isn't divided neatly into a lit side and a dark side. Instead, there is a lot of variation in both sides. The lighter side isn't all the same; we see a gradual transition from the lightest spot (the highlight) to the edge where things begin getting much darker. And in the darker side, the shading is not uniform. There's a fairly distinct area where light meets dark called the core shadow and you also see something called reflected light.

Reflected light is everywhere on almost all objects. It's light that has bounced (reflected) from some other surface. In the case of the ball, the light is reflected from the white surface on which the ball is resting. Put any two objects near one another and there's always some reflected light from both objects onto each other. Sometimes it's faint and may be of little importance to your picture, but reflected light can often be used to jazz up an otherwise dull area.

On the ball the reflected light is white, but if we introduce color (as in the example on this page) the reflected light will include whatever colors are nearby. So we're not only concerned with light, but with the color of the light.

REVERSE SHADOWS

Sometimes light behaves in a peculiar way to produce shadows where you least expect them. An example is a reverse shadow, one caused not by direct light on a subject, but by reflected light. Light behaves the same whether it comes directly from a primary source or via some other route.

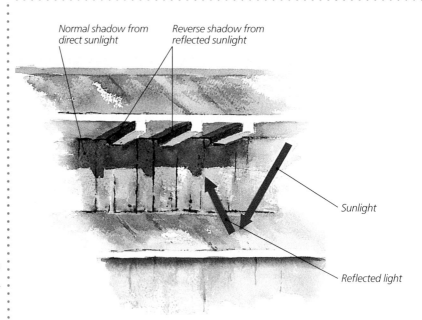

Normal shadow from direct sunlight

Reverse shadow from reflected sunlight

Sunlight

Reflected light

Reflected Light Can Cast Shadows
For the beams to cast shadows *upward* there must be a light source lower than the beams. It can't be the sun—it's high in the sky. The light source in this case is sunlight bouncing off the metal roof below the beams.

Back and Forth
Red light from the red ball is reflected in the surface of the white ball and vice versa.

YOU CAN MAKE IT UP

One of my first teachers painted even the dullest-looking subject in gorgeous color. When asked whether he actually saw all that color, he said not at first, but he forced himself to emphasize—even exaggerate—what color he did see and eventually he began to see loads of color in everything. So if you don't see it, put it there anyway. You're an artist and you have a right to make things up.

WHY DO WE CARE ABOUT REFLECTED LIGHT?

We use shadows as tools to help create depth in a picture, but there's no reason for them to be dull, dark, uneventful areas. Like any part of a picture, shadows should be made at least pleasant and at best exciting. Reflected light gives us a perfect way to wake up our shadows. Shadows often cover large areas of the painting: long shadows cast by buildings, for example. Those big areas could be dull and uninviting if we painted them, say, a uniform gray. But if we spice them up with some reflected surrounding color, we can make them a more exciting and more integrated part of the picture.

Reflected light can be effective anywhere on the surface of a picture because it adds a little oomph. You might wear out your eyes trying to find reflected light (it's not always so obvious) but don't be too hard on yourself. Just know it's there and put it in your painting wherever you think it will add some spark.

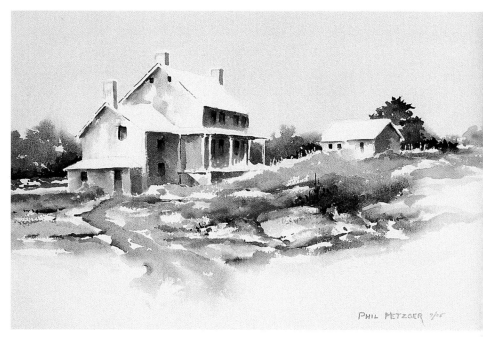

Ricocheting Color

This white house is surrounded by fields of color, so it's perfectly reasonable to expect some of that color to be bouncing around and hitting the house.

HOUSE ON HILL
Watercolor on Arches 300-lb. (640gsm) cold-pressed paper
18" × 24" (45.7cm × 61cm)

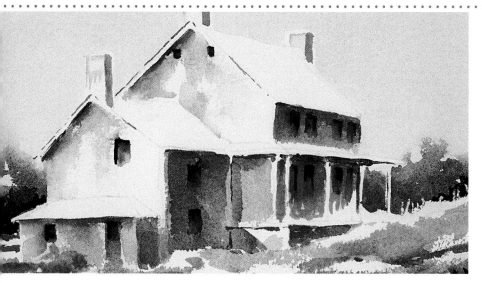

Detail

Here's a closer look at some of the (invented) reflected light in *House on Hill*.

WHAT AFFECTS A CAST SHADOW?

Everything affects a cast shadow: the light source or sources, the object blocking the light and the surface over which the shadow falls. Add to that the time of day, the color of the sky and an equation developed by a guy named Fresnel and you have a pretty complex subject. We'll take a brief look at the conditions that concern artists.

THE LIGHT SOURCE

The more concentrated the light from the source, the sharper the shadows. If you have more than one source—from a window and a lamp, for instance—you get fuzzy and perhaps overlapping shadows. Even if you use just a single source such as a bulb screwed into a reflector, you really have a double source because the bulb acts as one source and the reflector, a second. Whatever the source, if something else—e.g., a cloud or a curtain—interferes with the light on its way to your subject, the light that falls on the subject will be softer and the shadows it produces, less sharp.

Multiple light sources are especially important when you're painting street scenes or still lifes. You don't have a lot of control over the lights in the streets, but you can arrange your still life with more than one source to get some intriguing effects.

THE OBJECT BLOCKING THE LIGHT

The object blocking light and causing a cast shadow may be opaque or transparent, smooth or rough, colored or colorless, and so on. All these conditions can affect how the shadow looks.

Reflector Bulb Vase
 (top view)

Inner shadow (from
reflector and bulb)

Outer shadow
(from bulb)

An Object Lit By a Floodlamp

The solid vase gives a fairly strong, clean shadow, but notice the dark triangular shape in the middle of the shadow. It's there because the "single" light source I used, a photographer's floodlamp, is really *two* sources, a bulb and a reflector. What you see in the shadow is the overlapping of two shadows.

BELIEVE IT!

Trust your eyes and paint what you see—but try always to figure out why something unusual is happening. That way you'll have one more tool to use in your future paintings.

A Transparent Object

Light passes through the center part of the jar into what would be, for an opaque object, the shadow area. Less light gets through the thickness of the edges of the jar, so there's a better-defined shadow around the edges. The darker (and a bit more colorful) shadow close to the jar is caused by the opaque candies in the jar.

An Irregular Object

The cilantro gives a fuzzy shadow partly because of the overall irregular shape, partly because each leaf has an irregular edge and partly because of Augustin Fresnel (see sidebar below). This is the sort of shadow you'd expect from tree foliage.

DIFFRACTION

You've noticed that the shadow cast by a solid object is not solid. One of the reasons for that was explained by a fellow named Augustin Fresnel in this simple equation:

$dEQ = aA/r\ f(x)ds$

As I'm sure you know, this says that when light passes by an edge, it gets slightly bent in a sort of fuzzy way (the f in the equation must be for fuzzy). So the light passing around the edge of even a smooth, solid object gets a little messed up and produces a fuzzier shadow than you might expect. This phenomenon is known as diffraction.

SURFACE COLOR AND TEXTURE

The surface over which the shadow falls has a lot to do with how the shadow looks. The color of the surface affects the color of the shadow; that's why a good painting technique is to paint an area first without shadow and then paint the shadow *over* the area. The texture of the surface can make the difference between a relatively sharp shadow and a fuzzy one. A shadow falling on grass will be more broken, less sharp, than that same shadow falling on smooth pavement.

THE SURFACE CONTOUR

The shape of the surface will, of course, alter the shape of the shadow, too. Since shadows follow the contours of the surfaces they fall on, use them to help describe the "lay of the land." Cast shadows following the dips and rises of the ground or spilling over the objects in a still life go a long way toward describing the shapes of the ground or the shapes in the still life—and in so doing, they can add a good deal of depth to the scene.

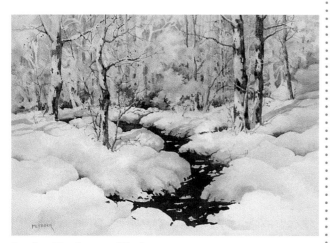

Putting Shadows to Work
Shadows are a wonderful tool for describing the shapes they fall on. Without the shadows, this could look like flat land.

WOODS CREEK
Watercolor on Arches 140-lb. (300gsm) cold-pressed paper
24" × 30" (61cm × 76.2cm)
Collection of Sunni Morgan

Same Shadow, Varied Surfaces
The tree's shadow first spills over a rock, then a path, then some grasses. Where it falls over the rock, it's pretty hard-edged because the rock is smooth; over the dirt path it's slightly rough-edged; but in the textured grasses the shadow is more broken and its edges get lost. I used the same neutral gray mixture (Cobalt Blue plus Raw Umber) for the entire shadow, but it looks a little different from one area to the next because the underlying colors (gray rocks, brown path, green grass) and textures show through. Notice how the shadow follows the contours of the land.

TRY THIS

Lay out several strips of paper, one white, some colored, some smooth, some textured. You can use coarse cloth for some texture, too. Put a vertical object, such as a vase or a book, near the strips. Darken the room and shine a strong light at an angle so that the vase or book casts a shadow across the strips. Notice how different the shadow appears as it crosses each strip.

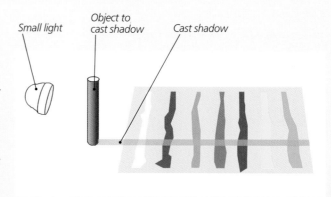

Small light

Object to cast shadow

Cast shadow

Strips of paper or fabric

OTHER INFLUENCES

The environment also affects shadows. Light from nearby objects bounces into shadows and gives them a little extra zing. Color from the sky may invade a shadow and affect the color you see there. One often sees unbelievably blue shadows in snow, partly thanks to the blue sky overhead; on a sunny summer day, there are lots of warm tints in shadows. The time of day also affects both the color and the length of outdoor shadows: the lower the sun, the longer the shadows, and the early and late light is often warmer (redder) than midday light.

Shadows in Vehicle Tracks

Vehicle tracks in snow, like footprints, are a combination of shadows—and they can be a wonderful way to direct the eye toward the center of interest. In this scene the sun is low and at the right. The light is hitting the vertical left edges of the furrows directly, so those edges are brighter than the flat snow, which is only skimmed by the sunlight. The darkest shadows are deep in the furrows. (This is also an illustration of linear perspective, discussed in later chapters.)

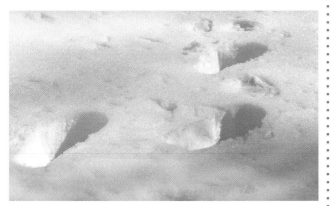

Shadows in Footprints

Even a footprint in the snow is defined by shadow. This is a subtle thing; notice that the shadow is darker where the footprint is deepest and notice, too, that the lightest area is on the vertical sides of the footprint, where the sunlight is hitting most directly because the sun is low in the sky.

BORROWED PERSONALITY

By itself, a shadow is pretty colorless. It's only thanks to its surroundings that it springs to life and has some personality. All the actors surrounding the shadow lend their light and color so the shadow can look smart.

TRY THIS

Get a sphere, such as a softball, and set it on a white surface. Aim a single light at it in a darkened room and carefully render it the way I did the ball on page 60. Start with light shading and work your way up to a fully rendered ball. Look for a highlight (which is just the reflection of light from the source), the core shadow, reflected light and cast shadows. Pay attention to the edges of the cast shadow.

SUMMARY

• The shadow on the side of an object away from the light source is called *shading*.

• Shadows on a surface caused by an object blocking the light are called *cast shadows*.

• Both shading and cast shadows help suggest depth.

• Shadows normally have darker value than surrounding areas, and that value difference adds spark to a painting or drawing.

• Overlapping shadows are darker where they overlap.

• The shadows in cracks, holes and crevices add depth to an otherwise flat surface.

• Shadows are not dead gray or black areas; they are generally full of light and color from their surroundings.

• The edges of a shadow may be sharp or fuzzy, depending on the texture of the surface and on the number of light sources.

• Shadows follow the contours of the surfaces they fall on.

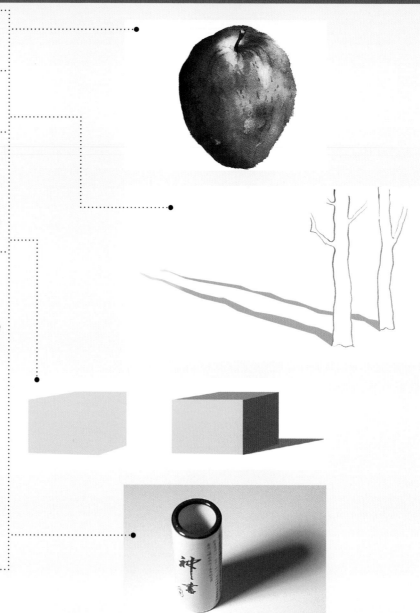

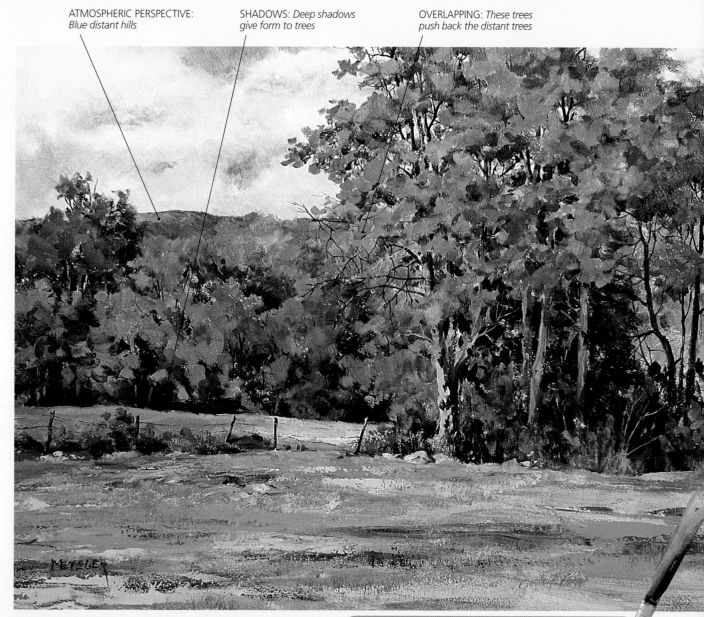

ATMOSPHERIC PERSPECTIVE: *Blue distant hills*

SHADOWS: *Deep shadows give form to trees*

OVERLAPPING: *These trees push back the distant trees*

COLOR PERSPECTIVE: *Warm foreground, cool distance*

SCALE: *Fence posts indicate size of trees*

SIZE VARIATION: *Larger trees forward, smaller to the rear*

IN THE PARK
Oil on canvas
16" × 20" (40.6cm × 50.8cm)
Collection of Marilyn Keil

Palette

1 Titanium White	8	Burnt Sienna
2 Cadmium Yellow Pale	9	Raw Umber
3 Cadmium Yellow	10	Terra Verte
4 Cadmium Red Deep	11	Phthalocyanine Green
5 Alizarin Crimson	12	Cobalt Blue
6 Raw Sienna	13	Ultramarine Blue
7 Burnt Umber		

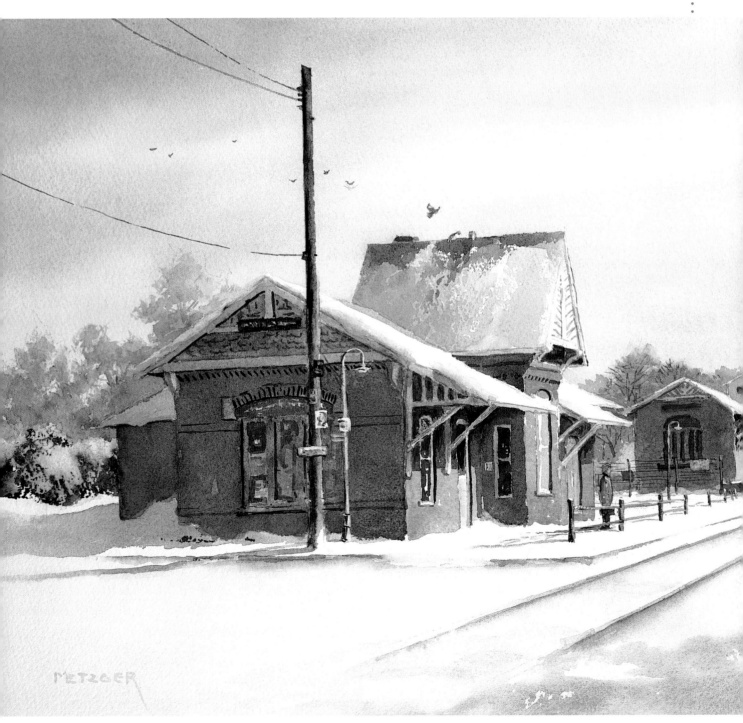

METZGER

PART 2

LINEAR PERSPECTIVE

A Few Simple Rules Open Lots of Doors

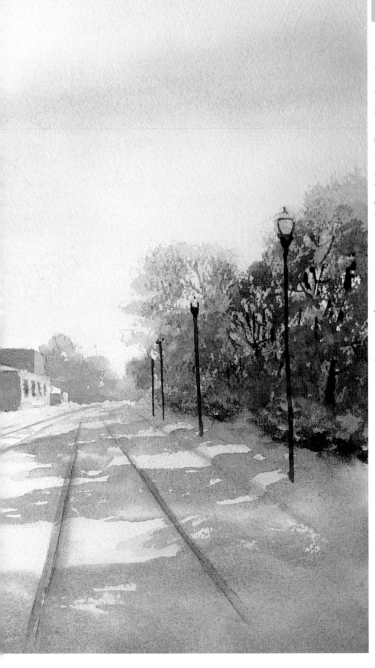

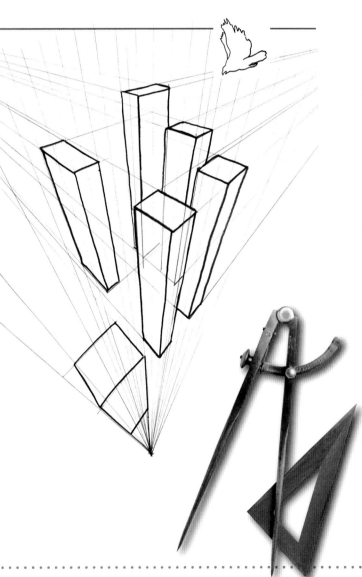

MORNING COMMUTER
Watercolor on Arches 300-lb. (640gsm) cold-pressed paper
14" × 25" (35.6cm × 63.5cm)

ONE-POINT PERSPECTIVE

All linear perspective is based on the idea that parallel lines receding from you seem to meet in the distance. They do this despite the fact that they are parallel and therefore should never meet. Like everything else in this book, it's all about how we see.

Let's revisit the train tracks from chapter three. You know the tracks are parallel, yet they meet at a point on the horizon. The tracks never really meet, of course, but they seem to. This is not so different from a row of posts or trees looking smaller and smaller as they recede. In fact, you can think of the wooden ties between the train tracks as if they were a row of posts that happen to be lying flat on the ground.

Converging Parallel Lines
These parallel tracks seem to meet at a point on the horizon.

DEFINITION

LINEAR PERSPECTIVE: *The technique of creating the illusion of distance with parallel lines that converge as they recede.*

WHITE HOUSE
Watercolor on Arches 140-lb. (300gsm) cold-pressed paper
18" × 24" (45.7cm × 61cm)

WHAT IS ONE-POINT LINEAR PERSPECTIVE?

One-point perspective is a special example of linear perspective in which all receding parallel lines meet at a single point, as do the railroad tracks on the preceding page. In the next chapter we'll see more common situations involving two points.

HORIZON VS. EYE LEVEL

We're all pretty familiar with what the horizon is. In the railroad picture you can see where the flat land meets the sky; that imaginary line where sky meets land is the horizon. If we were at sea, the horizon would be the line where the sky meets the sea. In one-point and two-point perspective all vanishing points lie on the horizon, so it's important that we know where the horizon is. If your scene includes flat land or the ocean, finding the horizon is a snap; you can clearly see it. But suppose there are objects in the way, such as hills, and you can't see the horizon, so you can't tell where to place a vanishing point. What to do?

We scrap the term *horizon* and substitute *eye level*. They are the same thing, but while you can't always tell where the horizon is, you do know where your eye level is: it's an imaginary horizontal plane passing through your eyes. If you stand up, your eye level rises with you; if you sit down, your eye level lowers.

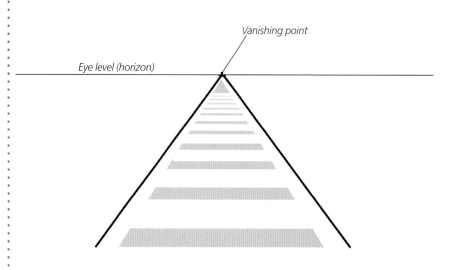

Vanishing point

Eye level (horizon)

WHAT IF I TILT MY HEAD?

That's a question I'm asked a lot when I define eye level. The answer is, it doesn't matter if you tilt your head up, down or sideways. You can wink, blink, close your eyes, rub them—no matter what you do, eye level always stays the same. It's still a horizontal plane passing through your eyes, and that plane *is* parallel to the ground (which, after all, is what horizontal means).

OK, so if you tilt your head to one side so one eye is lower than the other, then what? We'll just split the difference and say eye level is a horizontal plane across the bridge of your nose, halfway between your eyes!

EYE LEVEL

Understanding eye level is critical to understanding linear perspective, so let's take a closer look. Eye level is an imaginary horizontal plane extending outward from your eyes in all directions. Everything you see is either above, below, or at your eye level. In designing any realistic picture, it's imperative that you establish right off the bat exactly where the eye level in the picture will be.

You can see for yourself how important your eye level is by doing a simple experiment. Place any object, such as a mug, at the edge of a table. Stand up and look down at it; then kneel and look straight across at it; and finally, crouch low to the floor and look again. You'll see something like the three mugs shown on this page.

As you change your eye level, notice how different the mug looks. All its parts, such as its curved mouth and its handle, take on different shapes depending on the level from which you view them. If you were to draw the mug, you'd have to decide which position you like best and then stick with it. If you changed your mind partway through the drawing, you wouldn't end up with a realistic mug.

From Above
Mug seen from a high eye level.

Head On
Mug seen at eye level.

From Below
Eye level is below the mug.

HANG IT ANYWHERE!

Eye level has to do only with the scene in your picture. It has nothing to do with how high or how low your picture ends up hanging on a wall.

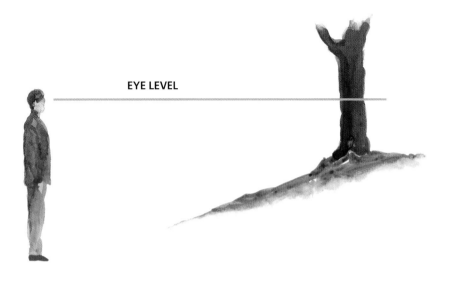

EYE LEVEL

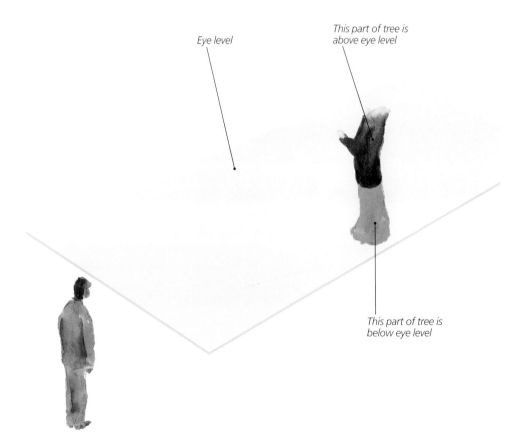

Eye level

This part of tree is above eye level

This part of tree is below eye level

Above and Below

A way to think about eye level: Imagine a huge sheet of glass parallel to the ground and at the level of your eyes. Everything above the glass is above your eye level and everything below the glass is below your eye level.

WHY EYE LEVEL IS IMPORTANT

Changing your mind about eye levels partway through a drawing will introduce inconsistencies in the composition that will probably destroy its effectiveness. If your subject is a landscape and you draw one building from a particular eye level and another from a higher or lower eye level, the buildings will not seem compatible. A casual viewer may not know a thing about linear perspective, but she'll know something isn't right about the picture. If your subject is a still life, the results can be even more confusing because the closer you are to your subject, the more damaging the shift of a few inches in eye level may be.

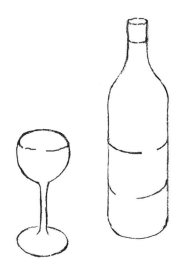

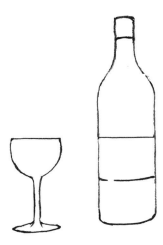

High Eye Level
A still life sketched from a standing position (high eye level).

Lower Eye Level
The same still life sketched from a sitting position (low eye level).

A Still Life In Trouble
Here's what happened when I sketched the bottle from a standing position and the glass from a sitting position. They clearly don't belong in the same picture unless perhaps the bottle is standing on a tilted surface and the glass, on a flat surface.

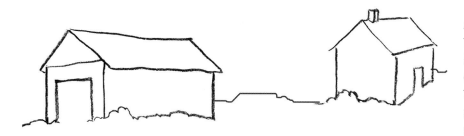

A Landscape Gone Wrong
The barn is sketched from a low eye level, but the house, from a higher eye level. They obviously don't belong in the same picture. This confusion may arise if you design a picture based on objects from different photographs.

USING BOXES TO DRAW OBJECTS IN PERSPECTIVE

Much linear perspective involves three-dimensional rectangular objects, or boxes. Buildings are obvious examples—and we'll spend a lot of time dealing with them—but many other things can also be considered boxes. A stretch of our railroad, for instance, can be thought of as a long, thin box.

Railroad-in-a-Box
Think of this set of railroad tracks as a thin box.

DRAW ANYTHING INSIDE A BOX

You can get a handle on drawing almost any object in linear perspective if you imagine the object confined inside a box. It's not always necessary to actually draw the box, but if you learn to visualize the box it can help your drawing. For example, a rounded tube can be easier to draw in perspective if you first picture it within a box.

1 **Draw the Box**
Draw a box in perspective.

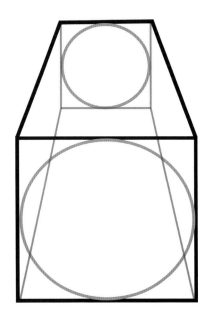

2 **Add Circles**
Use the outlines of the box to inscribe circles for the ends of the tube.

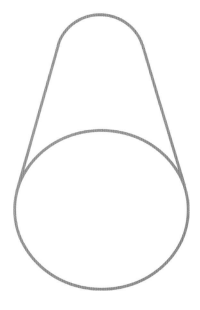

3 **Erase the Box, Then Finish**
Discard the box and finish the tube.

BOX IT UP

Envision objects either as boxes or combinations of boxes or as being drawn inside boxes. Boxes are at the heart of all linear perspective.

VANISHING POINTS

Let's return to the box on the preceding page. It's drawn in one-point linear perspective. What that means is that all of the box's receding parallel lines converge at a point at eye-level.

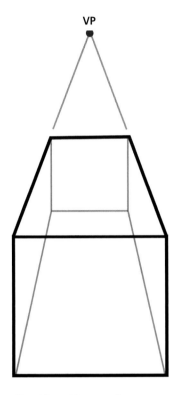

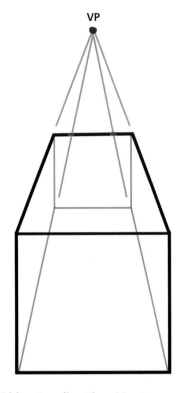

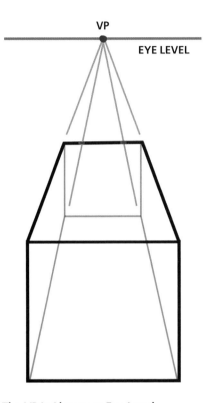

Receding Lines Meet at the Vanishing Point

If you extend the upper edges of the box, they meet at a place called the vanishing point (VP). You're looking down on the top of this box.

Hidden Receding Lines Meet at the Same VP

The box has another pair of receding lines—those at the bottom of the box—but they're hidden. Imagine the box is made of glass, so you can see all its edges. Mentally extend the bottom edges. They meet at the vanishing point, same as the top edges.

The VP Is Always at Eye Level

The vanishing point is always at eye level, so a horizontal line drawn through the vanishing point represents eye level.

DEFINITION

VANISHING POINT: *Receding parallel lines converge in the distance at eye level. The point where they meet is called a* vanishing point. *In one-point perspective all receding lines meet at a single vanishing point; in two-point perspective (chapter six) sets of lines meet at two vanishing points. In three-point perspective (chapter seven) we'll find vanishing points that are not at eye level.*

BOXES FROM ALL ANGLES

Just about everything around you is a box. The room you're in (unless you're in the Oval Office) is a box. Your desk, your books, your cabinets, your sink—they're all are boxes or they can all be inscribed in boxes. How you see those boxes depends on whether they're directly in front of you, above you, or below you.

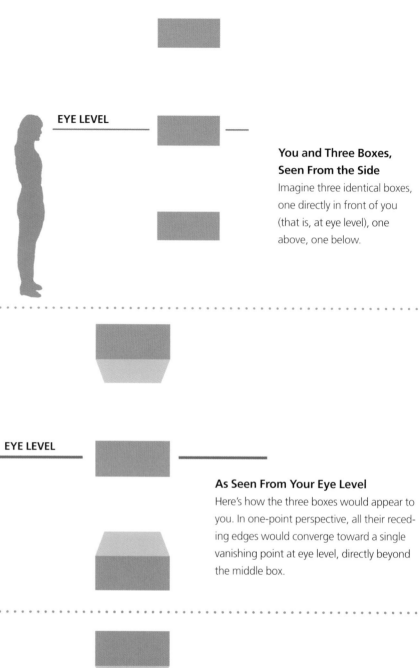

EYE LEVEL

You and Three Boxes, Seen From the Side
Imagine three identical boxes, one directly in front of you (that is, at eye level), one above, one below.

As Seen From Your Eye Level
Here's how the three boxes would appear to you. In one-point perspective, all their receding edges would converge toward a single vanishing point at eye level, directly beyond the middle box.

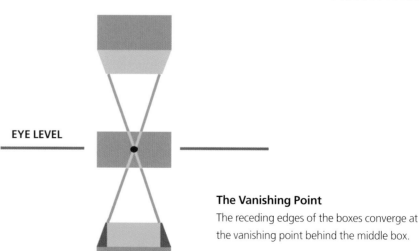

The Vanishing Point
The receding edges of the boxes converge at the vanishing point behind the middle box.

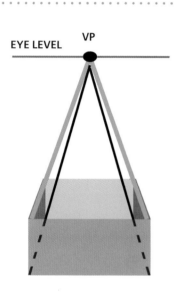

EYE LEVEL **VP**

Construction Lines for the Hidden Edges
Here's the topless lower box showing construction lines for both the top edges (heavy blue lines) and the hidden bottom edges (narrow dark lines).

AN EXAMPLE OF ONE-POINT PERSPECTIVE

The house on page 78 is rendered in one-point perspective. The eye level is below the bottom floor of the house. If you discard all the roofs, gables, porches and so on, you reduce the house to its basic form: a box. Alongside the house, below, I've shown the box. All the parts I've left out can be considered more boxes tacked onto this basic box, an idea we'll explore in later chapters.

IS IT ALL OR NOTHING?

Look again at the painting on page 78 and you'll notice that, while the house is shown in one-point perspective, the shed at the right is not. It's slightly turned and you see a bit of one of its sides; it's actually in two-point perspective (next chapter). It's not necessary that an entire picture be rendered in one-point perspective. Some are, of course, including the examples on the next page. But in many instances, the viewpoint is such that one object is dead-on in front of you and is seen in one-point perspective, while another object is to your right or left and is seen in two-point.

Look at *White House* on page 78. Imagine that the viewer shifts to the right, about halfway across the scene. From that viewpoint, he would no longer see the house in one-point perspective; he would see part of the side of the house and it would be in two-point perspective.

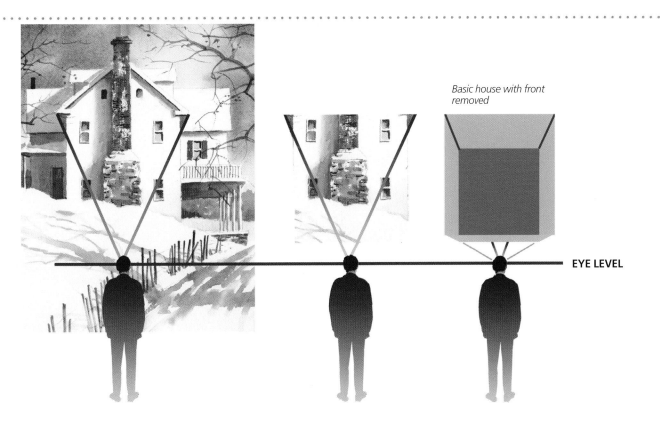

Basic house with front removed

EYE LEVEL

House in One-Point Perspective

A house seen in one-point perspective by a viewer whose eye level is centered below the house. The blue box represents just the basic house without the added-on side sections, porches and so on. The front face of the box is removed so you can see the edges retreating toward the vanishing point.

RENAISSANCE EXAMPLES OF ONE-POINT PERSPECTIVE

It was once more fashionable to depict a scene in one-point perspective than it is today. Many Renaissance scenes were drawn in one-point. Sometimes the artist liked the stability and symmetry of one-point; sometimes he used one-point because it conveys a sense of calm and order; and sometimes, no doubt, he simply liked playing with the then-newly discovered concept of linear perspective.

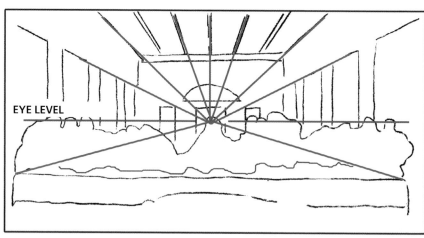

The Last Supper

This is a sketch of probably the most famous painting done in one-point perspective, Leonardo da Vinci's *Last Supper*, done between 1495 and 1497. All receding parallel lines—walls, ceiling, edges of table—converge at a single point near the center of the picture. One-point is a powerful way to focus attention where the artist wants it—in this case, on Christ. In this picture, Leonardo has placed the viewer's eye level at the same level as Christ's eyes.

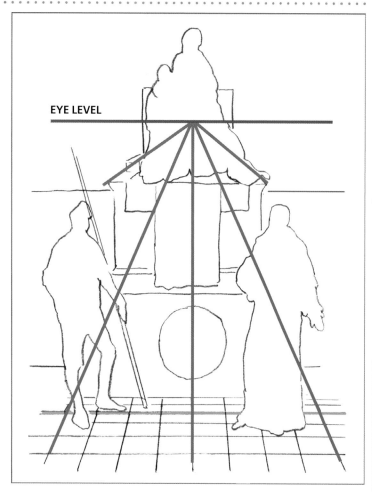

Castelfranco Madonna

One-point perspective plays a big part in the symmetrical painting *Castelfranco Madonna*, done around 1500 by Giorgione. Notice, in this sketch of the painting, that there's a small step up in the tile floor (the figure on the left, St. George, has his left foot on the upper step). The step provides a little break in the tile lines.

A BIT OF HISTORY

The concept and the rules that make linear perspective work were first devised by Renaissance architect Filippo Brunelleschi. Many artists immediately adopted Brunelleschi's perspective system and their paintings began to look three-dimensional. Brunelleschi is not known to have written down his ideas; that was done later by another Renaissance architect, Leon Battista Alberti.

NOT AN EXACT SCIENCE

Linear perspective is a system that mimics the way we see and, mostly, it's very accurate. But it's not perfect. It works beautifully for most situations, but in reality things happen on the fringes that you should be aware of.

REALITY CHECK 1

Suppose you can see both the front and a little of the side of an object, such as this cube. Usually, as we'll see in chapter six, this would require two-point perspective. The square front face would be pinched slightly at the edge farthest from you, so it wouldn't look quite square. But if the pinch is so tiny as to be nearly unnoticeable, should you care about it? Maybe not. You could draw this cube in either one-point or two-point and it would look quite satisfactory.

REALITY CHECK 2

Suppose you're looking at a couple of boxes right in front of you, but neither one is directly in the center of your vision. One is a little to the right and the other, to the left. Is one-point perspective reasonable here? We leave black-or-white-land and enter a gray area where a little judgment is required.

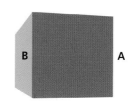

One-Point vs. Two-Point
The cube on the left is in one-point perspective; the one on the right is in two-point. Edge A is slightly shorter than edge B. Can you tell the difference?

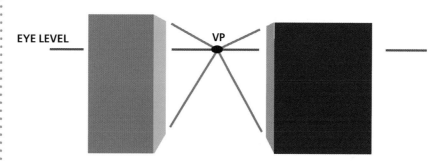

Close Enough
You can see a little of the sides of these boxes. Could they still be drawn in one-point perspective? Yes, because we're practical people and not hair-splitters. This scene feels comfortable and convincing in one-point, so that's what we can go with.

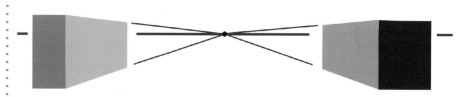

Needs Work
Now the boxes are farther apart and their front faces are far enough away from us that their top and bottom edges probably should be receding. It looks like we've crossed over into two-point perspective territory (see chapter six).

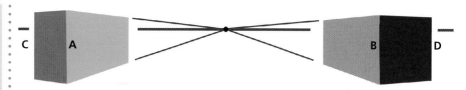

That's Better
I've trimmed the top and bottom edges of both boxes to put them in two-point perspective. Edges A and B are slightly longer than edges C and D. This feels more comfortable.

BUILD A ROOM IN ONE-POINT PERSPECTIVE

Let's use the ideas we've covered to build a room from scratch. We'll arrange everything in one-point perspective and decorate in blue.

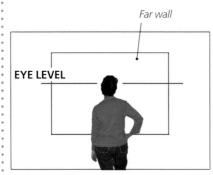

Far wall

EYE LEVEL

1 Establish Eye Level
Imagine yourself standing at the center of one end of a room, looking at the opposite wall. You'd like to build a door, some windows and some furniture, but first we need walls, floor and ceiling. To get started, locate the eye level. Depending on how tall you are, your eye level might be around five feet above the floor.

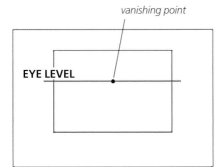

vanishing point

EYE LEVEL

2 Locate the Vanishing Point
You're standing halfway between the two side walls, so you're looking at a perfectly symmetrical scene in one-point perspective. The vanishing point will lie halfway across the far wall (on the eye level, of course). Establishing the vanishing point is critical because, as you'll see, it governs the slants of all the receding lines in the picture.

DO I NEED TO DO ALL THAT CONSTRUCTION?

No. Draw and paint freely; use constructions to solve problems. Understanding these constructions will help you figure out how to correct a picture that has problems, and help you avoid making perspective mistakes in the first place.

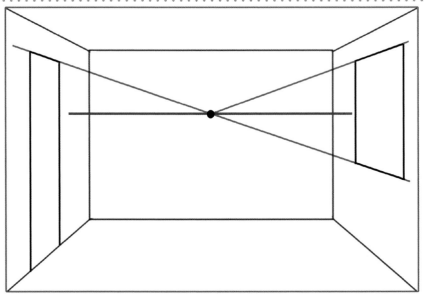

5 Add a Window
Add a window by locating the top and bottom of the window the same way you located the top of the door—by drawing lines through the vanishing point at appropriate heights. The top of a window is often at the same height as the top of a door. The bottom can be anywhere you want it to be. After drawing the top and bottom lines, draw verticals to establish the sides of the window.

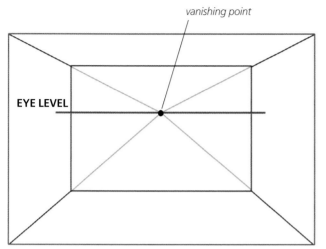

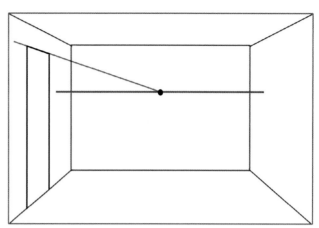

3 Connect the Corners of the Far Wall to the Vanishing Point

To get the four edges of the room (where walls meet floor and ceiling), all you need do is draw a line from the vanishing point through each of the four corners of the far wall. Now you have a room (the inside of a box).

4 Add a Door

Better have a door to get into the room. Make a guess at how high the doorway should be on the left wall and draw a line indicating the height; make that line pass through the vanishing point and that will give you the slant of the top of the doorway in perspective. (A typical door in this eight-feet-high room would be almost seven feet high.) Now draw vertical lines to form the sides of the doorway.

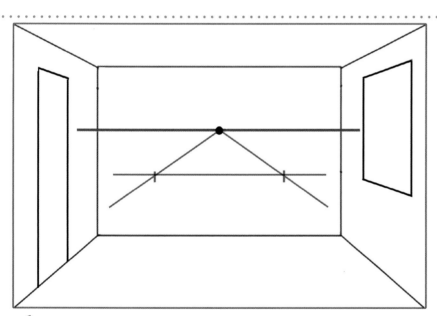

6 Draw the Rear Edge of a Table

Now we'll place a table at the far end of the room and, to keep things symmetrical (and easy), we'll center it against the wall. First decide how high you want the tabletop to be and draw a horizontal line for the height. That line is the rear edge of the table; on it mark off the width of the table. Then draw lines from the vanishing point through the two points you marked off.

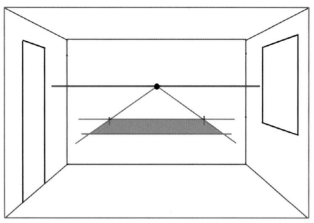

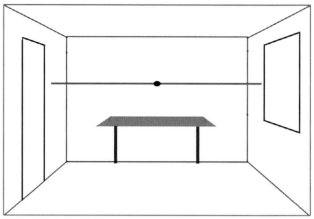

7 Finish the Tabletop
Draw a horizontal line to finish the tabletop. Shade it so you can see it better.

8 Add the Rear Table Legs
The table needs legs! It's hard to know how far down to extend the front legs, so we'll begin with the rear ones. We know how long they are: they go from the tabletop to the floor. Let's place them a little in from the edges of the table.

Guidelines for window height

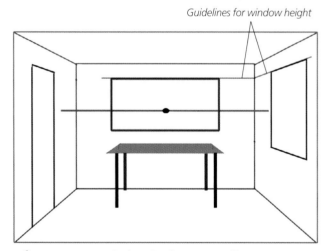

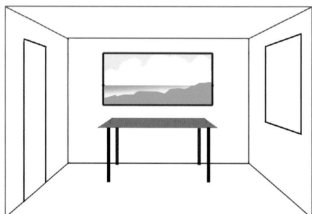

10 Create a Window in the Rear Wall
We have a room with some bare necessities, but how about a picture window over the table? That's easy; since it's in a wall that's not in perspective, all we need is a rectangle. If you want the top of the picture window at the same level as the tops of the door and the other window, draw a construction line back to the picture-window wall and that will tell you the proper height.

11 Indicate the Horizon
What might we see through the window? How about an ocean view? And where would the horizon be? Exactly at eye level; remember, horizon and eye level are the same. So we can finally erase our red eye level line and replace it with the actual horizon, where sky meets water.

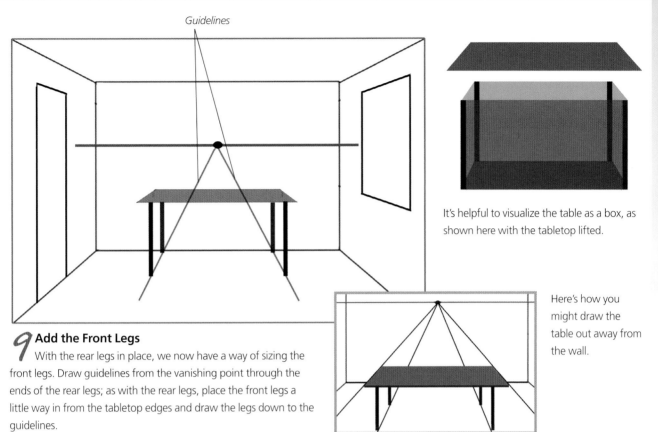

Guidelines

It's helpful to visualize the table as a box, as shown here with the tabletop lifted.

Here's how you might draw the table out away from the wall.

9 Add the Front Legs

With the rear legs in place, we now have a way of sizing the front legs. Draw guidelines from the vanishing point through the ends of the rear legs; as with the rear legs, place the front legs a little way in from the tabletop edges and draw the legs down to the guidelines.

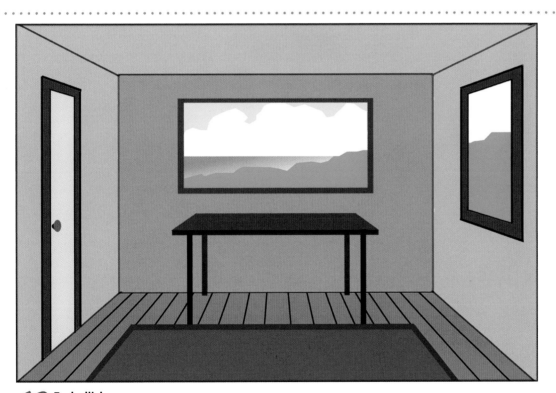

12 Embellish

The basic stuff is done. Now, using the same kinds of constructions that got us this far, you can enhance the drawing with details such as adding thickness to window and door frames and modeling the flat table legs to make them look three-dimensional.

- **Linear perspective is the technique of suggesting distance with parallel lines that converge as they recede. In one-point linear perspective, those lines meet at a single spot called the vanishing point.**

- In one-point and two-point linear perspective, the vanishing points are always at eye level.

- **Eye level is a horizontal plane through your eyes, extending outward in all directions.**

- Parallel lines that do not recede do not converge; they remain parallel.

- To do a linear perspective construction, start with what seems easy or obvious and build from there. For example, to figure out where to place the legs for the table, it was easier to begin with the rear ones that are close to the wall because you know the legs extend from the tabletop down to where wall and floor meet.

- **To help draw in perspective, visualize objects in a box.**

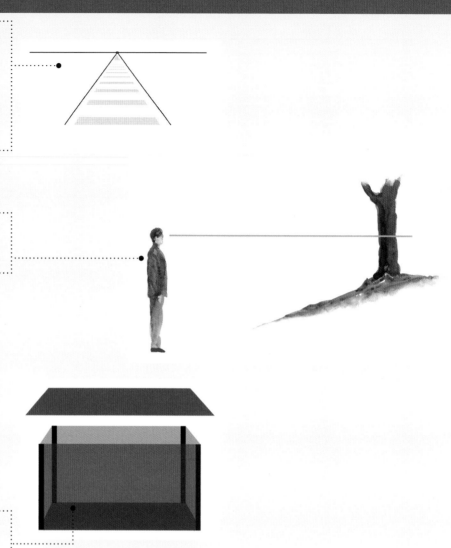

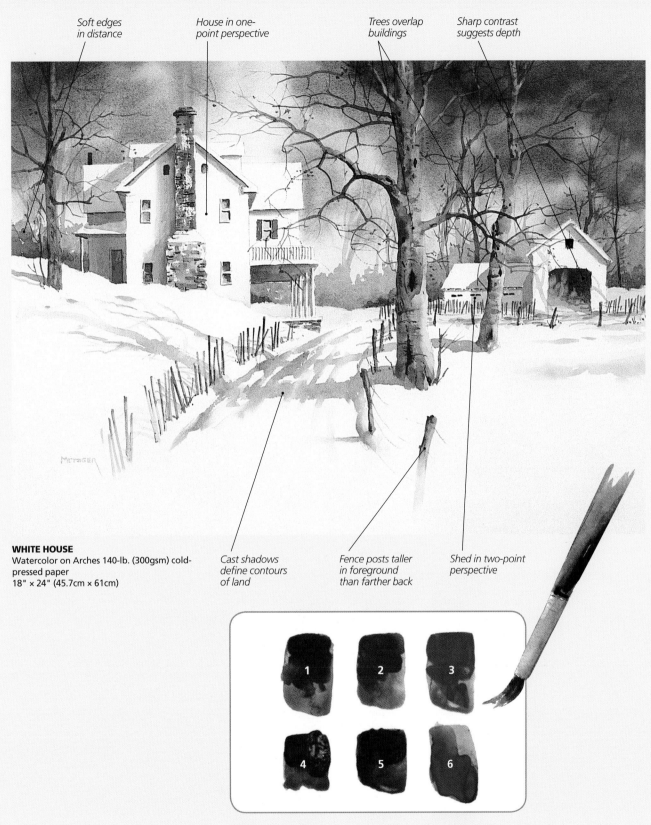

Soft edges
in distance

House in one-
point perspective

Trees overlap
buildings

Sharp contrast
suggests depth

WHITE HOUSE
Watercolor on Arches 140-lb. (300gsm) cold-
pressed paper
18" × 24" (45.7cm × 61cm)

Cast shadows
define contours
of land

Fence posts taller
in foreground
than farther back

Shed in two-point
perspective

Palette

1 Alizarin Crimson
2 Cadmium Red Deep
3 Raw Sienna
4 Raw Umber
5 Burnt Sienna
6 Cobalt Blue

VP EL

TWO-POINT PERSPECTIVE

As discussed in the previous chapter, when you can see only one face of a rectangular box, you're seeing it in one-point perspective. If you can see two of its faces, the box is in two-point perspective. There's a fuzzy area where so little of a second face is visible that it's reasonable to stick with one-point; but the truth is, that's a two-point view.

Box in One-Point Perspective

MARYLAND FARM
Watercolor on Arches 140-lb. (300gsm) cold-pressed paper 18" × 24" (45.7 cm × 61 cm)

ABBREVIATIONS

These are abbreviations we'll use in the remaining chapters:

EL = eye level
VP = vanishing point
PP = picture plane

DEFINITION

TWO-POINT PERSPECTIVE: *A type of linear perspective in which one set of receding lines meets at one vanishing point and another set meets at a second vanishing point, both at eye level.*

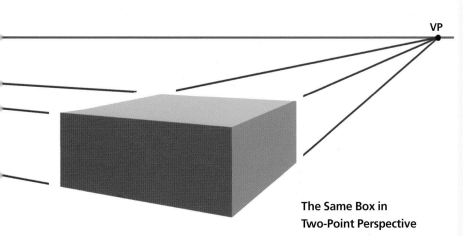

The Same Box in Two-Point Perspective

LOCATING VANISHING POINTS

If you look at a box in two-point perspective, both its vanishing points lie at eye level—but *where* at eye level? Let's take a cube and see what happens when it is turned to different positions.

A Cube in One-Point Perspective
This cube is in one-point perspective. Its vanishing point is hidden behind it at eye level.

BOXES THAT BEHAVE
Linear perspective is based on ordinary boxlike objects whose tops and bottoms are parallel to the ground. Every normal building, for example, is such a box, and so is a piece of furniture sitting on a floor or a book resting on a shelf. Objects that are tilted don't obey the rules of linear perspective.

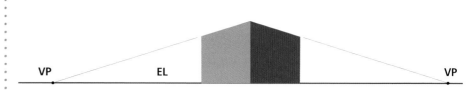

Rotating the Cube Creates Two-Point Perspective
Now the cube is turned so you can see equal portions of two of its sides, so it's in two-point perspective. The two vanishing points are equally distant to the right and left.

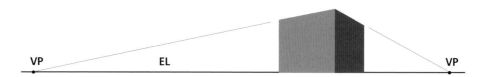

Turn the Cube More, and the Vanishing Points Move
Now you see more of one side than the other, and the vanishing points have shifted.

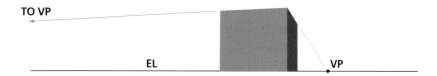

Vanishing Points Can Be Off the Page
In this position one vanishing point lies close to the cube but the other is way off the page. You would have to tape extra sheets alongside the drawing and extend the construction lines if you wanted to locate the missing vanishing point.

EYE LEVEL AND VANISHING POINTS

Always begin a picture by knowing where you intend the eye level to be. If necessary, draw a light horizontal line across the picture as a reminder. As you draw objects in perspective, remember that their vanishing points must lie somewhere along the eye-level line (we'll get into exceptions in the next chapter).

Suppose your picture includes objects that are above, below and at eye level. An example would be a landscape with buildings straight ahead, buildings high on a hill and buildings down in a valley; another example is a still life in which some objects are on a table, some near the ceiling and some on the floor.

Each object has its own unique set of vanishing points. The vanishing points for one object in a scene don't necessarily coincide (although they sometimes do) with those of another object in that same scene; but no matter how many different objects there are, their vanishing points all lie at eye level.

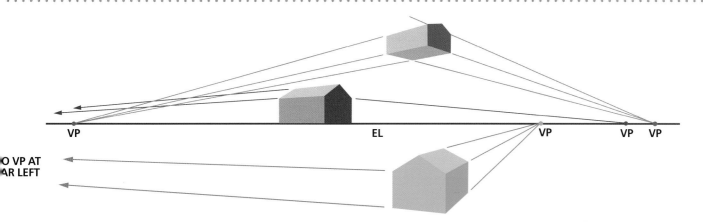

The Vanishing Point Is Always At Eye Level

These three houses sit at different levels in the scene: one on a hill, one in a valley and the other straight ahead. No matter how you turn them, all their vanishing points lie somewhere on the eye level. The vanishing points for the blue house on the hill happen to lie close enough to the house that they fit on these pages. Only one of the purple house's vanishing points is on the page; the other is far to the left. The same is true of the green house down in the gully; one of its vanishing points is off to the left. What's important is that each house has a pair of vanishing points and they all lie somewhere along the eye-level line.

Parallel Lines Converge

Here's a closer look at the green building from the previous illustration. There are two sets of receding parallel lines in this building: lines A and B in the front view and lines C, D and E in the side view. The vertical lines are also parallel, but since they are not receding from us, they don't converge.

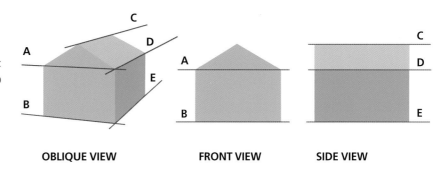

OBLIQUE VIEW FRONT VIEW SIDE VIEW

HOW TO GET THE ANGLES RIGHT

We talk a lot about vanishing points in linear perspective, but I'll tell you a secret: you never have to bother with them if you get all the angles right in the first place. If a line recedes toward the horizon and you draw it accurately, it will automatically cross the horizon right at the vanishing point. So, although we discuss vanishing points as a handy way of visualizing what's going on in linear perspective, it's those slants, or angles, we're really after. Art stores offer a number of gadgets to help get angles right, but you can do just as well with two simple measuring techniques that don't cost anything.

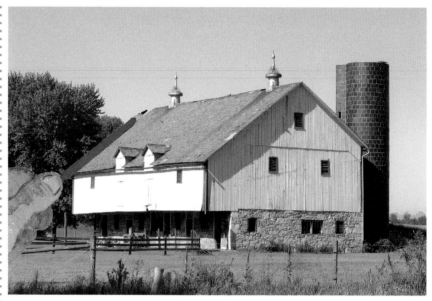

Method 1: Pencil
Hold a pencil (or any straightedge) at arm's length, elbow locked, and with the pencil parallel to the picture plane. Swivel your wrist to align the pencil with an edge of the object you want to draw. Keeping the pencil at that same slant, move it to your drawing surface and with another pencil copy the angle onto your paper.

THE KEY TO USING EITHER METHOD

These angle-measurement methods are practically foolproof, but with either method it's vital that you keep your elbow locked and don't allow your wrist to twist. The idea is to imagine you're holding the measuring tool (either a pencil or jaws) flat against an upright sheet of glass and that you're looking at the subject somewhere beyond the glass. Think of the imaginary glass sheet as your picture standing on end. Hold the tool flat against the "glass." Then imagine, as you lower the tool to your paper, that you're also lowering the imaginary sheet of glass to your paper, still holding the tool flat against the glass.

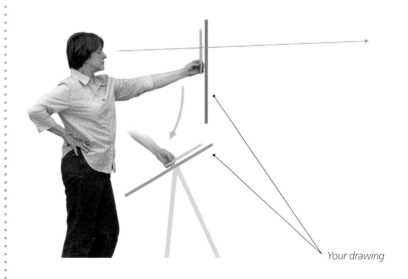

Your drawing

Keep Your Elbow Locked—and Don't Twist
Think of your picture plane as transparent and upright, like a window. You're looking through that window at a subject some distance away and copying the subject's angles.

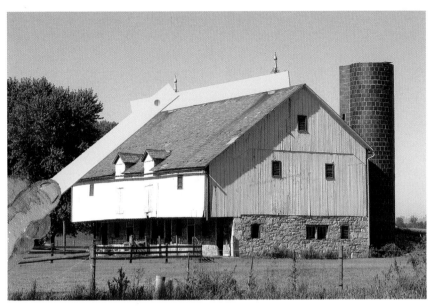

Method 2: Perspective Jaws

This is my favorite way of getting angles right. It requires a set of "jaws": two strips of cardboard fastened snugly at one end so you can move the strips apart at any angle you wish. Hold the jaws at arm's length, elbow locked (just like method 1), and align one jaw with any edge of your subject. Then rotate the other jaw to line up with some other edge; now you've got the angle between the two edges. Lower the jaws to your paper and copy the angle. It's practically foolproof!

TRY THIS

Making your own perspective jaws is easy. Cut two strips of cardboard (such as mat board) about an inch (25mm) wide and six or seven inches (15–18cm) long. Drill a hole through them at one end and fasten the strips with any type of fastener that will hold them snugly together but still allow them to move. A bolt with two nuts is a good option; the reason for two nuts is that the second one acts as a locknut to keep the first nut from loosening as you open and close the jaws. The jaws must be fastened tightly enough to stay put once you open them to a particular angle; they must not slip as you lower them to your drawing.

Bolt

Nuts

Cardboard strips

MORE ABOUT VANISHING POINTS

You don't begin a drawing with vanishing points. You begin by drawing what you see. You try to get the right slants to all those receding lines and, with a little luck, you finish without ever having located a vanishing point. Oh, happy day!

But suppose that, when you're done, your drawing looks cockeyed. You may not always know why it's not right, but you do know one or more objects don't look natural. It may be time to locate some vanishing points. How do you locate one? What are the rules?

First, decide exactly where in your picture the eye level is. Remember, eye level is an imaginary flat horizontal plane passing through your eyes. Draw a line on your picture representing that level. Now look hard at your subject and pick out an important receding horizontal line either above or below eye level, perhaps the top edge of a roof. Use your perspective jaws carefully to determine the slope, or angle, of that line and copy that line on your picture. Where that line crosses the eye-level line, that's a vanishing point. And now that you have the vanishing point, all the lines in the building that are *parallel* to the roof line should end up at that vanishing point. That's the beauty of locating a VP: once

you have it, it dictates the angle for other lines. You don't have to think about their slopes, or angles, you just aim them at the vanishing point.

Here's the green house from the illustration on page 99. Suppose you're satisfied with the basic lines showing the house in perspective (you've used the jaws to get those lines right). You've located the vanishing points and now you want to add some details to the house: a window, a door and some siding. You want them, of course, to be in proper perspective. You can add them easily by drawing lines from the object to the vanishing point.

1 Start With a Basic House
Here's a house in two-point perspective. Its vanishing points are established and we want to add a door to the front wall, a window to the side wall and some siding on both walls.

 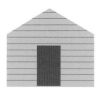

EL VP

2 Draw Lines to the Vanishing Point For the Top and Bottom Edges of a Window
If you're dealing with an ordinary rectangular window, its top and bottom edges are parallel to the top and bottom edges of the wall in which the window is placed. The window's horizontal receding edges will slant toward the same vanishing point as the wall's horizontal receding edges.

3 Finish the Window With Vertical Lines

Draw vertical lines to finish the window. You can place the verticals farther toward the front of the house or farther toward the rear—wherever you prefer. Later we'll see how to center a window in a wall.

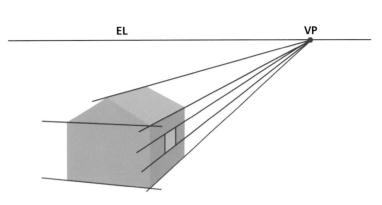

4 Add a Door Using Lines to the Other Vanishing Point

Build the doorway in the front face of the house the same way you inserted the window in the side of the house, but this time draw the construction lines toward the other vanishing point. Since that vanishing point lies pretty far off the paper, the only way to locate it exactly is to tape some extra paper onto the drawing and extend the eye-level line much farther to the left. But that's rarely necessary. Instead, lay a straightedge on the drawing at about the height you want for the doorway and then adjust the slant of the straightedge so that, by eyeballing, you think it's aimed at that far-left vanishing point. Your guess will usually be close enough.

Straightedge

5 Add Siding

To add siding in perspective, draw evenly spaced lines from each vanishing point toward the building. An easy way to do this is to keep one end of a straightedge positioned at a vanishing point and swivel the other end of the straightedge in even increments. In the case where you can't see the vanishing point, make an educated guess. I've shown just a few of the lines of siding. Notice the siding on one side of the building lines up with the siding on the other side (good carpenter).

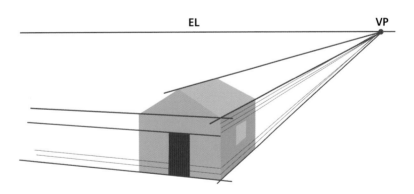

HINT FOR STEP 4

The top edges of doors and windows in many buildings are at the same height. So you can determine the height of the door by starting its construction line at the corner of the house at the point (the white dot in step four) where it meets the window construction line.

PERSPECTIVE CENTER

If you were to measure the walls of the green house in the previous example, you'd find the door and the window lie at the centers of their respective walls. But in the perspective view, things are different: they are now at the *perspective centers* of their walls. Let's see what that means.

To find the center of a rectangle, you draw diagonals across it; the center is located where the diagonals meet. To find the center of that same rectangle in perspective, you do the same thing: simply draw crossing diagonals.

WHY THE PERSPECTIVE CENTER IS IMPORTANT

Knowing where to locate the perspective center of a rectangle helps you to locate and draw other objects within that rectangle, such as doors and windows. It also helps you locate the peak of a gable in perspective.

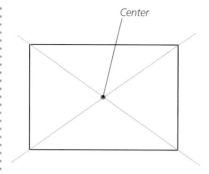

Center

Center of a Rectangle
To find a rectangle's center, draw its diagonals.

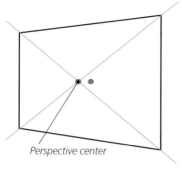

Perspective center

Center of a Rectangle in Perspective
The halfway-point is at the red dot, but the perspective center is the point where the diagonals cross.

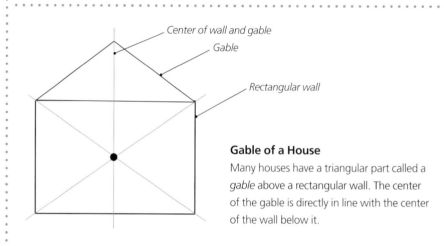

Center of wall and gable

Gable

Rectangular wall

Gable of a House
Many houses have a triangular part called a *gable* above a rectangular wall. The center of the gable is directly in line with the center of the wall below it.

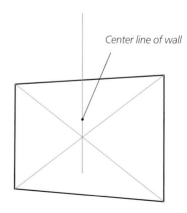

Center line of wall

Gable of a House in Perspective
Here is the wall turned in perspective. To add the gable above the wall, you need to find the wall's centerline (far left). Mark off the gable's height anywhere you wish along the centerline and draw lines connecting that point with the upper corners of the wall (near left). The gable is done and everything is in perspective.

LET'S BUILD A HOUSE

Here's a house seen from the front and from the side. On the following pages, we'll learn the basics of two-point perspective by building this house together. We'll imagine the house is on a little hill and we're viewing it from somewhere down the hill; that is, our eye level is below the house.

House, Front and Side Views
Everything about this house is symmetrical except for the chimney located at one end rather than in the center.

House in Two-Point Perspective
Here's a view of this house on a hill, turned so that it's in two-point perspective. This is the house we'll build in the demonstration on the following pages.

BUILD A HOUSE

As we build this simple house step by step, you'll see all the basic ideas of two-point perspective at work. Real houses, of course, offer a lot more challenges: dormers, porches, asymmetry and so on. We'll get into some of those problems later, but solving them depends on first understanding the basics.

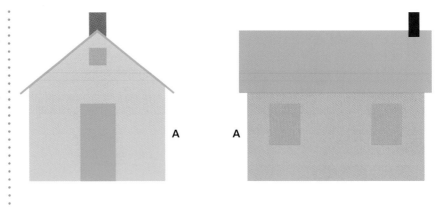

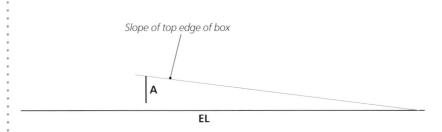

2 Draw One Slope

With a straightedge, try various slopes for the top edge of the box until you think the slope looks right. For this exercise, don't worry that the slope you choose might not be quite realistic; if you were drawing from a real house, you would measure the real slope by eye or by using a set of jaws.

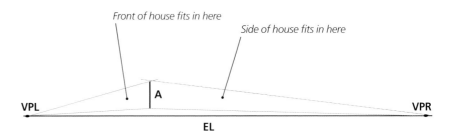

4 Draw the Bottom Edges of the House

Connect the bottom end of the vertical edge A to each of the vanishing points. The walls of the house lie between the pairs of slanted construction lines.

|A

EL

1 Draw the Eye-Level Line, Then the Nearest Vertical Edge of the House

First draw a horizontal line indicating eye level. Then establish the nearest vertical edge of the house (A). You could start the house anywhere, but the nearest vertical edge is a convenient place to begin.

Since the house is on a hill, let the bottom of the vertical edge end a bit above eye level.

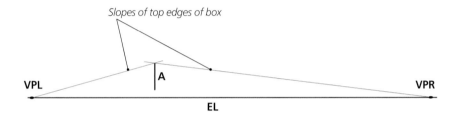

Slopes of top edges of box

VPL · · · · · · · · A · VPR

EL

3 Draw the Other Slope and Mark the Vanishing Points

Now draw a slanting line representing the slope on the other face of the box. Where each of the sloping lines crosses the eye-level line, mark a vanishing point. We'll call them VPL (vanishing point left) and VPR (vanishing point right). Those two vanishing points will guide all the rest of the drawing.

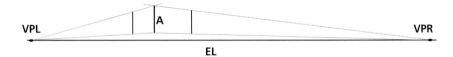

VPL · · · · · · · · A · VPR

EL

5 Establish the Length of Each Side of the House

Decide how wide each face of the house should be, then draw vertical lines representing the outer corners. If you were drawing from a real-life subject you would sight-measure the two sides using the thumb-and-pencil method and compare the widths of the sides to each other and to some other dimension, such as the height (A).

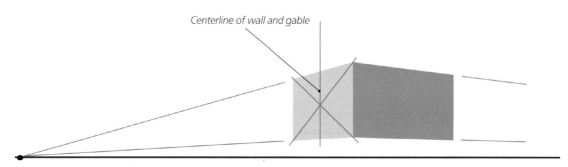

Centerline of wall and gable

6 Find the Perspective Center of the Front Wall

Now we have the two walls established (I've colored them for clarity). Next, you'll add the gable. To do this, first find the perspective center of the rectangular wall to which the gable will be added. Do that by finding where the wall's diagonals intersect.

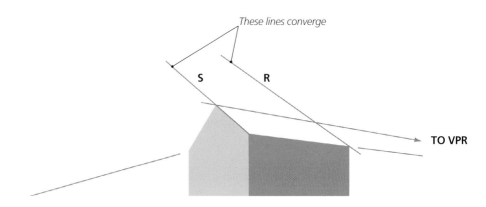

These lines converge

S R

TO VPR

8 Draw the Roof

To construct the basic roof, draw a construction line from the tip of the gable to VPR, giving you the slope of the roof's ridgeline (the highest edge of the roof). Then draw line R which, in the real building, is parallel to S, the other edge of the roof. However, as we'll discuss in the next chapter, R and S are parallel lines that are receding from us and therefore they converge and eventually meet far out in space at a third vanishing point. So, for now, just lean R slightly toward S.

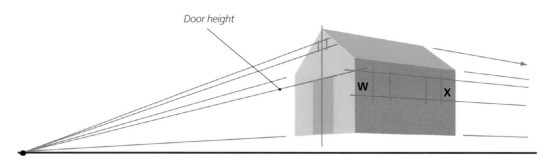

Door height

W X

10 Add Windows

The tops of the windows in the side of this house are at the same height as the door, so draw a line from the door-height line at the corner of the building to VPR. Draw a line for the bottoms of the windows to VPR. The windows fit between these two lines. The left window is a little wider than the right one and space W is wider than space X. Draw the small window above the door the same way you drew the door.

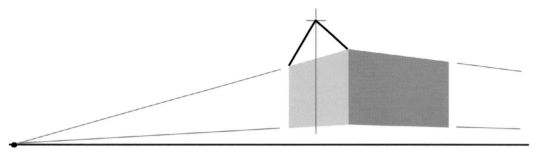

7 Draw the Gable

Sight-measure your subject and decide how high the tip of the gable should be. The gable seems a little more than half the height of the wall. Mark the appropriate height along the vertical centerline and connect that point to the two corners of the wall to form the gable in perspective.

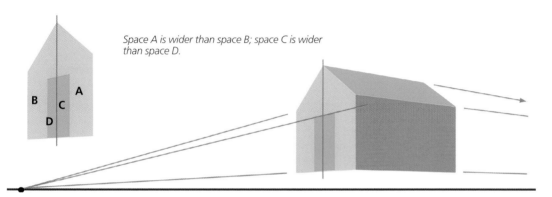

Space A is wider than space B; space C is wider than space D.

9 Add a Door

Add a door at the perspective center of the front wall. Start by marking how high you want the door to be (in these illustrations I've made the door and windows large to make the picture clearer). The door should be "centered" around the centerline of the wall—but don't forget that the door itself is in perspective. So just as there is a little less wall to the left of the centerline than to the right, there is also a little less door to the left than to the right. There are complicated constructions to get this exactly right, but for the sake of sanity, just eyeball your drawing and make sure there's a little more door showing to the right of the centerline than to the left.

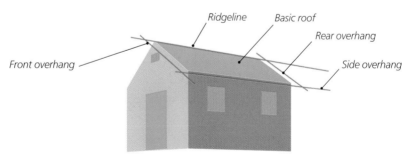

11 Draw the Roof Overhang on the Near Side

So far the house has only the foundation for a roof; it needs a roof cap. The roof cap overhangs the house in front and back and on both sides. Such details are important; without them, the house may look like a toy.

First, extend the roof's ridgeline front and rear. Next, draw a line representing the overhang at the side of the house. Draw lines for the overhangs at the front and rear of the house. To be practical, all these lines may be drawn parallel to their respective nearby basic roof edges. The overhang at the rear should be a little shorter than that at the front since it's in the distance.

12 Draw the Roof Overhang on the Far Side

To get the other side of the front overhang, draw line H through the tip of the roof cap parallel to the edge of the gable. The question is, how far down does that overhang extend? Take a look at the inset. Imagine a line connecting A and B in the inset and then draw that line (in perspective) on your drawing, again connecting points A and B. Now you know how far down the overhang extends.

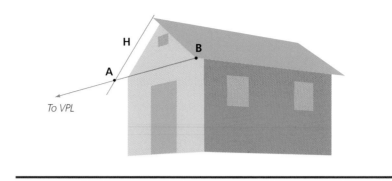

13 Finish the Roof Overhang

All that remains is to finish the overhang by drawing the (short) line from point A toward VPR. This little line is often done wrong; many people aim it toward the wrong vanishing point.

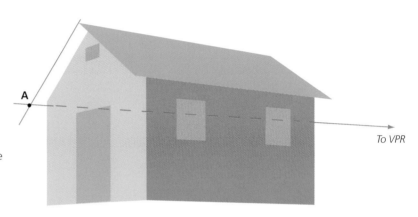

15 Draw the Front Face of the Chimney

Draw construction line A toward VPL—this is the top edge of the front face of the chimney. Draw line B parallel to the edge of the roof—this is where the chimney intersects the roof. Where B crosses the ridgeline, draw vertical (dotted) line C. What you have so far is the part of the chimney on the near side of the roof.

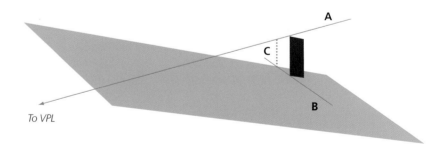

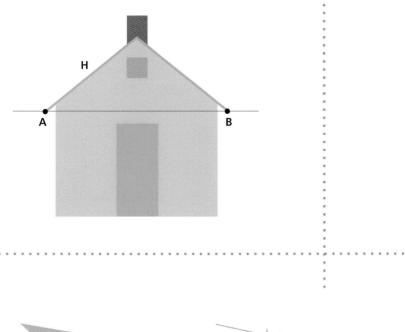

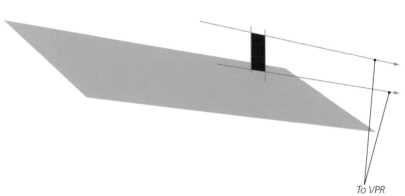

To VPR

14 Draw the Side Face of the Chimney

Draw a construction line for the height of the chimney and aim it toward VPR. Draw another line for the base of the chimney and aim it also toward VPR. Draw two verticals to define the thickness of the chimney. This completes the side of the chimney facing us. Notice the top edges of the chimney are the highest edges above eye level, so they have the steepest slopes of all the receding horizontal lines.

16 Finish the Chimney and Add Some Edges

Finish the chimney by drawing its far vertical edge. Like anything in perspective, the part of the chimney farther away should be slightly narrower than the nearer part (just as we saw in the door and windows). Add a few edges to help give the windows, door and roof a bit of thickness.

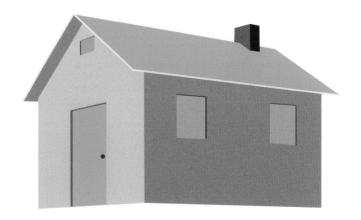

SEEING THE HIDDEN EDGES

It's helpful in linear perspective to "see" hidden edges and surfaces. The house you just built is, at its heart, simply a box with details added on. If you begin with a box, drawing with linear perspective will be much easier.

Basic Box
Here's the main part of the house: a basic box. Because eye level is lower than the entire house, you can see up under the box.

Visible Edges
Here are the visible edges of the box.

Hidden Edges
Sometimes it's helpful to visualize an object as though it were made of glass, so you can imagine seeing through the faces and discerning the inside (hidden) edges.

Strange Goings-On
Let's take apart the glass box and compare its parts. In a rectangular box, opposite faces are equal in size and shape. But the minute you put that box into perspective, pairs of sides are no longer equal either in size or in shape. The same is true of the ceiling and the floor, whose shapes are vastly different in perspective.

DRAWING THROUGH

One way to capture the depth or thickness of an object is to draw its hidden lines. This helps you understand the construction of the object. This technique is called *drawing through*.

The idea is to imagine the parts you can't see to help you better understand the parts you can see. In chapter three we discussed seeing and drawing a tree as a combination of cylinders, making the curves of the cylinders explicit even though you can't always see them. That's an example of drawing through. This technique is particularly helpful when drawing curves, but it's also helpful in drawing rectangular objects such as the box on the previous page. As a practical matter, draw through using strokes you can easily erase later if you wish. Here are some charcoal and pencil sketches illustrating the concept of drawing through.

TIME OUT!

We've been dealing with accurate slopes and angles and there's more of that to come, but let's take a little breather. If you get slopes and angles just right and if you force your edges to hit the appropriate vanishing points, you'll end up with a technically correct drawing. But it may also be sterile, too "correct," too fussy. Relax. Most objects in real life aren't perfect, and even if they were, you wouldn't necessarily want them perfect in your paintings and drawings. Art, after all, is all about interpreting, modifying, putting your own spin on things; otherwise, where's the pleasure? If your subject droops from age and wear or if it's been malformed in some appealing way, draw it that way.

So why worry about linear perspective at all? The reason is, if you begin drawing an object with a sure knowledge of its basic structure—the way it was meant to be before time and circumstances altered it—you'll be vastly more competent at drawing it convincingly in its altered state. In the shed at right, I understood the way it was supposed to look—the way it probably did look when it was built over a hundred years ago. But part of what appealed to me was the wear that was apparent in its sagging roof, so that's what I painted.

PERSONALITY

This shed served as a carriage house for a Civil War–era home. Today the main part is a garage and the smaller part, a one-time chicken house, now shelters a family of groundhogs. The building is drawn just as it is, droops and all.

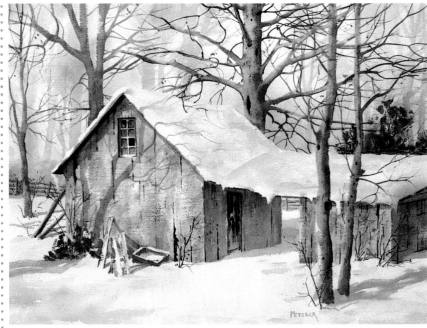

OLD SHED
Watercolor on 140-lb. (300gsm) Arches cold-pressed paper
18" × 24" (45.7cm × 61cm)

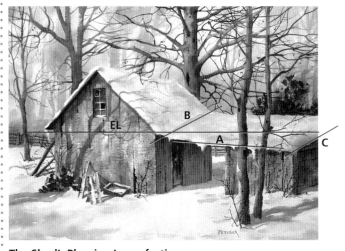

The Shed's Pleasing Imperfections
The eye-level line is about where indicated, but some of the edges of the building refuse to obey the rules. Edge A, for example, slopes to the right, but ought to be horizontal since it's so close to eye level. Edges B and C have a peculiar slant, but that's only because that part of the roof actually was built on a slant, rather than flat, to allow water to roll off.

THE RIGHT SLANT

The slants of all receding lines in your picture depend on the eye level. Receding lines above eye level slant downward toward the eye-level line and receding lines below eye level slant upward toward the eye-level line. A receding line that happens to fall right at eye level slants neither up nor down. Here are variations of the scene at the beginning of the chapter showing how different eye levels affect slanting lines.

REACHING THE VANISHING POINTS

In these examples, the vanishing points are far off the page. You could locate them by widening the paper, but that's rarely necessary. It's usually enough to see the vanishing points in your mind's eye and to mentally extend lines toward them.

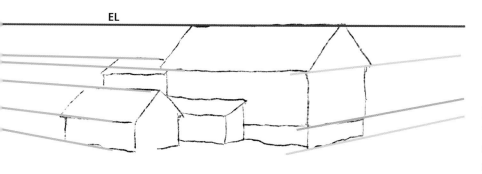

High Eye Level

The eye level is relatively high, at the roof's ridgeline. All receding horizontal lines slant up toward the eye level.

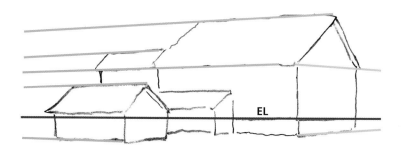

Medium Eye Level

Here I've lowered the eye level. The receding lines above eye level slant down; those below eye level slant up.

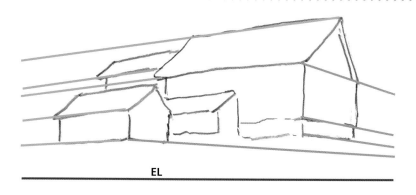

Low Eye Level

Now the eye level is very low and all receding lines slant down.

In class I sometimes use a visual aid suggested to me by an artist friend, Kay Poole. Draw a network of receding lines on a large sheet of cardboard and cover it with acetate. Using a grease pencil, draw a basic building in two-point perspective and add windows and doors, using the lines under the acetate as guides. You can erase the grease pencil and try as many combinations of windows, doors and other objects as you like. You can easily make this grid for your own practice—or you can draw right here in the book. It's a good way to learn how the objects you draw should diminish in size and spacing as they recede and to notice the shapes of objects in perspective.

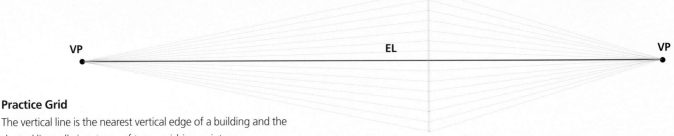

Practice Grid

The vertical line is the nearest vertical edge of a building and the slanted lines all aim at one of two vanishing points.

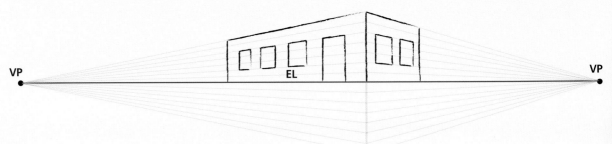

One-Story Building

Here's one way you can locate windows and doors. This might be an apartment house or a warehouse. I've placed the windows with gradually diminishing spaces between them, which is how they would look in perspective if, in reality, they were evenly spaced. This may remind you of the subject of chapter three: diminishing sizes and spacing. Such diminishing is really an example of linear perspective.

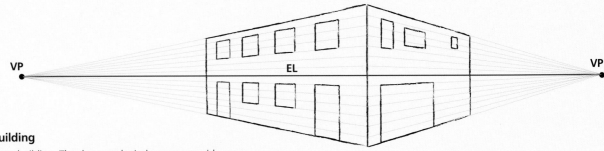

Two-Story Building

This is a two-story building. The doors and windows on one side are neatly organized, but those on the other side are done more whimsically. In all cases, the shapes and sizes are in reasonable perspective.

DISTORTION

DISTORTING BY MOVING VANISHING POINTS

To depict an object realistically in perspective, the most important thing you can do is to accurately establish angles, or slopes of lines, either by eyeballing or by using a set of perspective jaws. If you get the slopes right, you need never consider the vanishing points. But sometimes you think you nailed the slopes and yet your picture doesn't feel right; it looks either too flat or too squeezed. If too flat, your vanishing points are probably too far out from the object; if squeezed, the vanishing points are too close to the object. In either case, you can experiment by gradually shifting the vanishing points and noticing how the shifts affect the drawing of the object. Sometimes you may purposely distort a scene (don't forget, as an artist you can do what you want) and one way to do so is to shift the vanishing points dramatically.

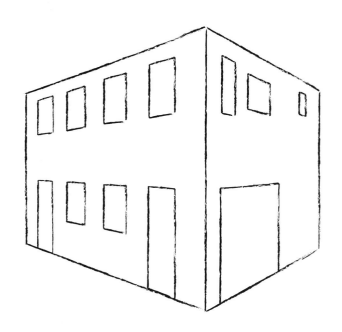

Squeezed

The vanishing points are close to the subject, so the subject looks squeezed. If you're looking for a fantasy effect, you could squeeze even more and end up with a narrow building where comic-book characters might live. But no matter how much you squeeze, all the parts of the building will remain compatible.

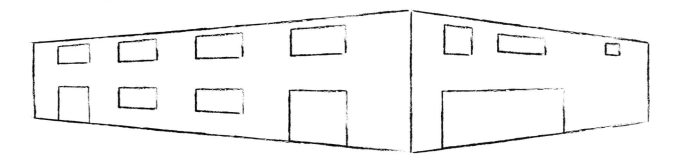

Far Out!

The vanishing points are located far from the subject. If you move them sufficiently far out, the subject will look nearly flat, no perspective at all.

CAMERA DISTORTION

I've seen many paintings that faithfully reproduce a scene and yet seem wrong. They're almost always done from photographs—perhaps literally traced from photographs—and that's their problem. Photos tend to show distortion around their edges because no lens is perfect; the cheaper the camera, the more likely it is that the edges will be distorted. Such distortions are particularly evident in shots of city scenes with buildings crowded against the edges. The vertical lines of the buildings nearest the edges of the photo and more or less parallel to the edges are likely to be curved or slanted or both. Some slant is due to three-point perspective (see chapter seven), but much is due to camera distortion. As long as you're aware of all this, you can easily straighten things out in your drawing; but if you stubbornly copy the photo, your picture may miss the mark.

CONE OF VISION

It's generally agreed that we see things relatively undistorted within a conical volume extending from our eyes like a visual megaphone. The angle of the cone is about 60 degrees; with our eyes looking straight ahead, we see clearly 30 degrees to the right, 30 degrees to the left, 30 degrees up and 30 degrees down. Beyond this cone of vision our sight is increasingly unreliable. Happily, the 60-degree cone suits most of our needs.

Camera Distortion Demonstrated
This is a perfectly rectangular piece of mat board photographed up close using a decent digital camera. Notice the slightly curved edges.

How to Reduce the Distortion
By backing away from the subject and then using the zoom feature on the camera, much of the distortion is eliminated. The same would be true if I had backed away and not zoomed; the image would be smaller, but it would all be nearer the center of the lens and therefore less distorted.

Camera Distortion in an Architectural Scene
Although some of the inward tilt at the edges of this cathedral is caused by the low eye level (the building is in three-point perspective), a lot of the tilt is camera distortion.

FINDING BOXES WITHIN OBJECTS

Drawing a box in perspective is easy, so if you can "see" an object as a box or as contained within a box, you can draw it more easily. With a little mental practice you can imagine many, if not most, objects as boxlike. The boxes can be a little loose—no need for perfection—and still they'll be helpful. Here are a couple of examples of trucks-in-a-box.

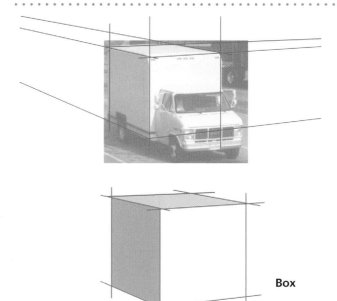

Box

One-Box Truck

This truck is well below eye level. Its body is rectangular except for a few rounded corners, so you can easily see it as a box and treat it in perspective just like any other box. (The truck is shown dimly so you can better see the construction lines.)

Two-Box Truck, Box 1

This tanker truck has two boxes at an angle to one another. Here is the box for the tank part of the truck.

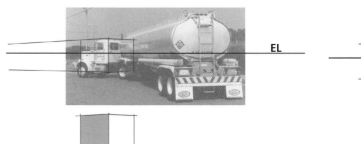

Two-Box Truck, Box 2

Here's the box for the cab of the two-box truck.

Two-Box Truck in Perspective

Here's the truck reduced to a couple of boxes.

USING DIAGONALS TO DIVIDE SPACE

Suppose you have a long space in perspective that you want to divide into equal parts. The space could be vertical, such as a wall with columns, windows or doors, or it might be horizontal, perhaps a tile floor. Normally you would eyeball the scene and sketch its sections in ever-diminishing sizes, fill in the windows, doors or whatever, and that would be that. But occasionally you need more accuracy, so you might use the so-called method of diagonals.

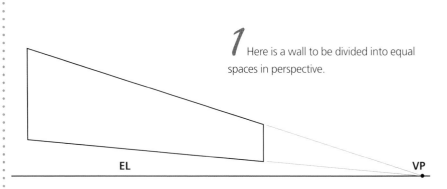

1 Here is a wall to be divided into equal spaces in perspective.

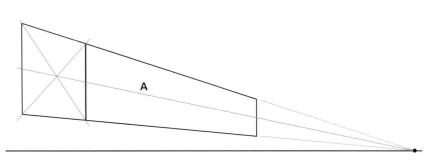

3 Draw the first rectangle's diagonals; they cross at perspective center. Draw line A through the perspective center and the vanishing point.

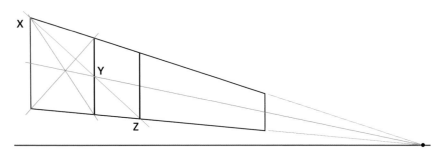

5 Draw a vertical line through point Z. Now you have a second rectangle in perspective and sized perfectly, relative to the first rectangle.

Why Does This Construction Work?

Look at any adjacent pair of rectangles in perspective (such as the shaded pair to the right) and you see they may be considered as two halves of a single rectangle in perspective and the slanted lines turn out to be diagonals of the larger rectangle. As you repeatedly draw diagonals and verticals, all you're doing is adding on rectangles in proper perspective. This method isn't only about dividing a wall. The successive verticals you drew could well be fence posts, columns or power poles. Or the "wall" could be laid flat and we could draw tiles in perspective (we'll do that in Part 3).

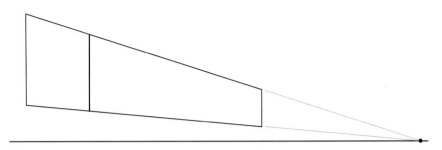

2 Estimate the first space and draw a vertical line to mark it off. Like many first steps in perspective, you eyeball a situation and sketch a beginning; then if it doesn't look reasonable, erase and begin again.

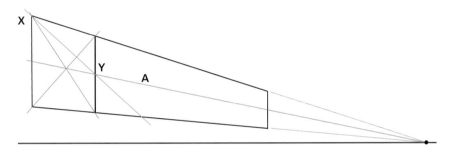

4 Draw a line from the near corner (X) of the first rectangle through the point (Y) where line A crosses the far edge of the rectangle.

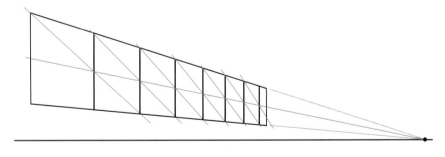

6 Repeat for as far as you want to sub-divide the wall. If, as here, the last rectangle doesn't exactly coincide with the end of the wall, change the wall!

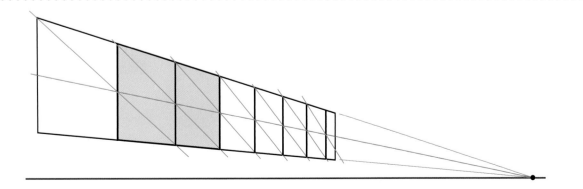

LINEAR PERSPECTIVE OVER SHORT DISTANCES

Linear perspective often involves large objects, such as buildings, seen at some distance, but of course the rules of perspective work over short distances as well. In chapter five we saw a length of railroad track enclosed in a box, illustrating that a railroad bed has depth, or thickness, in addition to length and width. The same is true of common objects such as windows and doors; they may be only a few inches deep, but making those inches clear in your drawing can make the difference between a flat, lifeless drawing and one that looks realistic.

Flat Window
This window offers no sense of depth at all.

A Doorway in Two-Point Perspective
By painting this doorway from a position a little to one side (instead of from straight in front of it), I introduced two-point linear perspective. The short lines aiming for a nearby vanishing point, along with the cast shadow, provide the picture with plenty of depth.

PIENZA DOORWAY
Acrylic on canvas board 11" × 8" (27.9 cm x 20.3 cm)
From a photo by Jeffrey Metzger

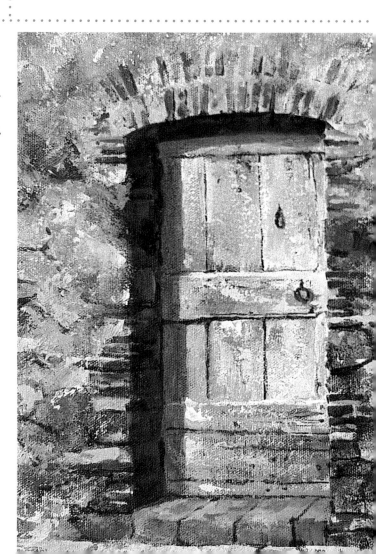

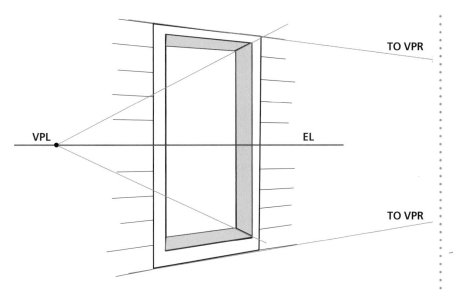

Adding Depth

This is the box-space into which the window fits. Think of the window—the frame and all—as a thin rectangular box. Its lines behave exactly like the lines in the rest of the building, seeking out their respective vanishing points.

Seeing the Details

This is a double-hung window. The lower part is recessed behind the top part. Noticing such details and including them in your drawing adds a lot of realism (and depth) to your work.

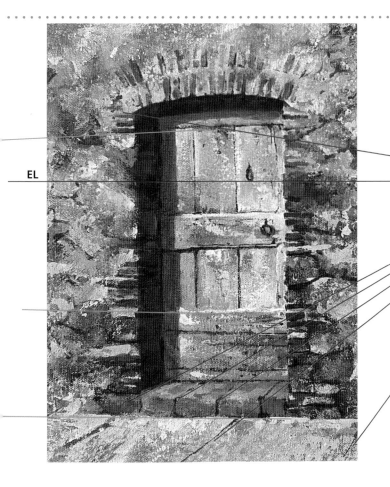

Construction Lines

The second vanishing point is far off the page. The subject is old and worn, so don't expect all the construction lines to hit the vanishing points dead-on.

DUCKS IN A ROW: ESTABLISHING SCALE

You can use linear perspective to properly scale a series of similar-size objects at varying distances from the front of the picture. We've already done that with rows of windows, fence posts, bricks and the like, but there are less obvious situations where this technique is useful. Let's look at a scene that includes people, sailboats, docks and ducks, and see how linear perspective can help get things scaled properly.

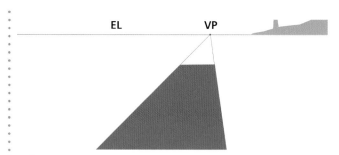

1 You're standing back from the scene and your eye level is as shown. In front of you is a dock. The receding edges of the dock end up at a vanishing point at eye level (that is, the horizon).

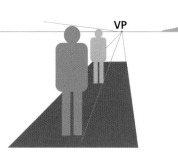

3 The man walks forward and a second man walks onto the dock. Their eye levels are roughly the same, so the tops of their heads and the soles of their shoes line up neatly in perspective. If you squeeze more same-size people onto the dock, they'll all fit nicely between the construction guidelines.

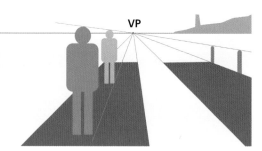

4 Add a second dock. If it's parallel to the first one, its edges will aim for the same vanishing point as the first dock. Let's show some of its pilings; they all line up in perspective, just like fence posts.

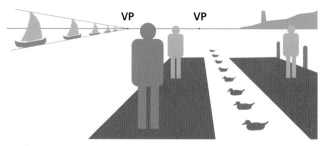

7 Finally, let's add a row of sailboats. The row need not be parallel to the docks. We'll give the boats a separate vanishing point on the eye-level line.

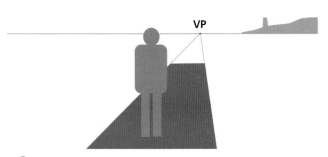

2 A man walks out on the dock. He's about your height, so your eyes and his are at about the same height. The eye-level plane therefore passes right through his eyes.

REGIMENTATION

The use of a couple of perspective guidelines can help keep objects in a scene looking reasonably sized, relative to one another—but of course you would rarely line things up so rigidly. Instead you would arrange objects in a more comfortable, familiar way. In the scene shown here you might scatter the ducks and sailboats, for example, and orient them in different positions.

When you include people in a scene, if they are all standing on a flat surface, and if they are all pretty much the same height, their eye levels will all be the same. Knowing this helps you to keep more distant figures in scale with closer figures, as in our example. In your drawing or painting, however, you would need to introduce variety by making some figures taller and some shorter, and by placing them in a variety of poses.

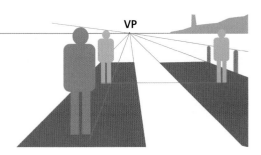

5 To add a man to the second dock directly across from one of the men on the first dock, draw horizontal lines from the top of the first man's head and the bottom of his feet across to the second dock. Fit the new man between the horizontal lines.

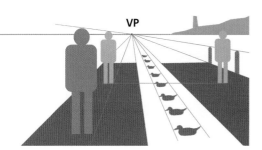

6 Along come some ducks; they understand perspective, so they line up in a neat row parallel to the docks.

DEFINITION

SCALING: *Drawing objects in correct proportion to one another according to how far they are from the front of the picture.*

SUMMARY

- **Like all types of linear perspective, two-point perspective is based on rectangular objects whose top and bottom surfaces are horizontal planes parallel to the ground.**

- In two-point linear perspective, you can see more than one face of the object.

- The receding horizontal lines in one face meet at a vanishing point; the receding horizontal lines in the other face meet at a second vanishing point.

- Both vanishing points lie on the eye-level line.

- For the time being (until the next chapter) all vertical lines remain vertical.

- **No matter how many objects there are in a scene, each has its own set of vanishing points and they all lie on a single eye-level line**

- To get angles (and therefore slopes of lines) accurate, rely on measurement with perspective jaws. Use construction lines and vanishing points only to solve problems.

- Receding lines above eye level slant down; those below eye level slant up.

- **Don't forget the importance of perspective in small objects or over short distances..**

126

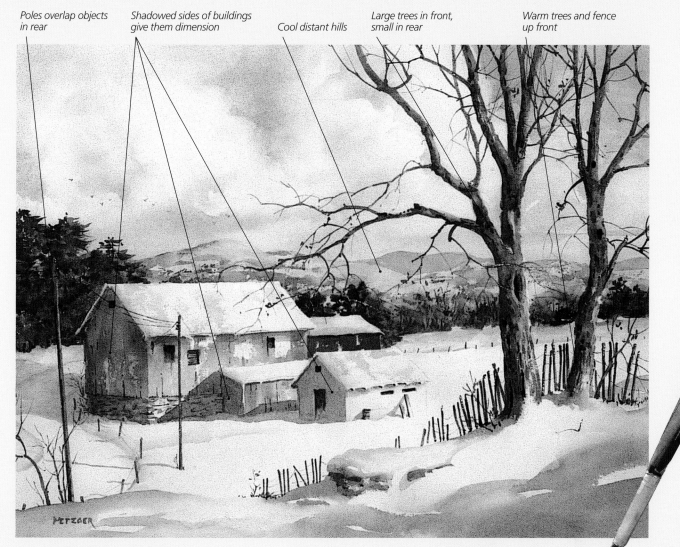

Poles overlap objects in rear

Shadowed sides of buildings give them dimension

Cool distant hills

Large trees in front, small in rear

Warm trees and fence up front

Buildings are in two-point perspective
Fences get smaller as they recede

MARYLAND FARM
Watercolor on Arches 140-lb. (300gsm) cold-pressed paper
18" × 24" (45.7 cm × 61 cm)

Palette

1 Cadmium Yellow Light
2 Raw Sienna
3 Raw Umber
4 Burnt Sienna
5 Alizarin Crimson
6 Cobalt Blue
7 Phthalocyanine Blue
8 Ultramarine Blue
9 Phthalocyanine Green
10 Cadmium Red Deep

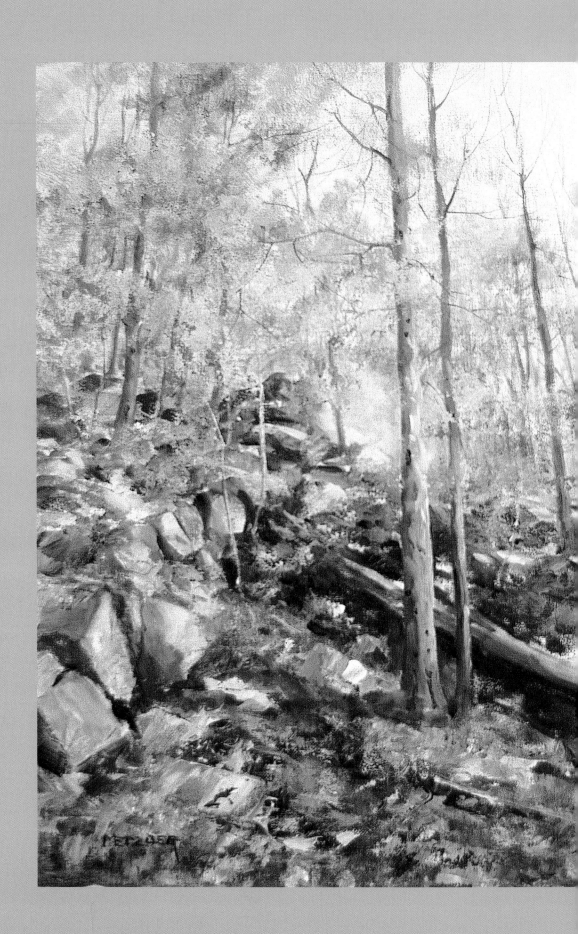

THREE-POINT PERSPECTIVE AND BEYOND

So far we've described a neat world where all vanishing points are at eye level, all vertical lines stay vertical and everything is just dandy. Now let's get real. Some vanishing points are off in space, nowhere near eye level, and there's no such thing as a perfectly vertical vertical! The truth is, *every set of receding parallel lines converges at a vanishing point somewhere.*

For the painting on the opposite page I purposely sought out a stand of trees in a nearby park that were all individually pretty much vertical with no appreciable lean. I painted them from down a hillside, a low vantage point, so they were all above my eye level. From that position, every one of them appeared to lean inward. If you project them high enough, all the trees appear to meet (more or less) at a point (yes, a vanishing point) high above eye level. Gracious!

EL

When Verticals Converge
Each tree is vertical, yet they all appear to converge at (or near) a vanishing point.

SPRINGTIME
Oil on canvas board
16" × 12" (40.6 cm × 30.5 cm)

A WARPED WORLD

According to Einstein, nothing much is really the way it seems. If you could travel faster than light, you might set out on a trip and arrive before you leave! Well, that's a little beyond this book (and beyond me), but the physicists also tell us there's really no such thing in the universe as a straight line. I don't know about the universe, but in our little world of sight, that's pretty much the case. All these straight lines we've been talking about for a couple of chapters aren't all that straight; we just call them straight to keep from going bonkers. But as straight lines stretch farther from the center of our vision, they begin to appear ever-so-slightly curved. For most of our art we can ignore the curving and blissfully draw straight lines that everyone will accept as just fine. But if you were doing sculpture or architecture on a large scale, you'd have to take into account the way humans see things. Classical builders learned to add slight curvatures to columns and long walls to compensate for the way we see.

In our ordinary-sized drawings and paintings, we can usually ignore the aberrations that occur in lines in our peripheral vision. But lines in our central vision do other things we can't ignore. We've already seen that the horizontal edges of rectangular objects seem to meet at vanishing points somewhere along our eye-level line; if we ignored that phenomenon, our pictures would look awfully strange. Until now we've allowed vertical lines to be vertical, but it's time to deal with the fact that vertical parallel lines converge in much the same way as horizontal ones. Furthermore, oblique parallel lines—lines that are neither horizontal nor vertical—may also converge. Let's start by looking at the vertical edges of a cube.

Cube From Below

We would normally draw a cube in perspective, seen from below, like this, with its vertical edges remaining vertical.

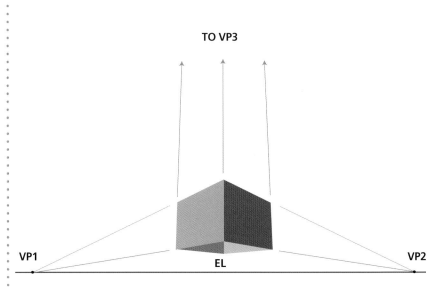

Vertical Edges Also Recede

In reality, the vertical edges of the cube in this view are not quite parallel. If you were to place in front of you a large enough cube, you could line up straightedges with the vertical edges and see that they slightly converge (upward, in this case). And why not? The vertical edges of the cube are parallel and in this view they are receding from us, just as the horizontal edges are receding, so it makes sense that they will seem to eventually meet. Where they meet is at a third vanishing point.

SKYSCRAPERS

Think of a skyscraper as a very tall rectangular box. Seen from one end or the other—that is, from below or above—the parallel vertical edges of this long box appear to converge just as the horizontal parallel edges we've considered in previous chapters do. If your eye level is low, the vertical edges converge toward a vanishing point above the skyscraper, or below the skyscraper if your eye level is high. In this New York City aerial view, eye level is high and all the vertical edges of the buildings converge at a vanishing point deep in the earth. This photograph was taken with a good camera and is quite accurate. You often see aerial photos that are much more distorted at their edges, taken with a less-accurate lens or shot purposely in such a way as to exaggerate distortion—the so-called "fishbowl" effect.

VP

Many Converging Verticals
A cityscape from a high eye level. The buildings' vertical edges converge at a vanishing point deep in the ground.

VANISHING POINTS AND EYE LEVEL

Horizontal lines recede to vanishing points at eye level. Vertical lines recede to points above or below eye level. When you have lots of verticals, all will converge toward the same vanishing point, either high in the air or deep in the ground. This becomes clearer when we consider both a bird's-eye and a sidewalk view of the same subject.

Pedestrian's View
Here's how skyscrapers look from the sidewalk.

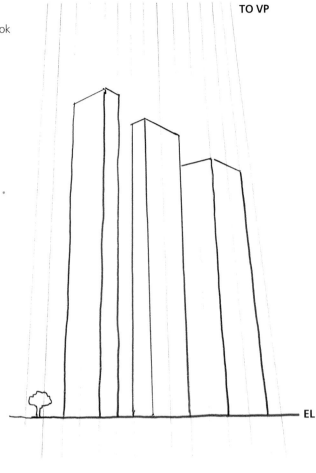

Bird's-Eye View
Seen from high above, the vertical edges of all these rectangular buildings recede to a vanishing point deep underground. If you turn the page upside-down, you'll have a worm's-eye view, that is, a look at the skyscrapers from deep down in the earth.

REALITY CHECK

Hardly any skyscraper is a plain rectangular block; they make all sorts of departures from rectangularity. Most are built with a natural taper from bottom to top, some have upper stages that are smaller rectangular solids than the base, some have rounded upper portions, and so on. The illustrations here ignore those facts and instead treat skyscrapers as ordinary rectangular boxes.

THREE VANISHING POINTS: HOW THEY WORK

In the sketches on the previous page, vanishing points are located far above or below eye level. Because of the dramatic effect of those vanishing points on the drawings, it's easy to forget about the other vanishing points that lie at eye level. They affect the drawing exactly as discussed in previous chapters.

To understand what's going on, let's revisit the skyscrapers seen from a high eye level. As you'll see if you play with these constructions, the farther down in the earth you place the third vanishing point, the narrower the "fan" will be and the less spread out the buildings will look.

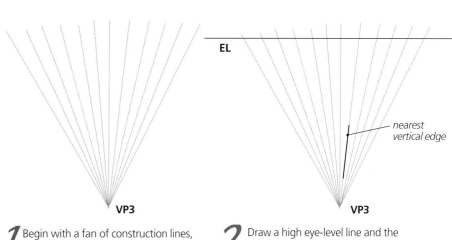

1 Begin with a fan of construction lines, all starting at what will become the third vanishing point.

2 Draw a high eye-level line and the nearest vertical edge of a building.

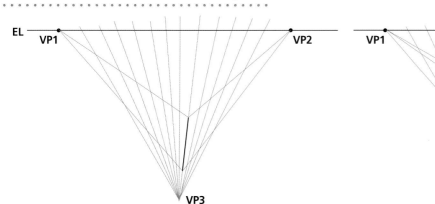

3 Make educated guesses and locate the two regular vanishing points on the eye-level line. Tape on extra paper if necessary. Then connect the top and bottom of the vertical building edge to the two vanishing points.

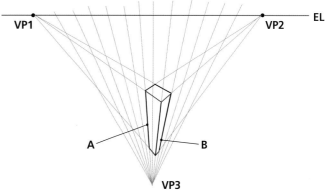

4 Decide how wide you want the two faces of the building to be and draw lines A and B. Finish by drawing the top of the building (a rectangle in perspective).

TRY THIS

If you drew the grid for drawing buildings in two-point suggested in the previous chapter (page 116), you might use that same grid to investigate three-point skyscrapers. Take your horizontal grid and turn it ninety degrees to make it a vertical grid. Now use the lower half of the grid as the "fan" in the illustrations above, and sketch in some skyscrapers with your grease pencil.

• VP

133

POINT OF VIEW

How you see an object depends a lot on how distant you are from it and the angle at which you view it. If you view an object from even a moderate distance, it will look flatter and less angled than if you see it up close; if you view it broadside, it will appear flatter than if you view it at a sharp angle. In the painting on this page, the scene is viewed from a moderate distance and the eye-level line runs across the middle of the picture, so the two vanishing points lie far to the left and right at eye level. The verticals are short and, seen from such a distance, show no appreciable convergence, so there is no third vanishing point worth considering. In the photo below, however, you see a building up close and at an angle, rather than broadside, so two-point perspective is very much in play; furthermore, the eye level is low, so the verticals converge to a third vanishing point.

A Distant Point of View

In this combination painting and drawing, linear perspective is fairly flattened, but there is considerable depth, thanks to plenty of overlap, diminishing sizes and spacing and sharp value contrasts.

FREDDIE'S FARM
Pen and ink with watercolor on Strathmore illustration board
30" × 40" (76.2 cm × 101.6 cm)

A Close-Up Point of View

When I photographed this scene, my eye level was about the same as the eye level of the two people in the foreground. The "vertical" lines show the slight inward tilt of the columns and the edge of the distant building. These lines converge toward a vanishing point high above because I shot the scene from a low eye level and I was relatively close to the building. Had I photographed from much farther away and from some higher perch, the convergence of the verticals would be much less noticeable. Some of this tilt, especially of the columns near the edge of the picture, is due to camera distortion (see page 118).

The lines converging toward the left at eye level don't meet crisply at a single well-defined vanishing point, partly due to camera distortion and partly because the curb and steps in front of the building have a slight curve.

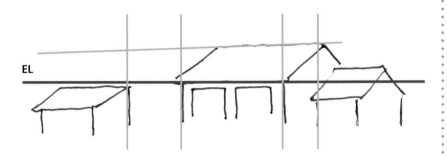

EL

Short Verticals May Not Converge Noticeably
Most of the horizontal lines in the buildings lie so close to eye level that there is little visible slant. The verticals are all short and don't appear to converge.

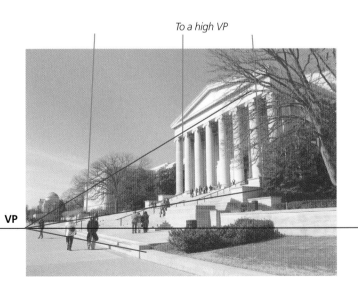

To a high VP

VP

ENTASIS (EN´·TUH·SIS)

If you draw or paint columns, especially in a large format, you might take a tip from ancient sculptors and architects. They learned long ago to design architecture with slightly curving lines in order to combat the optical illusion of sagging or concavity that occurs when perfectly straight lines are used. When we view a column that is perfectly vertical and uniform in thickness, the column appears to be slightly pinched in its middle and a little top-heavy. Classical architects found that the illusion is negated by tapering the column (so that it's a bit narrower at the top than at the bottom) and by making its vertical edges slightly curved outward (convex). That little trick is called entasis and it was well known by Greek and Roman architects—the Parthenon in Athens is a prime example of its use—but it was known many centuries earlier by the builders of ziggurats in Mesopotamia. Each ziggurat wall had a slight outward horizontal bulge when viewed from one corner to the next.

(Based on a discussion in *The Artist's Illustrated Encyclopedia*, North Light Books.)

INCLINES

We've gradually worked our way from one to two to three vanishing points, and you may be thinking that's that: three is all we'll ever need. But the truth is, there is no limit to the number of vanishing points that may occur in a scene because anytime you have receding parallel lines, you have another vanishing point. The only vanishing points that are at eye level are those to which horizontal lines recede; the rest all fall at various places in space, as we'll see.

These new vanishing points we are about to look at are the result of parallel lines that are inclined; that is, neither horizontal nor vertical, but somewhere in between.

Incline From the Side
Inclines are all around us. A tasty example is a wedge of cheese. Seen from the side, the cheese wedge shows little perspective.

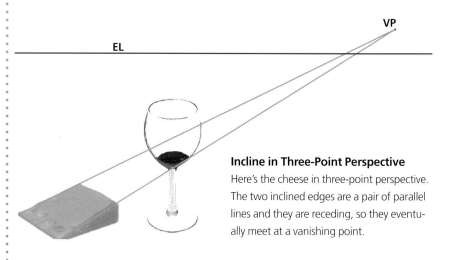

Incline in Three-Point Perspective
Here's the cheese in three-point perspective. The two inclined edges are a pair of parallel lines and they are receding, so they eventually meet at a vanishing point.

TIP

If you have a little trouble seeing the inclined edges converge, try a little more wine.

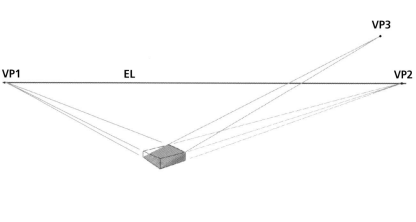

The Box Trick Again
It's helpful to think of the cheese wedge as half of a rectangular block sliced diagonally.

RAMPS

Almost every ramp you find is built like
a cheese wedge. In the example below,
one ramp's edges converge rapidly
toward a vanishing point and the other
ramp's edges converge only slightly to a
far-off vanishing point.

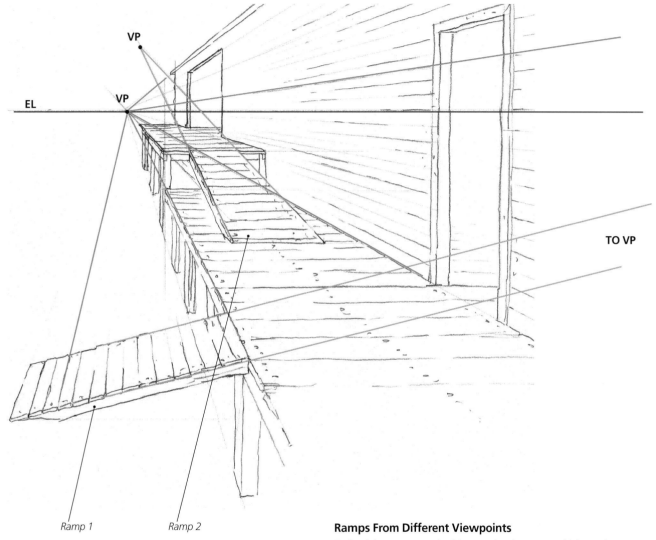

VP

EL VP

TO VP

Ramp 1 Ramp 2

Ramps From Different Viewpoints

Each of the two ramps in this scene has its own vanishing point,
neither at eye level. The vanishing point for ramp 1 is far to the
right and above eye level (if you use a straightedge you can check
for yourself where the ramp's lines meet). The edges of ramp 2 also
converge at a vanishing point above eye level.

Besides that of the ramps, there's a lot more linear perspective
going on here. The most prominent receding lines are those in the
face of the building; they all converge to a vanishing point at eye
level. The edges of the boards on the elevated walkway converge at
a vanishing point at eye level far to the right.

SLANTED ROOFS

Another common incline is the ordinary slanted roof. In most views, slanted roofs lean away from the viewer, so their parallel edges recede to a vanishing point. The railroad station shown at the beginning of Part 2 (page 76) illustrates this kind of perspective, along with both one- and two-point perspective.

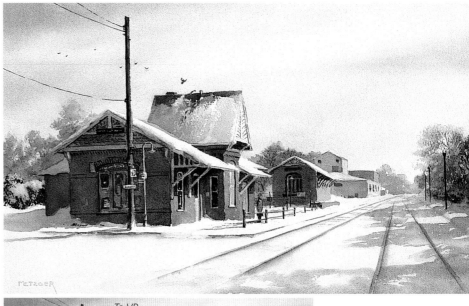

Complex Scene

The railroad tracks at the lower right of the picture are in one-point perspective. Except where they curve in the distance, the tracks are straight and parallel to each other and nearly parallel to the line of buildings. The buildings are in two-point perspective. Since they are parallel to each other, they share the same vanishing points, one of which is very near (for all practical purposes, the same as) the vanishing point for the tracks. The second vanishing point for the buildings is far to the left. So far, all the vanishing points are at eye level. Each slanted roof has its own vanishing point (not at eye level) and behaves exactly like the cheese wedge on page 136. Eye level is neither very high nor very low, and the buildings' verticals are relatively short, so the verticals do not converge.

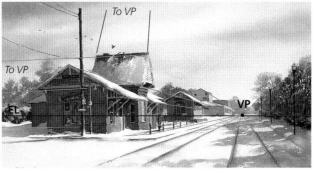

Detail: The Station

The architecture of the station may be confusing, so here's a look with the front dormer removed. The colored area represents the roof without its various indentations and interruptions.

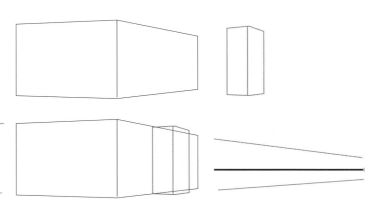

The Station as Boxes

Here are the main boxes making up the station. The small box is the part that the dormer sits on. If you were to add an object (such as a door or window) in one of these walls, the top and bottom edges of that object would slope toward the same vanishing points as the top and bottom of the wall itself.

PAINTING SLANTED ROOFS

This station is a popular painting motif where I live. I've excluded some surrounding objects, such as cars, parking meters and other buildings, because I felt they intruded on the quiet mood I was after.

MATERIALS

WATERCOLORS
Typical watercolor palette with a warm and cool of each primary color

PAPER
300-lb. (640gsm) cold-pressed watercolor paper, 14" × 25" (35.6cm × 63.5cm)

BRUSHES
All synthetic: 1-inch (25mm) and 2-inch (51mm) flats, nos. 6 and 12 rounds

OTHER
Masking fluid and a small Colour Shaper or other application tool that wipes clean easily

1 Paint the Sky and Treeline
Wet the entire paper and then cover it with big splotches of very pale blue, yellow and red; this is an underpainting that will subtly show through later paint layers. Dry the surface with a hair dryer. Re-wet the sky area with plain water, brushing carefully around the buildings. Paint the sky with long horizontal strokes of blue, pale green and yellow, leaving some white for the clouds. Begin the bare trees with light purple-gray raggedy strokes to suggest the trees' textures.

2 Begin the Brickwork
Mask any fussy areas you think will be hard to paint around, such as the front roof supports. Paint all the brickwork red-orange at the value you think sunlit brick should have. Paint it all the same way, including the areas that are eventually to be in shadow. Dry.

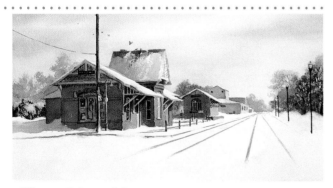

3 Detail the Buildings
Give the buildings solidity by darkening the shadowed areas. Use blue or purple over the previously painted light red-orange. The part of the roof not covered with snow is green. Paint enough sharp detail around windows and doors to get them firmly established. Use a little drybrushing to suggest brickwork. Darken the trees opposite the station with purple-gray.

4 Finish (shown on opposite page)
Use a soft blue-gray for the cast shadows and for the suggestion of tracks. Long shadows, like long horizontals in the sky, help suggest a quiet morning for the lone commuter waiting for a train. When painting the utility pole, apply mask on both sides of the pole to keep from slopping paint into the sky area. Tip: When you use masking tape or drafting tape on textured paper, press it down firmly to keep paint from seeping under the tape and giving you a ragged edge.

ROOFS: A CLOSER LOOK

Roofs slant at all kinds of angles, so their converging receding edges aim at many different vanishing points. Although you can certainly use perspective jaws to give edges the right slant, it's usually sufficient to squeeze a pair of edges slightly together and not fuss about accuracy. Some examples will make this clear.

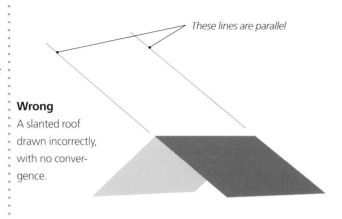

These lines are parallel

Wrong
A slanted roof drawn incorrectly, with no convergence.

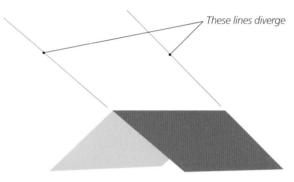

These lines diverge

Wrong Again
Worse yet, this roof is drawn with its edges converging forward rather than receding.

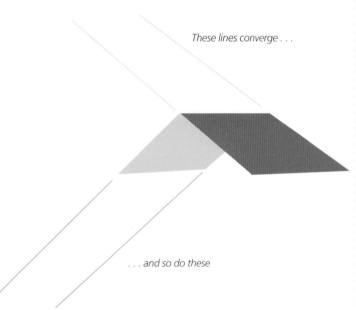

These lines converge . . .

. . . and so do these

A Surprise
If you could see the other side of the roof, you'd notice that its edges converge (because they are parallel receding lines), but in this case they converge downward. Of course, you can't see that side of the roof, so who cares if it converges! When we discussed "drawing through" (page 113), I hope it was clear that "seeing" unseen edges helps with our overall understanding of an object—and that understanding helps us to draw better.

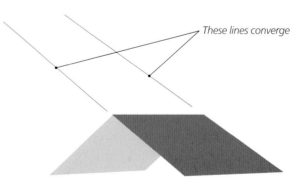

These lines converge

Right
This would be about right.

STAIRS

Fancy sets of stairs, such as circular ones, can be a daunting exercise in perspective, but ordinary straight stairs are no problem at all. If you see them as just another example of an incline, rather like our earlier cheese wedge, they become less complicated to draw. (In Part 3 we'll get into more detail.)

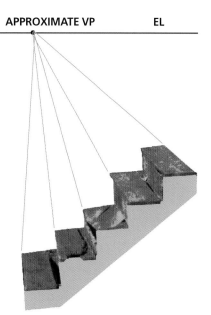

APPROXIMATE VP **EL**

An Old Set of Stairs
I'm not sure you'd want to walk up these stairs, but they're intact enough for us to see how they're put together.

The Stairs in Perspective
I've isolated the stairs so we can see what's going on. Eye level is as shown and, allowing for the decrepit condition of the stairs, perspective lines are roughly as shown. In a broken-down subject like this, don't expect everything to be textbook perfect!

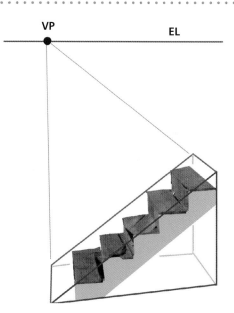

VP EL

Envision the Stairs as a Wedge
The basic stairs as a wedge in perspective.

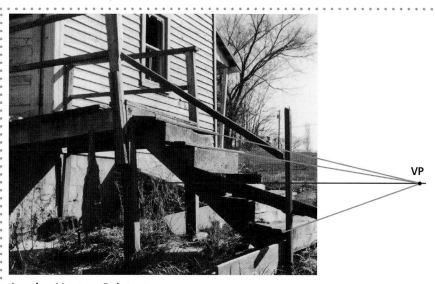

VP

Another Vantage Point
Here's another view of the steps, showing a little different perspective. Eye level for the first photo was relatively high; here it's much lower. From any position, you can see the stairs as a wedge.

ROADS AND PATHS

One of the most effective devices for leading a viewer into a landscape is a road. It's wide in the foreground, becoming narrow as it recedes, and its pull is irresistible. Roads or paths can become gimmicks—some of us use them perhaps too often—but done right, they can be an effective perspective tool.

DISAPPEARING ROADS

In rolling countryside, a road that dips and vanishes and reappears draws your eye in like a magnet as your brain automatically fills in the missing sections.

STRAIGHT SHOTS AND ZIGZAGS

Sometimes a road or path leading directly into the picture (often aimed at the picture's center of interest) is a good dramatic perspective technique, but it's a little like erecting a sign that says, "Look this way." A wandering road serves the same purpose without being quite so obvious, and the trip along the wandering road is usually a little more entertaining.

FLAT OR STEEP?

A flat receding road looks wider up close than in the distance—often much wider. But that same road climbing a hill in front of you diminishes in width much less rapidly.

MAKING A ROAD BEHAVE

It can help to see a road as a series of ramps and sketch in some construction lines. It's especially important to observe how the width of a road changes as it rounds a bend and changes direction. Remember that a road appears widest when moving straight into the picture; it appears narrowest when it runs left to right across the picture.

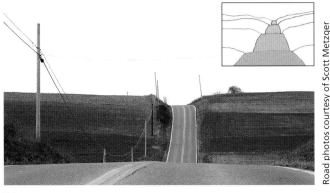

Road photos courtesy of Scott Metzger

Dip
This road dips out of sight, and when it reappears it's magically skinnier! Your imagination supplies the missing pieces and you experience a real sense of distance. Alongside the road, the utility poles also become lost and then found, all helping to pull you in.

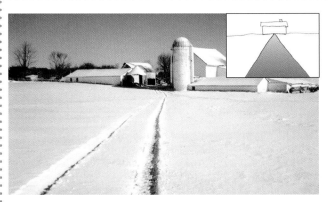

Straight Path
A straight shot toward the center of interest, but is it too severe?

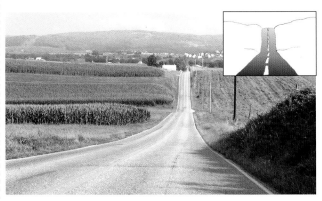

Steep Hill at a Distance
The part of the road nearest us is on relatively flat ground so it diminishes rapidly in width as it recedes, but when, in the distance, it climbs a steep hill, its width varies little—it looks almost as if standing on end!

Dip and Curve

This road not only dips but gets lost going around a bend and comes out the other side narrower.

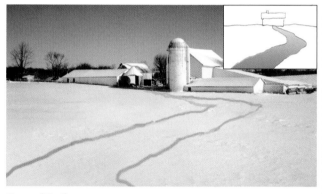

Curved Path

I've doctored the photo to make the road wander. Is this shape more comfortable?

EYE LEVEL MATTERS

Your position makes a big difference. If you see a road from high above—from an airplane, for example—it appears to have a uniform width. But if you're on the ground, standing on the road, its width (as you see it) changes dramatically from very wide at your feet to a narrow ribbon far away.

TIP

You know a road or path should be wide up front, but how wide? A good way to get this right is to use scaling, that is, make the road width compatible with some other known object nearby, such as a person or a fence post. For example, a common country dirt road might be about three times as wide as a fence post is high (see the drawing below). The point is, provide clues to size by placing other objects nearby whose sizes are well understood.

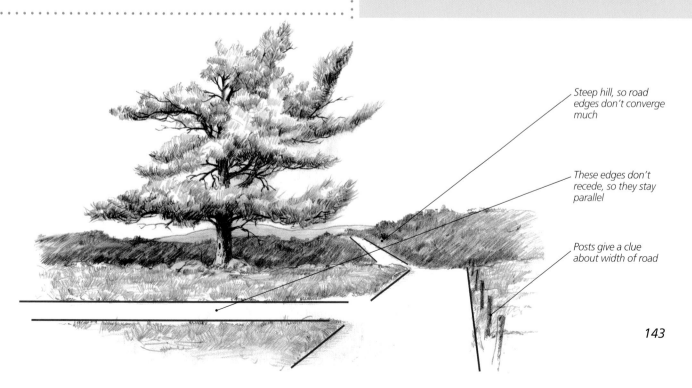

Steep hill, so road edges don't converge much

These edges don't recede, so they stay parallel

Posts give a clue about width of road

- **Every set of receding parallel lines converges at a vanishing point.**

- The vanishing points we are most concerned with are those in one- and two-point perspective; they lie at eye level.

- Many vanishing points do not lie at eye level. They occur above or below eye level, either where verticals converge or where oblique lines converge.

- **Tall objects, such as skyscrapers, should show convergence of their vertical edges when seen from a low or high eye level.**

- The vertical edges of a group of skyscrapers all converge toward the same vanishing point.

- Short objects, such as ordinary houses, that are near eye-level may reasonably be drawn with all vertical lines remaining vertical rather than converging.

- If those same short objects are far above or below eye-level, their vertical edges may be seen to converge toward a vanishing point above or below eye level.

- **Parallel lines that are oblique (neither horizontal nor vertical), such as the edges of any incline, converge at a vanishing point not at eye level.**

- Lines near the outer edges of a photo are often distorted because of imperfections in the camera's lens.

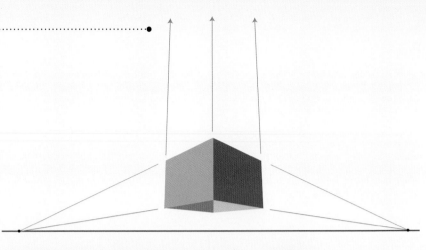

Photo from www. istockphoto.com/Steffen Foerster

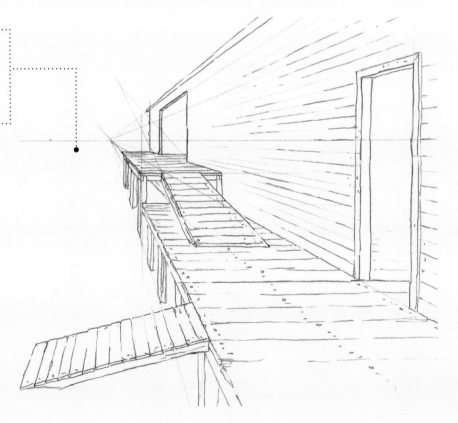

144

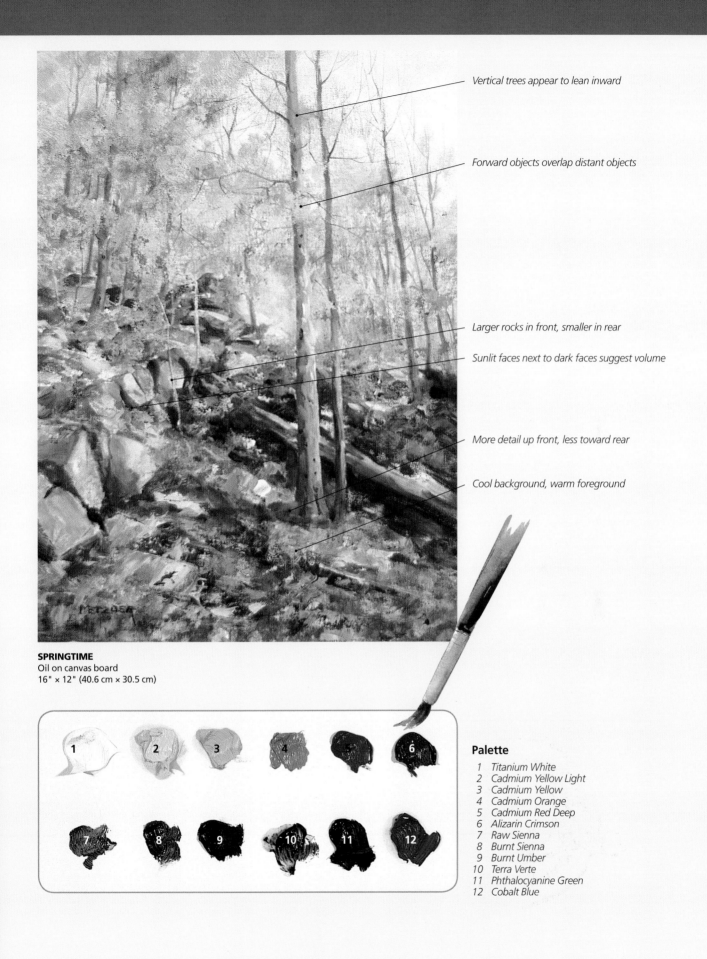

Vertical trees appear to lean inward

Forward objects overlap distant objects

Larger rocks in front, smaller in rear

Sunlit faces next to dark faces suggest volume

More detail up front, less toward rear

Cool background, warm foreground

SPRINGTIME
Oil on canvas board
16" × 12" (40.6 cm × 30.5 cm)

Palette

1 *Titanium White*
2 *Cadmium Yellow Light*
3 *Cadmium Yellow*
4 *Cadmium Orange*
5 *Cadmium Red Deep*
6 *Alizarin Crimson*
7 *Raw Sienna*
8 *Burnt Sienna*
9 *Burnt Umber*
10 *Terra Verte*
11 *Phthalocyanine Green*
12 *Cobalt Blue*

CURVES IN PERSPECTIVE

The world isn't made of straight lines and rectangular boxes; happily, there are curves of all sorts to break the monotony. Many of the curves we see are either circles or their close cousins, ellipses. An ellipse, in fact, is nothing more than a squashed-down circle, a circle in perspective. Because circles and ellipses are part of so many things around us—dinner plates, coins, wheels, eyeballs, cups, cans, poles, tree trunks, arms and legs—it's important to draw them properly in perspective.

Eye Levels, High and Low
Seen straight on, this dinner plate is a circle. At an angle, it's an ellipse. The closer it comes to your eye level, the flatter or thinner the ellipse until, right at eye level, it's a straight line.

EYE LEVEL CAN THROW YOU A CURVE

For all subjects to be rendered with linear perspective, eye level is critically important. As your eye level shifts, every shape in front of you changes at least slightly. In the case of the dinner plate, as eye level changes, the perimeter of the plate changes from a circle to a straight edge.

APPLES, NUTS AND PEARS
Watercolor on Arches 300-lb. (640gsm) cold-pressed paper
16" × 24" (40.6 cm × 61 cm)

THE SIMPLEST CURVE: A CIRCLE

For rectangular objects, the simplest shape is a square; for curved objects, the simplest shape is a circle. The two are, in fact, related. A circle may be inscribed exactly inside a square: the circle's diameter is the square's width or height.

Starting with a square …

…we can fit a circle perfectly inside the square…

…and their centers coincide.

If we turn the square so we see it in perspective…

…the circle inside it becomes an ellipse…

Perspective center of both shapes

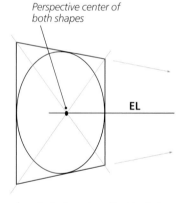

…and again their centers (that is, their perspective centers) coincide.

All Positions Work

The circle in perspective may be tilted at any angle you wish; it still becomes an ellipse and it may be envisioned as fitting inside a square that's in perspective. As we'll see, thinking of the ellipse as inscribed within a square in perspective helps you draw the ellipse correctly.

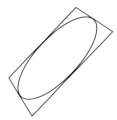
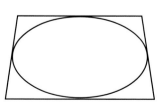
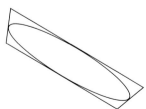

ANATOMY OF AN ELLIPSE

There's one big difference between a square in perspective and a circle in perspective: the square loses its symmetry, but the circle does not. The circle becomes an ellipse, a shape that remains symmetrical.

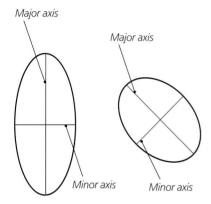

Major axis

Major axis

Minor axis

Minor axis

Geometry of an Ellipse

The long dimension of an ellipse is called the major axis; the shorter is the minor axis. An ellipse is symmetrical around either axis.

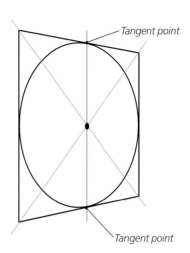

Tangent point

Tangent point

Perspective Center

On the opposite page we saw how you might think of an ellipse as a curve inside a square in perspective. Here's a closer look. The green line through the ellipse's perspective center tells us exactly where the ellipse is tangent to the top and bottom sides of the square; that is, the points where the ellipse actually touches the square. In fact, that's about the only value there is in locating the perspective center of an ellipse.

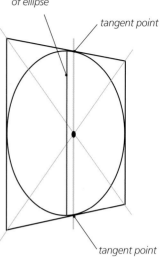

Major axis, true centerline of ellipse

tangent point

tangent point

Symmetry

The ellipse is actually a symmetrical shape: it's symmetrical around the purple line. That line is the major axis and it divides the ellipse in two. Notice that the ellipse is at its widest along that line.

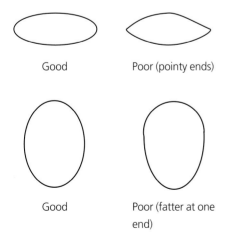

Good

Poor (pointy ends)

Good

Poor (fatter at one end)

Why the Fuss?

We care about how an ellipse is constructed because that knowledge helps us avoid the commonest pitfalls in drawing and painting them. An ellipse just brushes the sides of an imaginary square, as we've seen; it does not whack the side of the square and abruptly change direction. Many people draw ellipses with pointy ends, like an almond, and that's wrong. Every ellipse is a smooth curve that gently changes direction and never lurches.

TIPS FOR DRAWING SMOOTH CURVES

1 Turn your paper as you draw. We all find certain hand positions more comfortable than others, so draw the part of the curve that feels comfortable and keep turning the paper to finish the curve.

2 Practice "drawing through," which we talked about earlier (see page 113). Instead of drawing only the part of the curve you can see, lightly draw the rest of the curve, the part you can't see. This is especially helpful in avoiding those pointy ends on ellipses.

RELATING ELLIPSES TO EYE LEVEL

The closer an ellipse is to your eye level, the narrower it appears (as was demonstrated with the dinner plate). Conversely, the farther from your eye level, the fatter, or more rounded, it appears. In the still life on page 146 there are many circular objects—the pot containing the plant, the wine glass, the decanter, the two silver bowls—and they all appear as ellipses.

BE DECISIVE!

Pick an eye level—only one—and stick with it!

Ellipses Fat and Thin

Here are some of the circular shapes in this still life, all seen as ellipses. What's most important to notice is that the lower an ellipse is (that is, the farthest from eye level) the fatter, or more nearly circular, it appears.

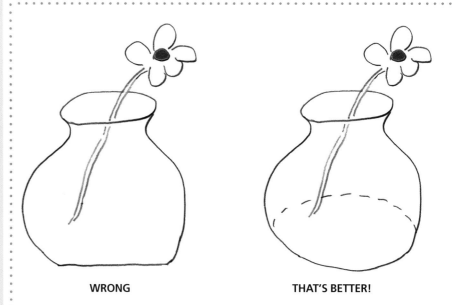

WRONG THAT'S BETTER!

Common Error

Suppose you're looking at a rounded vase below eye level. You're looking down into the vase and its mouth is clearly curved, but the bottom edge is harder to see and the temptation is to draw it flat because you know it must be flat. But if you could see all the way through the vase, you'd easily notice that the bottom is rounded.

ELLIPSES: FAT OR THIN?

How do you get a handle on whether an ellipse should be fat or thin? There are two general situations to consider: ellipses above or below eye level and ellipses to the right and left of you.

ELLIPSES ABOVE AND BELOW EYE LEVEL

Consider a stack of circular discs such as coins, tires or plates. The stack begins at your feet and rises high above you. One disc is right at your eye level, so all you see is its edge and it looks to you like a flat object. The disc on the floor at your feet is quite curved, and the one at the top of the stack is even more curved. The farther above or below your eye-level a disc is located, the more nearly circular it looks.

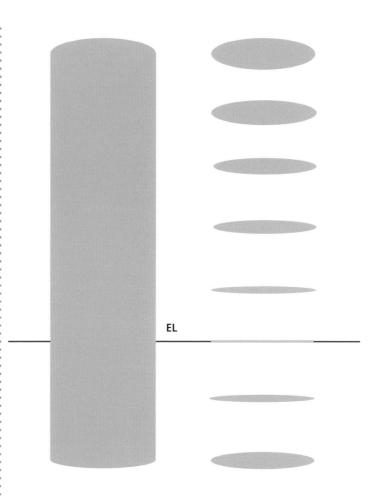

EL

Discs High and Low
Here are some curvatures you would see if you were close to the stack of discs. The farther back you stand from the stack, the less curvature you see. I've ignored the fact that the sides of the stack would slightly converge above and below eye level.

ELLIPSES RIGHT AND LEFT

Imagine a long row of discs stretching to your right and left, maybe the ends of a row of large sewer pipes lying in a storage yard. They will not look like a row of smaller and smaller circles (A in this illustration). The farthest ones from you will look narrow, while the ones closest to you will look more nearly circular (B).

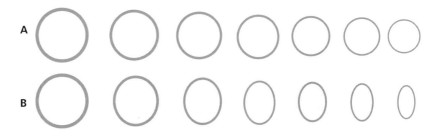

Discs in a Row
You're standing in front of the leftmost discs. The row of circular discs stretching away to the right will look like B, not A.

TRY THIS

Since ellipses are so often a part of our drawings, it's helpful to understand how they're constructed. You can make a perfect ellipse using a string and two pushpins.

Stick a pushpin through each end of a piece of string about six inches (15cm) long. Push the pins firmly into a piece of cardboard, one pin about four inches (10cm) from the other. Make the string taut by inserting a pencil point into the loop. Keeping the string taut and the pencil vertical, draw a closed arc. This may get a little clumsy as the string gets wrapped around the pushpins, but hang in there and when you've completed the arc you'll have a perfect ellipse! Well, almost perfect—it takes a little practice.

Move the pins a little closer together or farther apart and draw more ellipses. The farther apart the pins are, the flatter the ellipse. See where they need to be for the ellipse to become a perfect circle.

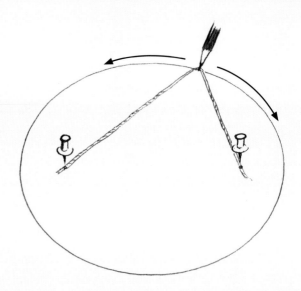

DEFINITION

Foci *and* axes: *The location of each pushpin is called a focus of the ellipse. The line through the two foci is the major axis, and the shorter line midway between the foci and perpendicular to the major axis is the minor axis. The sum of the distances from any point on the ellipse to the two foci is equal to the length of the major axis. The string in the illustration above is exactly as long as the major axis.*

DRAWING THROUGH

We discussed drawing through in chapter six (page 113). Using that technique (represented in the drawings on the opposite page by dotted lines) helps us to visualize what's going on; it also helps us draw ellipses with rounded, not pointed, ends.

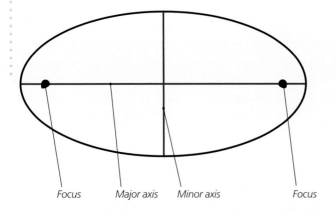

Focus Major axis Minor axis Focus

CYLINDERS

A cylinder, for our purposes, is an object whose cross-section is a circle; that is, if you slice a cylinder perpendicularly anywhere along its length, the slice will be a circle. Examples of cylinders are water pipes, some drinking glasses and cups, soup cans, round pencils and most silos. What's important to us is that the end of a cylinder seen in perspective is—you guessed it—an ellipse. To get a feel for how a cylinder should be drawn, look at a soup can on your pantry shelf. The shapes of the ends of the can will vary considerably depending on your eye level.

REAL CYLINDERS

If you paid attention in geometry class, you knew right away that my definition of a cylinder is suspect. A cylinder's cross-section does not have to be a circle; it can be an ellipse or a square or, for that matter, any plane shape you wish. An ordinary board, such as a two-by-four, is a cylinder, and so is a hexagonal pencil. But what we're concerned with in this chapter are cylinders whose cross-sections are circular.

 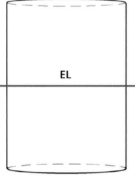

Low Eye Level

If your eye level is at the bottom of the can, the circular bottom looks like a straight line.

Medium Eye Level

With eye level about halfway up the can, you see both the top and bottom as slightly curved.

 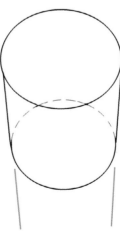

High Eye Level

Looking down on the can from high above, the end, while still slightly elliptical, looks nearly circular. The higher above the can you are, the more nearly circular the top appears. Notice that in this extreme view, the sides of the can slant slightly inward toward a vanishing point far below.

FINDING CYLINDERS AROUND US

A culvert that you may pass over when driving down the road is cylindrical. The handle of your flashlight is probably cylindrical and so is a tire on your car (roughly, at least). If you look at the ends of any of these objects it's easy to see their circular shapes, but seen in perspective they may be a little more difficult to draw.

A

B

The wheels and tires in this view are obviously ellipses, but it's not so obvious how the ellipses should be oriented. Drawing a wheel with its major axis vertical, as in A, is not quite right. The axis (and the ellipse) should be slanted as in B. That's because eye level is a little above the wheel.

TRY THIS

Think of wheels and tires as ends of a cylinder in perspective. There's an interesting attribute of any cylinder in perspective that's a helpful aid to drawing: the major axis of the ellipti- *cal end of the cylinder is always drawn at a right angle to the axle of the cylinder. If you think of the ends of a cylinder connected by a line through their centers, that line is the axle—just like the axle connecting opposite wheels on a car or truck. A little construction will make this clear.*

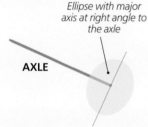

Ellipse with major axis at right angle to the axle

1 Draw the axle that will connect the wheels. Give it a little slant so our wheels will be in perspective. Then draw a light construction line at a 90-degree angle to the axle. That line represents the major axis of the elliptical wheel.

2 Add an elliptical wheel with its major axis lying on the earlier construction line. Try different widths for the wheel until it feels reasonable.

3 Add an elliptical wheel on the other end of the axle. This wheel should be smaller than the near wheel, but its major axis should have the same slant. To help with its size, sketch two light construction lines from the near wheel, slightly converging as they recede. Draw two more ellipses to give the wheels thickness.

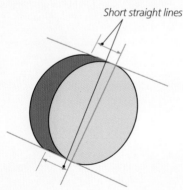

Short straight lines

4 What we've created is a virtual cylinder that has the two wheels as its ends. Like any object that recedes, the cylinder narrows a bit from front to rear.

5 Add a set of wheels at the other end of this contraption. I've put everything in a box to show two-point perspective at work here.

6 The front ellipse is closer to us than the rear one, so the front ellipse is slightly larger. Notice the straight lines that connect the ellipses.

FORESHORTENING

Foreshortening is the representation of an object as shorter than it would be if it were parallel to the picture plane. The result of foreshortening is to make the object appear to recede. It's common to think of foreshortening as involving rounded objects such as arms, legs and tree limbs, but in fact even rectangular objects in two-point perspective are foreshortened; their sides are seen as shorter than they really are. Anything you see at an angle (not straight on) is foreshortened.

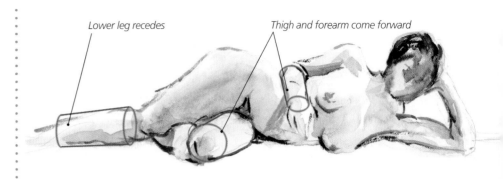

Lower leg recedes

Thigh and forearm come forward

The Body As Foreshortened Cylinders
Most of the sections of this figure are foreshortened. If you think of the body as a combination of cylinders (more or less) you can see how some advance, some recede, just like tree limbs.

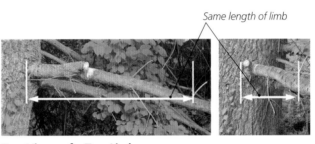

Same length of limb

Two Views of a Tree Limb
Here are two views of the same section of a limb. In one, the limb seems much shorter because of the sharp viewing angle.

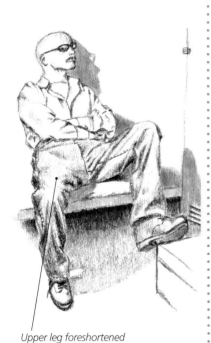

Upper leg foreshortened

Foreshortnening the Figure
In this drawing, the man's right thigh is severely foreshortened because it is coming toward us. Compare the apparent length of the right thigh to the left—why, the right one is half the length of the left!

NOT MY FAULT
Nathan Carlisle
Carbon and graphite on acid-free sketchbook paper
10½" × 8" (26.7cm × 20.3cm)

Turning a Corner
All the sections of this fence are pretty much equal in size, but when the fence turns a corner, the receding sections appear much shorter than they really are.

DRAWING CURVED OBJECTS

As we've seen in other chapters, choosing an eye level and sticking with it is critical if you are to have any hope of making a drawing that looks plausible. If you shift your eye level partway through a picture, the result will be a picture that doesn't make visual sense. In addition, if you move to your left or right while you draw, you may introduce other inconsistencies.

Moving around while you draw may be particularly troublesome if your subject contains ellipses. If you shift position, an elliptical object may appear fat in one view and thin in another.

The solution, of course, is to stay put. In your studio, you can mark the position of your feet on the floor; outdoors, you can use a couple of sticks to remind you where you need to stand or sit while making your drawing.

Standing . . .
Here is a group of objects as seen from a standing position.

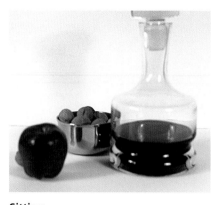

Sitting . . .
The same objects as seen from a sitting position. There's a big difference.

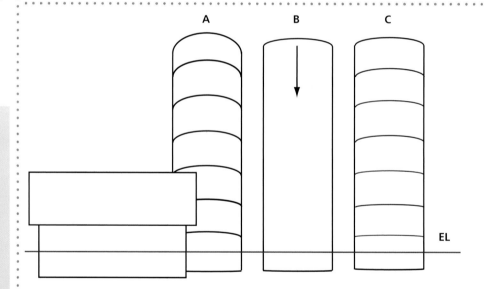

Getting Carried Away
Sometimes, in an attempt to get curves right, we overdo it. Suppose you're drawing the curved hoops of a silo. If you start with hoops near eye level and gradually work your way to the top, by the time you get there you may have too much curve. The result is a silo (A) that looks as if it might fall over backwards. A better way is to begin at the top with what you think is a reasonable curve (B) and then work your way down. Silo C looks more reasonable.

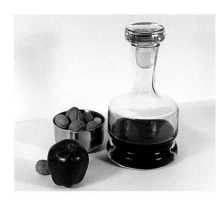

Moving Left . . .

The objects again seen from a standing position, this time just a foot (30cm) or so to the left of the original position. Notice the overlapping of objects as you move from one position to another. In this view you can see a space between the decanter and the bowl, but in other views you don't.

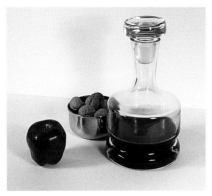

. . . and Moving Right

Move just a foot (30cm) to the right and again everything changes. The single walnut is completely lost!

TRY THIS

Symmetry is not always desirable; sometimes rigid symmetry can rob a picture of its looseness and charm. But for those times when you really do want symmetry, here's one useful technique using the lopsided vase from page 150 as an example.

Old left side — New left side (copy of right side)

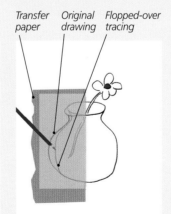

Transfer paper — Original drawing — Flopped-over tracing

1 Suppose you want to make this vase more symmetrical. Copy the vase on a piece of tracing paper and draw a vertical line down the middle.

2 Let's say you like the right side better than the left. Fold the tracing paper at the vertical line and flop the right side of the paper over on top of the left side.

3 Slip a sheet of transfer paper underneath the tracing paper and trace the new left side.

4 Erase the old left side and you have a brand-new non-lopsided vase!

PUTTING CURVES IN BOXES

Not all curves, of course, are circles or ellipses. Some, such as parabolas, are symmetrical and mathematically precise, but many, if not most, are unique curves formed by nature or by some human designer. For some objects, such as a telephone or a boat, enclosing them in a box might help a little, but let's face it: to draw such objects you need to rely more on observation, plumb lines, measurements and the skill that comes with constant practice. For more regular curved objects, such as the arches below, enclosing them in imaginary boxes can be very helpful.

Not-So-Round Apple
Cut through this apple and you see an unexpected cross-section, something like a square with rounded corners.

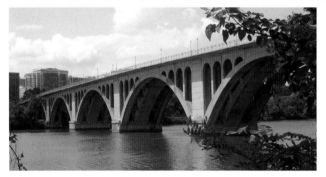

Symmetrical Arches in Perspective
Although the arches in this bridge are neither circular nor elliptical (they're parabolic), they are symmetrical; so if we imagine one of them in a box we can turn the box at an angle, draw the box in perspective and then draw the enclosed arch in perspective.

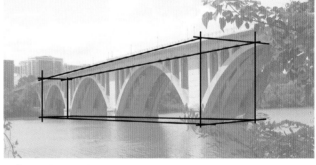

1 **See the Bridge in a Box**
First imagine the bridge in a box. This bridge, like most, has a gentle curve convex upward, so it doesn't fit perfectly into a rectangular box—but close enough.

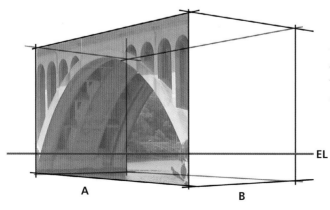

2 **Choose One Arch**
Now let's concentrate on one of the arches and put it in a box. Look carefully at the arch; notice edges A and B slant slightly upward toward eye level.

EL

A B

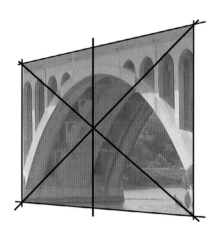

Elusive Shapes

You can squeeze this phone into a box and that might help you draw it in perspective. Objects such as this are great subjects for sharpening your drawing skills. Aside from the curved phone itself, notice the curves of the coils on the cord; they're more or less elliptical. How you draw those ellipses defines all the subtle changes in the cord's directions.

Boat-in-a-Box

Sometimes it may help to box a boat, but it's more helpful to draw, draw, draw those subtle curves most boats have. There is no formula for the curves; they're entirely different from one boat to another. Using perspective jaws can be some help in getting the curves right. Use the jaws to find the angle at various points along the curve, copy those angles on your drawing and then connect them all with a smooth line.

3 Find the Perspective Center

Consider just the face of the arch. Draw the diagonals of the enclosing perspective rectangle and draw a vertical line through the center to locate the top of the arch.

4 Start From Scratch

So far we've superimposed lines on the actual bridge, but suppose you're sitting on the riverbank with your sketchpad and all you have so far is this. Exactly how does the curve of the arch fit in this perspective box?

5 Inscribe the Arch

Here's a pretty good stab at the curve of the arch. If you look closely you'll see that after the curve crosses the vertical "center-line" of an enclosing rectangle (shown in blue), it continues to rise slightly before it begins to curve downward. That's similar to how an ellipse behaves. The widest part of an ellipse is not where it touches an enclosing rectangle, but a little beyond that tangent point (see page 149).

- The simplest curve is a circle. A circle can be inscribed within a square.

- Seen in perspective, a circle is an ellipse. An ellipse may be inscribed within a square in perspective.

- An ellipse is a smooth, symmetrical curve. It has no pointy ends or abrupt changes of direction.

- There is only one eye level for each picture and all curves must relate to that eye level. The closer a horizontal ellipse is to your eye level, the narrower it appears; an ellipse far above or below eye level is rounder, approaching circular shape.

- In a row of ellipses facing the picture plane, those farthest away appear narrower.

- Turn your paper, if necessary, to draw smooth curves.

- When drawing a tall, rounded object such as a silo, start at the topmost curve and work your way down to eye level.

- **Foreshortening is the apparent shortening of an object as it recedes.**

- To draw a curved object in perspective, it's sometimes helpful to envision it inside a box in perspective.

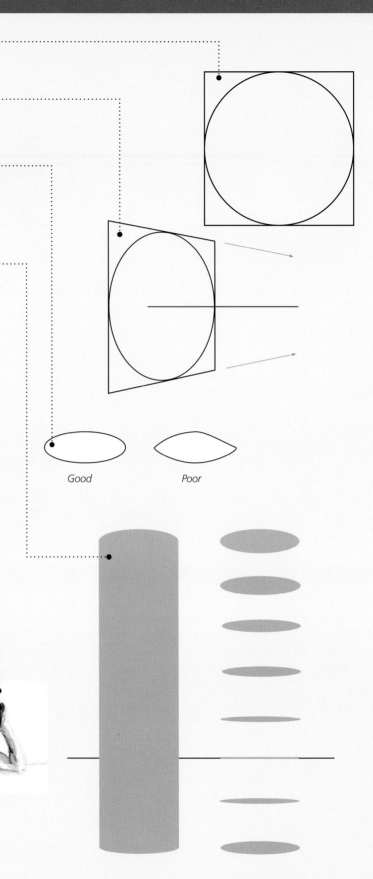

Good Poor

*Warm colors and
more detail up front
than in rear*

*Overlapped objects get
pushed back*

*Lots of circles in perspective (ellipses)
Sharp value contrasts give feeling of depth
Sharper detail in front than in background*

APPLES, NUTS AND PEARS
Watercolor on Arches 300-lb. (640gsm) cold-pressed paper
16" × 24" (40.6cm × 61cm)

Palette

1 *Cadmium Yellow Light*
2 *Cadmium Orange*
3 *Cadmium Red Deep*
4 *Alizarin Crimson*
5 *Raw Sienna*
6 *Raw Umber*
7 *Burnt Sienna*
8 *Phthalocyanine Green*
9 *Cobalt Blue*
10 *Ultramarine Blue*

REFLECTIONS

Reflections are images that reach your eye indirectly, such as by bouncing from a mirror or from a water surface. They add an intriguing new dimension to many realistic drawings and paintings and often give a picture an extra measure of depth. Reflections are usually thought of as occurring on flat horizontal surfaces, but really, they can occur on any surface. In this chapter we'll explore how reflections behave. Once you understand the basics, you can easily add reflections to a scene in a convincing way.

 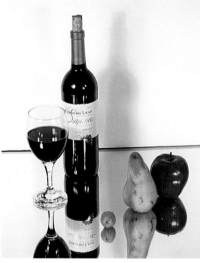

Reflections Add Depth

The added reflections come forward, which makes the actual objects appear farther back. The cast shadows aiming toward the rear (see page 64) also add depth to the picture.

WHERE'S THE EMPHASIS?

When you paint reflections in a picture, it's important to decide right away what's most important: the objects or their reflections. If you give them equal weight, the picture may look divided in halves, with both parts of equal importance. It's also a good idea to paint objects first and then their reflections, so you can more easily align the two.

NEEDWOOD STREAM
Oil on canvas
16" × 20" (40.6 cm × 50.8 cm)

WHAT ARE REFLECTIONS?

For us to see any object, light from the object has to reach our eyes. Under most circumstances, light flows to us directly from the object; but often it also detours and reaches us only after first bouncing from some other surface. That bounced image is called a reflection.

Reflections don't just happen haphazardly. They follow a simple rule: *The angle of incidence* (the angle at which light strikes a surface) *equals the angle of reflection* (the angle at which light bounces away from the surface).

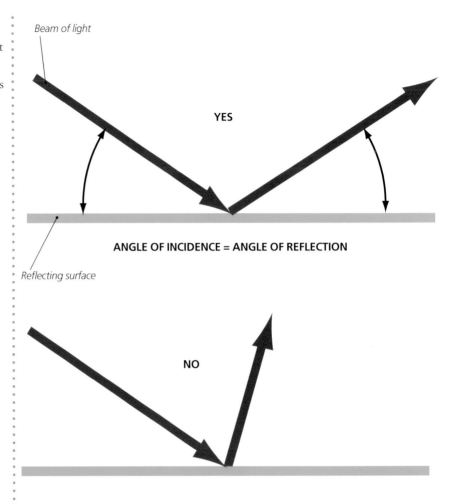

Beam of light

YES

Reflecting surface

ANGLE OF INCIDENCE = ANGLE OF REFLECTION

NO

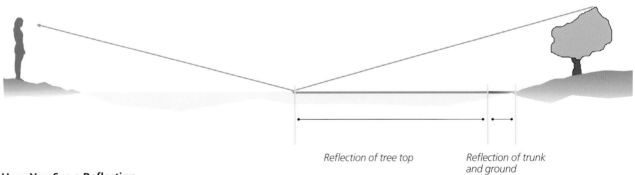

Reflection of tree top

Reflection of trunk and ground

How You See a Reflection

Imagine you're standing on the shore of a lake. Across the lake is a tree and on the lake's surface you see the tree's reflection. Although you, the observer, don't realize it, the reflection you're seeing is actually stretched far across the water. You don't see it as being that long because you're seeing it foreshortened.

DIFFERENT POSITIONS, DIFFERENT REFLECTIONS

Let's say you're looking at the reflection of a tree at the edge of a lake. As you walk along the shore, the reflection "follows" you. Wherever you go, you still see the tree's reflection. A friend walking with you sees the tree's reflection, too, but he sees a slightly different one from the one you see. You may position yourself to one side or another or at a higher or lower vantage point, and you still see a reflection, but it changes slightly as you change your position. What's important, as always, is that you paint what you see from one given position.

But suppose you're *inventing* a scene, or part of one. Say you want to add a distant hill, but there's no hill in the real scene, so you wonder: Would that hill reflect in the lake in the picture's foreground? The answer, unequivocally, is *maybe*. It depends on how far back the hill is. The farther back the hill is from the lake and the observer, the less chance it will reflect. That means you have the option of letting it reflect or not.

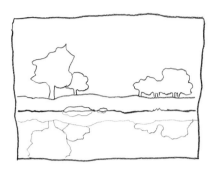

Needs Something
The sketch looks too bare.

Add a Hill
Let's add a hill. Should the hill reflect?

Add a Reflection
This would be reasonable; it says the hill is close enough to reflect. But the previous sketch would also be reasonable if you decide the hill is too far away to reflect.

Why a Faraway Hill Might Not Reflect
Hill A is positioned so that light from it can reach the lake and bounce away to an observer's eye. Hill B is far enough back that light from it can't reach the lake at a point where it would then bounce to this particular observer; hence, no reflection.

HOW REFLECTIONS BEHAVE

Reflections on a flat surface are sometimes surprising, but their behavior is always predictable.

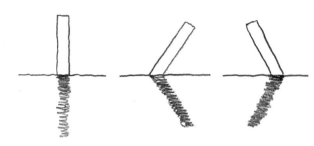

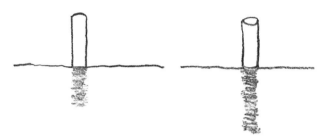

Post Near Water, Leaning Left or Right

Suppose we have a post at the edge of a pond. If the post is vertical, so is its reflection. If it leans right or left, its reflection leans the same way.

Same Post, Leaning Backward or Forward

If the post leans away from you (above, left), you see it foreshortened, so its reflection is shorter than the post. If the post is leaning toward you (above, right), its reflection appears longer than the post. Look at the pear in the still life on page 161; it too leans forward, producing a reflection that looks longer than the pear does.

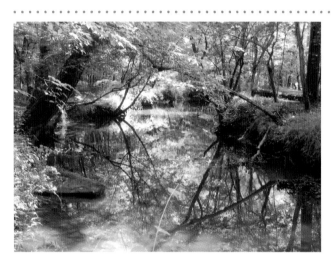

Reflections Are Sometimes Smoke and Mirrors

In this photo and diagram of a woodland stream, you can see some peculiar effects. Trees 5 and 6, for instance, are clearly separate, yet their reflections appear to be joined; tree 5 is partly hidden from our direct view by its foliage, yet its reflection is uninterrupted; and you can hardly see tree 4, but its reflection is clear.

TRY THIS

Place two or more brightly colored objects, such as a yellow pear and a red apple, near each other, then look really closely at both to see the bit of red reflected in the yellow and vice versa. Put them on a white cloth and look for bits of their colors reflected onto the cloth, especially in cast shadow areas. This subtle reflection of colors from object to object occurs everywhere: green from a tree reflected in a white house, for example, or red from a barn reflected in a white silo. Such nuances can help enliven a painting.

Place a large flat mirror on a tabletop. If you don't have such a mirror, try a piece of glass or clear acrylic with a sheet of dark mat board under it. Arrange some objects on or near the mirror, dim the room lights and try these ideas to see how reflections are affected.

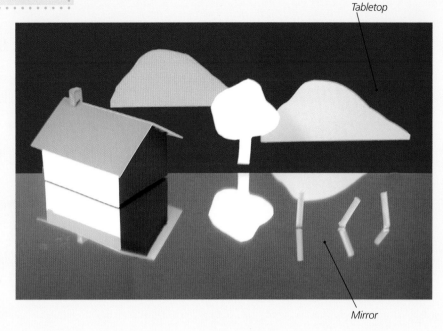

Tabletop

Mirror

1 Turn an object to different positions. For example, rotate the house and notice that in some positions you can see parts of it (such as under the roof overhang) not visible in the real house. Notice, too, the cast shadow under the left overhang that's visible only in the reflection.

2 Tilt objects right, left, backward and forward.

3 Move objects close to the mirror and then farther back. If you allow enough working space you'll notice, for instance, that moving a hill or tree far enough back will eliminate its reflection. Of the two same-height hills shown here, only the forward one shows a reflection. If I had lowered my eyes (and the camera) all the way down near the level of the mirror, I'd see both hills reflecting.

4 Change your position. Squat down with your eyes almost at the level of the mirror; stand up; climb a stepladder. You'll notice that the reflection of an object seen from a high perch is significantly different from its reflection seen from a low position.

5 Shine a light beam from a flashlight on the objects, letting the flashlight simulate the sun. Move the light around. Notice that as the "sun" moves, the cast shadows keep shifting but reflections do not.

6 With a spray bottle, spritz water over the surface of the mirror by spraying droplets into the air and letting them fall to the mirror. The idea is to simulate a rippled pond surface (rather than the smooth, calm surface of the dry mirror). This will only approximate outdoor conditions, but you'll see some difference between the sharp reflections and the blurry ones.

7 Shine a strong beam of light on the "rippled" surface to get an idea of how moonlight would look on a rippled water surface.

MORE LEANING

Just as the reflection of a post leaning away from you usually looks shorter than the post, so does that of any other object, such as a sloping riverbank. The closer you are to the level of the river, the more nearly equal will be the bank and its reflection; if you move to a place higher above the river, the riverbank will appear larger than its reflection.

HARD AND SOFT REFLECTIONS

A reflection on a smooth, hard surface is sharp-edged and clear. There is nothing to disrupt the orderly bounce of light according to the rule discussed earlier: angle of incidence equals angle of reflection. On a rough surface, reflections are blurry and broken. To see why, think of the rough surface as many tiny surfaces, each one relatively smooth, but each one turned at some slight angle away from the others.

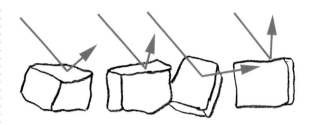

Many Tiny Mirrors

Think of a rough surface, such as a paved road, as made up of countless little blocks. Light bounces from each block in a direction determined by the tilt of that particular block. The result is that the reflected rays get scattered, resulting in a fuzzy reflection. (In reality, rather than blocks, the tiny surfaces might be curved, as in rippled water, but the result is the same.)

Calm Day

On a calm day with no breeze, the water's surface is perfectly still, so reflections are about as sharp as they would be in a mirror.

CALM WATER
Pencil on Strathmore bristol paper
6.25" × 10" (15.9 cm × 25.4 cm)

Breezy Day

The more rippled the water is, the fuzzier and longer the reflections.

RIPPLED WATER
Pencil on Strathmore bristol paper
6.25" × 10" (15.9 cm × 25.4 cm)

BACK TO BASICS

Although reflections are quite predictable, especially on a flat surface, they can often fool you because of the positions of the objects relative to one another or because of your position as you observe them. As we've said so many times in this book, if you paint what you see it's hard to go wrong. If you're painting a scene out of your imagination, of course, that rule doesn't help. In that case, setting up objects on a mirror will quickly answer a lot of questions.

WHY REFLECTIONS GET LONG

The boats in rippled water on the opposite page create reflections that are both fuzzy and long. The fuzziness is easy to understand; the countless little ripples, like the many small pebbles in a road, scatter light in many directions. But why should the reflections be so long?

The answer again lies with the ripples. Think of each ripple as a tiny mirror. Each mirror is tilted at a little different angle from the others, so each one sends reflected light in a slightly different direction. Some of those little mirrors all the way across the pond will be positioned just right, at any given moment, to reflect light toward an observer.

Think of a moonlit night on water. You're standing on the shore (with a companion, I hope) and gazing across the water. The moon is bright overhead, and round. If the night is calm and the water smooth, the moon's reflection will be round and relatively sharp. More often, though, the water will be rippled and the moon's reflection will be a long, choppy streak that may extend right up to the shore in front of you. In addition to the streak, you'll see tiny reflections off to both sides of the main streak. Each reflection is from a wavelet that just at that moment happens to be in such a position that light from the moon bounces from it directly to your eye. As the wavelet changes shape, that bit of reflection disappears, but others may take its place.

Long, broken reflections occur in many ways. Reflections in a wet street are often long and broken, like the moon reflection, and sometimes they aim in crazy directions because of the slant and curvature of the reflecting surface.

Calm Night
In calm water, the moon has a relatively sharp reflection.

Breezy Night
In choppy water, the reflection is broken and elongated by the wavelets.

Rainy Road Conditions
On roads in the rain, reflections are likely to be blurry because no road is perfectly smooth. The bits of gravel, concrete or dirt break up reflections the way rippled water does.

REFLECTIONS IN CURVED SURFACES

Reflections on flat surfaces are straight-forward; they are in line with and are more or less inverted copies of the objects. But on curved surfaces, reflections aren't always what you expect.

Wavy Glass
The glass face of this building is slightly curved and is divided into sections; the windows are unevenly formed, resulting in warped reflections of buildings and trees across the street. The playful reflections change shape significantly as you walk along and change your viewing position.

Curved Metal Teapot
This teapot is full of curves that produce some crazy reflections—the kind you have to observe because they're hard to predict. Notice that the gourd and the nut show right side up in the convex lower bulge of the pot, but they reappear upside down higher up where the curve is concave—in fact, they appear twice in that curve! There are also tiny bits of reflections in the legs and other parts of the pot. The big grayish reflections in the middle of the pot are of various objects in the room.

Fun-House Mirror Effect
Whoops! The gourd is sitting on a support so it's a couple of inches off the tabletop. Now its reflection is strange and elongated.

Another Double Reflection
The brush reflection curves upward at the bottom of the pot, but downward at the top, and, like the gourd and nut, it's repeated in that top curve. The nut is above the brush in the bottom reflection, but below it at the top.

Round Metal Bowl
The sides of this round bowl are fairly straight vertically, and that gives rise to some more unusual reflections. The gourd and the strawberry next to it show up as elongated shapes; the other strawberry is closer to the bowl and is not elongated. The farther from the bowl the object is, the more elongated its reflection. Notice that the reflections are dark compared to the objects; that's because the reflections are of the sides of the object away from the light source.

REFRACTION

Refraction is the change of direction that occurs when a beam of light leaves one transparent medium (such as air) and enters another of different density (such as glass or water) at an angle.

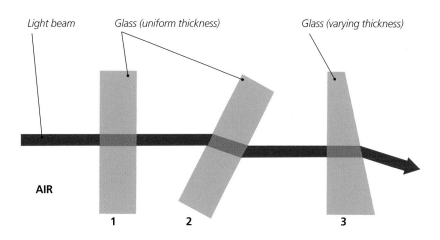

Light beam Glass (uniform thickness) Glass (varying thickness)

AIR

1 2 3

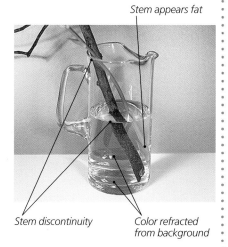

Stem appears fat

Stem discontinuity

Color refracted from background

Light Refracted by Glass and Water

You can see the upper parts of the two stems through air and clear glass, but light from the immersed parts of the stems passes through water as well as glass on the way to your eye. The light detours, giving the illusion that the stems are disjointed. In addition, the immersed stems seem fatter than the dry parts. The green stem seems most distorted because it's so near the curved edge of the pitcher, where the most distortion occurs. You can also see a little distortion as the green stem passes behind the thick lip of the pitcher. There are other instances of refraction, such as the color of the background showing up in the water and in the base of the pitcher.

Light Refracted by Glass

Light traveling perpendicularly from air into glass (1) continues in a straight line. It slows down in the glass but doesn't veer. Light hitting glass at an angle (2) gets slowed where it first hits the glass. The rest of the beam hasn't hit the glass yet, so it keeps traveling fast, causing a sort of mini-cartwheel about the first contact point. As the beam exits the glass back into air, the reverse happens and the light travels in a direction parallel to its original direction, but offset. Light entering and then leaving glass that's not uniform in thickness changes direction as it exits.

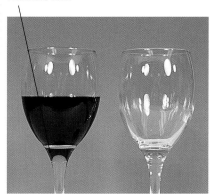

Refracted color

Wine Glass

What looks like wine at the top of the stem of the glass is refracted color, not wine.

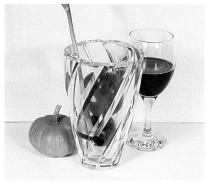

Thick Glass Vase

Bits of color are refracted all over this thick vase. When light is refracted, it sometimes follows a mysterious course and ends up where least expected. Notice the bulges in the parts of the wine glass and gourd seen through the vase.

MIRAGES

Mirages, often associated with desert areas, are the result of refraction. As light from a distant object (an oasis maybe?) strikes layers of air that have varying densities, the light is redirected (refracted) by the layers. When conditions are just right, the refracted light sometimes reaches an observer far from the light's origin so the observer "sees" the distant object as if it were quite near. You don't have to be near a desert to see mirages—they're commonly seen by drivers along long stretches of hot highway on a summer day. The heated layers of air over the highway act the same as layers of other transparent substances, such as water or glass.

S U M M A R Y

- Reflections are images that reach your eye indirectly by bouncing from some surface.

- **Reflections behave in a predictable way. When light strikes a smooth reflecting surface at a given angle, it bounces away at that same angle.**

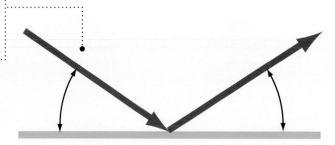

- The position of the observer is important. It's possible for a reflection to be seen by one observer but not by another at a higher or lower elevation.

- **A reflection leans in the same direction as the object.**

- Reflection problems can be worked out easily by moving objects around on or near a flat mirror.

- Reflections are not related to shadows. As a light source moves, shadows move, but reflections stay put. In some situations, a reflection and a shadow may coincide.

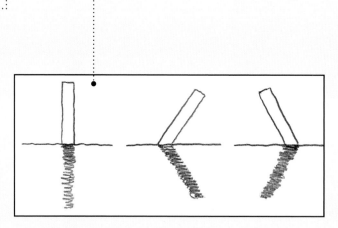

- Reflections on a smooth surface are sharp; those on a rough or rippled surface are fuzzy.

- Reflections on a rough or rippled surface are the combination of countless small reflections from each of the many facets of the surface.

- Reflections are not always well-defined images; often they are just hints of color that bounce between nearby objects.

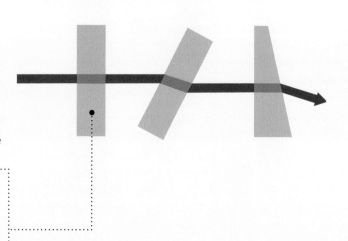

- Often you may see a reflection of a reflection (we'll look at an example in Part 3).

- **Refraction occurs when light changes direction as it leaves one transparent medium and enters another of different density at an angle.**

172

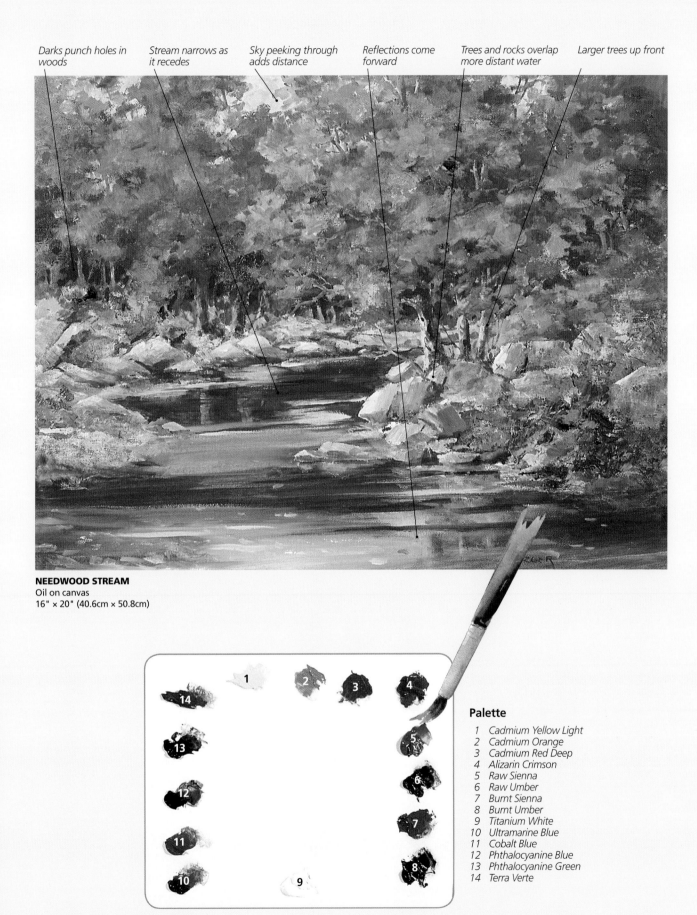

Darks punch holes in woods

Stream narrows as it recedes

Sky peeking through adds distance

Reflections come forward

Trees and rocks overlap more distant water

Larger trees up front

NEEDWOOD STREAM
Oil on canvas
16" × 20" (40.6cm × 50.8cm)

Palette

1 Cadmium Yellow Light
2 Cadmium Orange
3 Cadmium Red Deep
4 Alizarin Crimson
5 Raw Sienna
6 Raw Umber
7 Burnt Sienna
8 Burnt Umber
9 Titanium White
10 Ultramarine Blue
11 Cobalt Blue
12 Phthalocyanine Blue
13 Phthalocyanine Green
14 Terra Verte

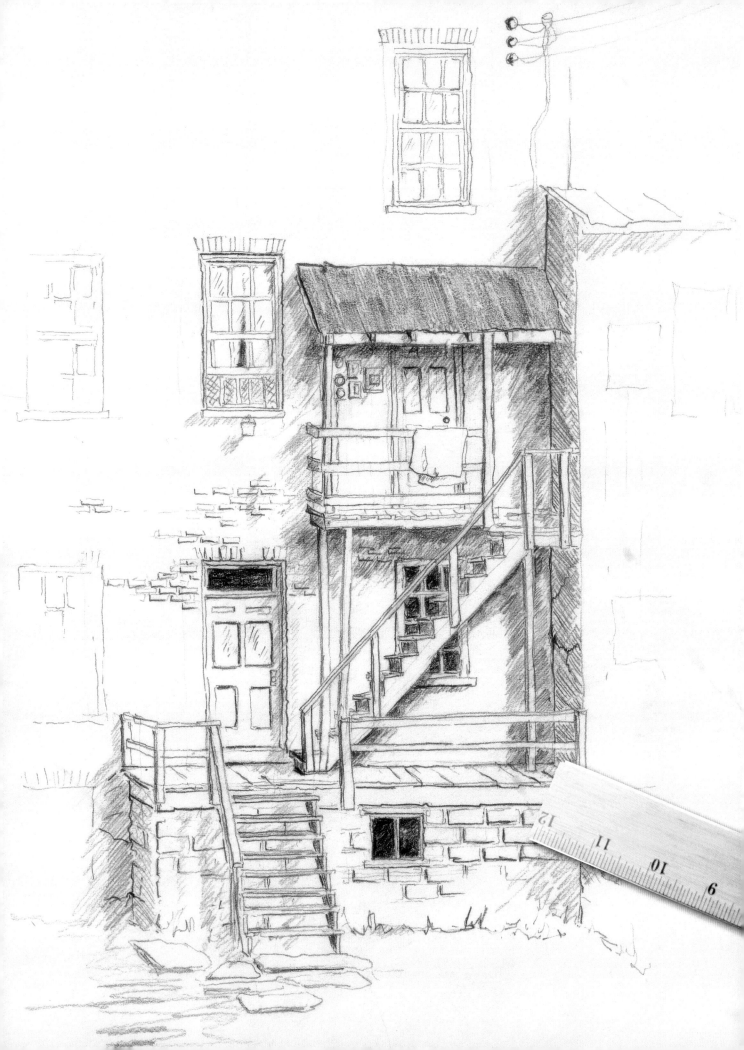

PART 3

LINEAR PERSPECTIVE

Special Problems

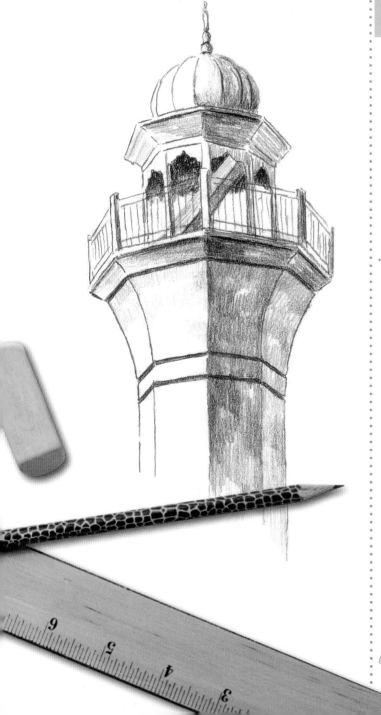

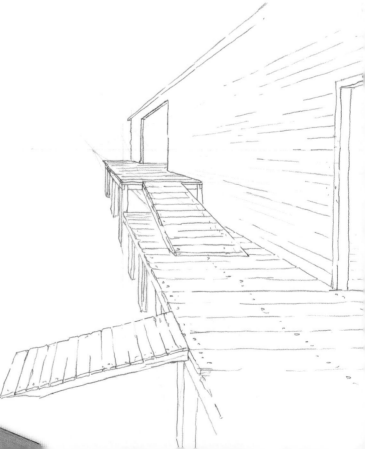

DORMERS

Think of a dormer as a miniature house or box stuck at right angles onto a larger house. Its lines aim at the same vanishing points as the lines of the main house.

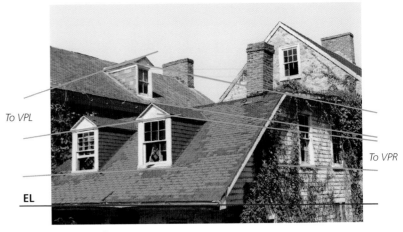

Some Real Dormers
Here's dormer heaven. We'll concentrate on just one; the others are built exactly the same way. To get oriented, here are a few basic perspective lines.

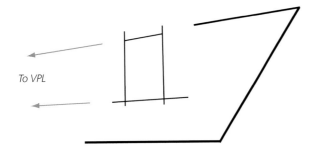

3 Draw the Dormer's Top Edge
Draw the top edge to complete the basic perspective rectangle of the dormer.

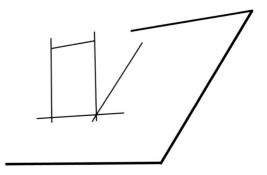

4 Indicate Where the Dormer Meets the Roof
Show where the dormer joins the roof by drawing a line parallel to the edge of the main roof.

TAKE IT EASY

When you tackle any perspective problem, start somewhere easy and let one step lead you to the next. Linear perspective constructions tend to grow in a methodical, sensible way.

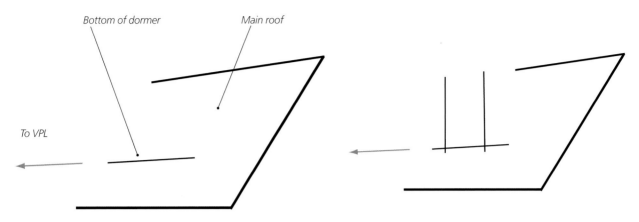

1 Sketch the Roof Lines and Locate the Dormer
Sketch the edges of the main roof because the dormer's lines will be directly related to the main roof lines. Draw a line for the bottom edge of the dormer; it should aim at VPL just as the two main roof lines aim at VPL.

2 Draw the Dormer's Verticals
Draw the vertical sides of the face of the dormer.

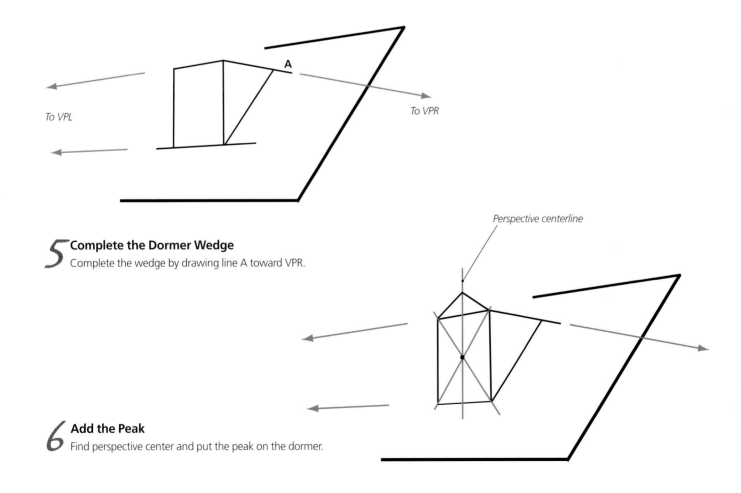

5 Complete the Dormer Wedge
Complete the wedge by drawing line A toward VPR.

6 Add the Peak
Find perspective center and put the peak on the dormer.

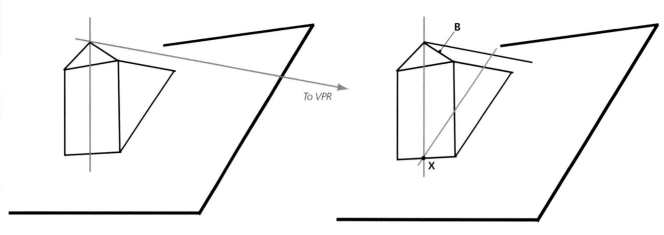

To VPR

7 Construct the Top Edge of the Dormer's Peak

The top edge of the dormer's roof aims at VPR. Show that with a construction line.

8 Add a Construction Line for the Dormer Roof

To finish the dormer roof we have to draw the short oblique line that shows where the dormer roof intersects the main roof. It's tempting to draw a line parallel to the front edge (B) of the dormer roof, but because of the slant of the main roof that wouldn't be quite right. To get it right, draw a construction line from point X up the slope of the main roof. That line divides the dormer into halves (in perspective, of course).

PICTURE IT

If you separate the dormer from the house, extend it and imagine it as its own little house, it looks like this.

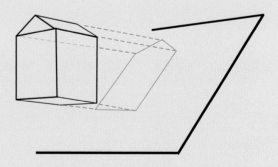

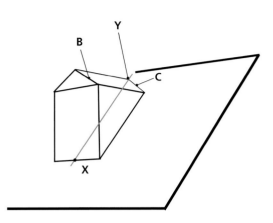

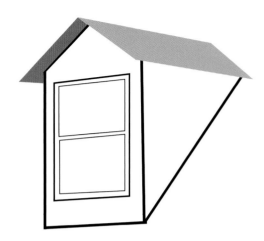

9 Finish the Dormer Roof

That last construction line intersects the top edge of the dormer's roof at point Y. Draw line C and the basic dormer is complete. Notice that edges B and C are not parallel.

10 Add Details

Add details, such as the roof cap. Look closely at the windows in the photograph on page 176; you'll find them more complex than I've shown here.

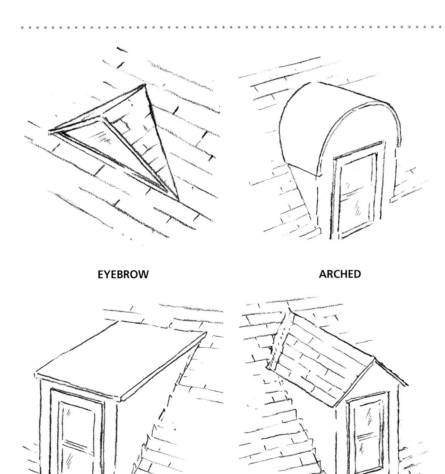

EYEBROW

ARCHED

FLAT

GABLED

A Variety of Dormers

Four of the many types of dormers you can use to enrich a house drawing.

TILE FLOORS

If your drawing includes a tile floor, there is a simple linear perspective construction you can use to put the tiles in perfect perspective, but as we've said earlier in this book, all linear perspective constructions have limits. They are a mathematically correct way to draw things, but such constructions ignore what happens in our peripheral vision. The constructions are accurate in the 60-degree-or-so "cone of vision" directly ahead of us (page 118), but beyond that cone straight lines appear ever-so-slightly curved.

An Outdoor Tile Floor

Seen straight on, this tile floor lends itself to an easy perspective construction.

2 Place the First Tile

Estimate the size of the first tile. Take time to get it feeling right because all the remaining construction depends on this first tile.

1 Mark Eye Level, Vanishing Point and Tile Rows

This floor will be in one-point perspective. To get started, decide how far the floor extends and mark where it meets a far wall. In the outdoor tile floor in the photograph, there is no far wall, but usually there will be one because most floors are inside a building. Mark your eye level on the far wall and place a vanishing point at its center. Next, draw lines representing the rows of tiles; at this point, these could be floorboards. A reasonable way to draw the rows is to mark off equal spaces along the front edge of the floor and draw lines from those marks to the vanishing point.

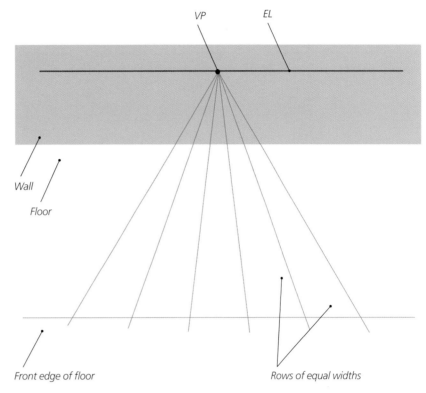

VP EL

Wall

Floor

Front edge of floor Rows of equal widths

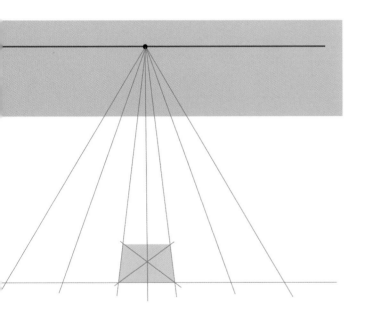

P

3 Find the First Tile's Perspective Center

Find the perspective center of the tile and draw a line through it to the vanishing point.

4 Connect the Midpoint of the Tile's Rear Edge to a Front Corner

Draw a line from either front corner of the tile through point P (the midpoint of the side of the tile).

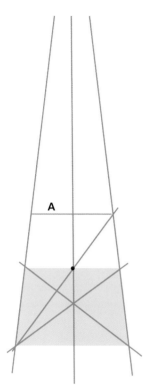

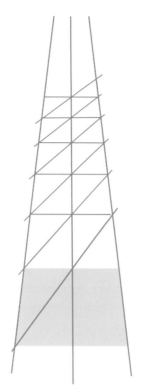

5 Complete the Second Tile

Draw line A to complete the second tile.

6 Repeat to Create More Tiles

Now it's easy to repeat the process, drawing the oblique lines and marking off tiles.

7 Draw the Tiles in Adjacent Rows

To draw the tiles in adjacent rows, draw horizontal lines across each tile joint in the first row.

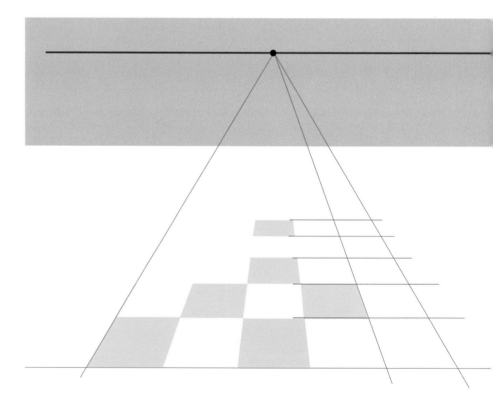

TILE FLOORS AT AN ANGLE

If the tiles are either laid at an angle or viewed at an angle, a similar construction may be used, but you will need to use two-point perspective.

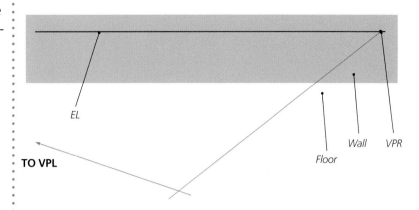

EL

TO VPL

Floor *Wall* *VPR*

1 Mark Eye Level and Vanishing Points

Begin the same as in the previous example by locating the wall, the floor and the eye level. Then judge the slants of the two nearest edges of a tile and draw construction lines to two vanishing points (one may be well off your paper). If you're drawing an actual floor, use perspective jaws to get the two slants right.

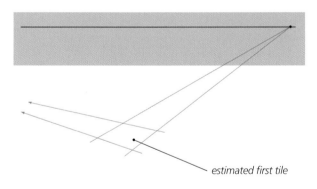

estimated first tile

2 Place the First Tile

As in the first example, estimate the size of the first tile and draw lines to the two vanishing points.

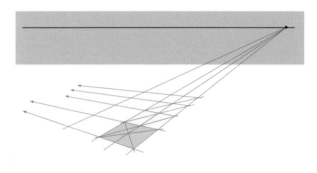

3 Construct the Remaining Tiles

The construction is similar to that in the first example. In this case, however, the tiles get slightly smaller to the left and to the right as they are farther removed from the first tile.

SPOKED WHEELS

Time to think outside the box, as the saying goes, and see how linear perspective constructions might help in drawing objects that are not boxes. A technique called *projection* enables us to see an object in one view and draw it in another. We'll start with a spoked circular wheel and see how to show it in perspective.

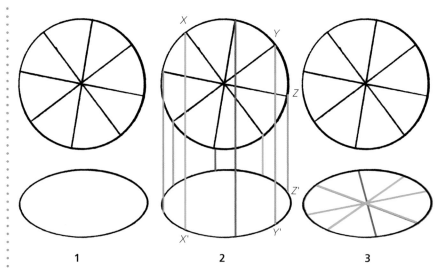

1 2 3

Spoked Wheel

1 Here is a circular wheel with spokes. Imagine flopping the wheel over toward you so you see it now in perspective as an ellipse. How do we draw the spokes?

2 Draw light construction lines from the ends of spokes on the wheel toward the ellipse. Point X' is the projection of point X, and so on.

3 Connect the opposite endpoints of the spokes. What results is a good approximation of how the wheel should look in perspective, ignoring for the moment such attributes as the thickness of the wheel and spokes.

Steering Wheel

Here's a slightly harder exercise. This might be a car's steering wheel (A). Imagine grabbing the top of the circular wheel and flopping the wheel way over toward you. When you project the spokes down to the ellipse (B) it's still not obvious how to draw the spokes in perspective; there's nothing to tell us how they meet near the middle of the ellipse. One solution is to extend the spokes all the way across the steering wheel (C) and project the extensions downward. In the ellipse, draw the spokes all the way across and you can see how they intersect near the center of the ellipse (D). The shaded area is a good approximation of the three spokes in perspective.

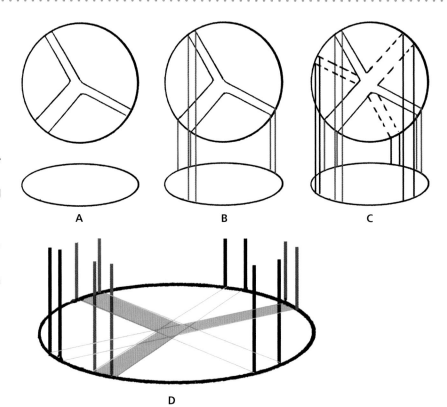

A B C

D

COLUMNS AND TOWERS

Projection can help you draw grooves or windows in proper perspective as they go around a column.

Fluted Column

An end view and blank side view of a fluted column. There are sixteen evenly-spaced grooves around the column.

Project the Grooves Downward

Draw lines straight downward from the grooves' edges to the column. To project not just the location of the grooves but also their widths requires careful projection of both edges of each groove.

Windows in a Tower

Suppose you want to add windows to a cylindrical tower—here's one approach. Similar to the last example, here's a top view of a round tower showing the placement of its windows.

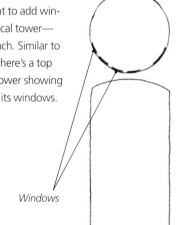

Windows

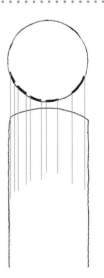

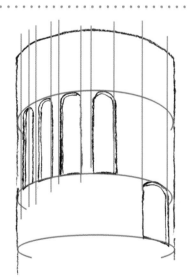

Project the Window Edges Downward

Project lines downward to show width and spacing of windows.

Complete the Windows

Now the windows can be sketched. It helps to draw a couple of ellipses as guides for the tops and bottoms of the windows.

NUTS!

Got a nut around the house? It might be fun to draw it. That little item has lots of interesting angles, and projection can help you get them right.

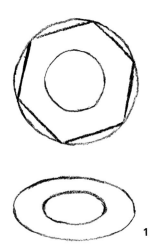

1

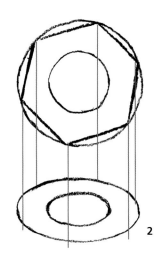

2

Drawing a Hexagonal Nut

1 Draw the nut inside a circle in any position you like. Draw two ellipses below representing the nut and the nut's hole in perspective.

2 Project each of the nut's corners down to the outer ellipse. You can imagine flopping the nut over backwards, as I've done here, or forward, whichever suits you.

3 Extend the nut's sides vertically to show the thickness you want. Notice that the receding faces of the nut are in perspective, so pairs of edges such as X and X' and Z and Z' should converge slightly.

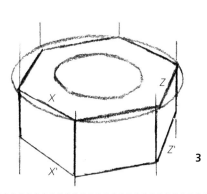

3

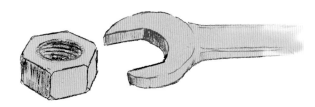

Nut and Wrench in Perspective

Odd items such as this can be fun to draw. Look closely for features such as the slightly rounded shoulders at each of the six corners and the slant of the threads inside the nut.

TRY THIS

Use the projection method to draw a view of this dome and the supporting pillars at its lower layer. Draw a circle for the top view of the dome and divide the circle into as many pie-sections as there are pillars around the dome. Draw an elliptical cylinder in which to sandwich the pillars. Project lines downward from each pie-section to represent the pillars and the spaces between them, as suggested in the sketch.

MINARET

Similar in some ways to lighthouses and other towers, this minaret, located above eye level, is a good drawing subject. It's octagonal in cross-section; the octagons fit nicely inside a circle and their perspective cousins fit within ellipses.

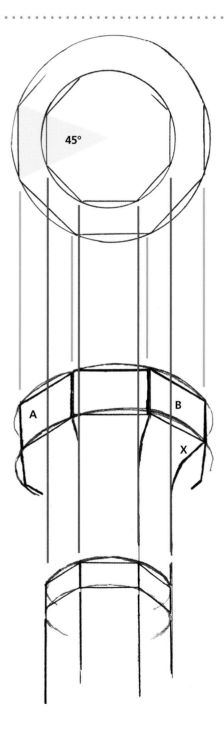

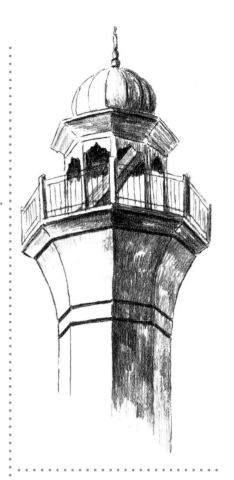

Drawing a Minaret

Drawing the parts of the minaret is not so different from drawing the nut in the previous exercise. Draw two concentric circles and inscribe equal-sided octagons in them. The larger circle represents the wide top part of the structure (the fenced walkway) and the smaller circle is for the stem of the structure. To create the octagons you might first divide the circles into eight pie-slices of 45 degrees each.

Directly below the circles draw a pair of ellipses for each section. Project lines (here, blue for the large octagon and red for the small) vertically downward to the ellipses and use the points of contact to sketch in the large and small octagons in perspective. Join the two perspective octagons with gently curved lines X and the basic minaret is finished! Notice the receding faces of the octagons, such as A and B, are in perspective, so their top and bottom edges converge slightly.

STAIRS

Sets of stairs can be an intriguing part of a picture, but they are sometimes tricky to draw. For this on-the-spot sketch, the worn stairs were what attracted me most, but there are also good shapes, textures and values to play with.

SEEING THE STAIRS

In the pencil drawing, eye level is about at the top of the upper set of stairs, almost at the level of the upper porch floor. That should mean you wouldn't see the floor itself, only its edge; but the porch and its floor are sagging with age (tell me about it!), so you see a bit of the top of the floorboards. You could straighten out such sags and make the drawing "correct," but you'd lose the flavor of the place. Despite the sags, you can see a general obedience to perspective.

Each set of stairs has its own set of vanishing points on the eye-level line.

HARPER'S FERRY BACKYARD
Pencil
11" × 8" (27.9cm × 20.3cm)

STAIRS FROM SCRATCH

For this exercise we'll imagine perfect stairs because what we want to explore is basic structure. Once we understand that, it's easy enough to let time and weather warp things as much as we like. Let's assume we have a floor and a wall with a doorway; we want stairs from the floor up to the door. Eye level is above the top step and the room is in two-point perspective.

Wall *Floor* *EL* *Side wall*

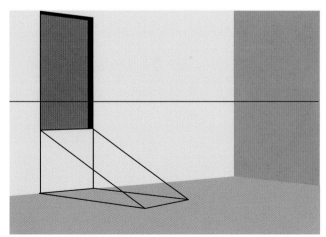

1 We need some stairs to get up to the door.

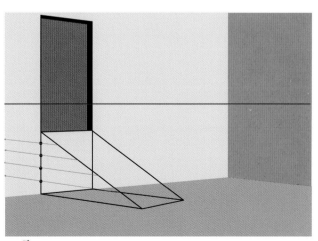

2 Here's how far out we want the steps to extend. (We could make them steeper or less steep; either way, the construction would be the same.)

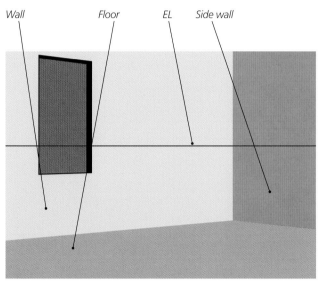

3 Make the wedge that will contain the steps. This is also how you would create a ramp.

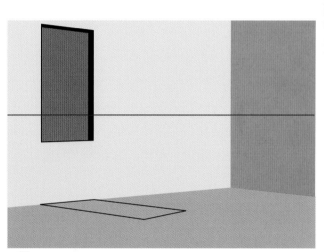

4 Mark off equal segments to show the height of each step. In a real situation, you would know the total height and an appropriate height for comfortable steps. Draw lines through these marks toward VPL.

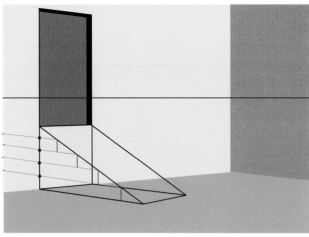

5 Draw the risers (the vertical parts of the steps).

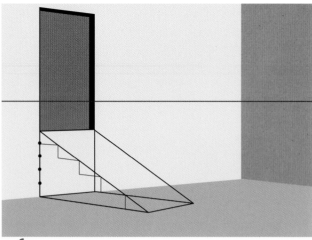

6 Draw the treads (the horizontal parts of the steps) and get rid of the construction lines.

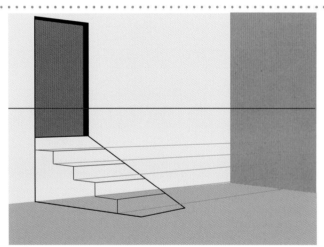

9 Draw construction lines to VPR for the rear edges of the treads.

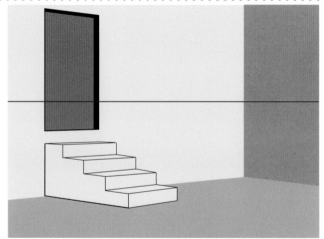

10 Draw the vertical risers and complete the treads. Notice that you can see less of the tread on the step nearest the eye level than on those farther from eye level.

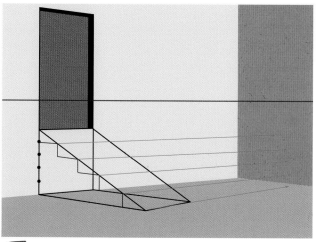

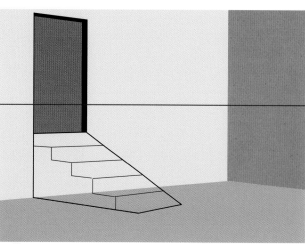

7 Draw construction lines to VPR for the front edges of the steps.

8 Draw the front edges of the steps and get rid of unnecessary construction lines.

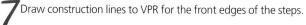

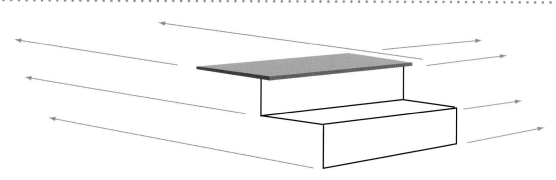

11 Add details such as a finished tread on top of each basic tread. The finished tread is a simple flat rectangular slab with edges aiming at the same vanishing points as the rest of the structure.

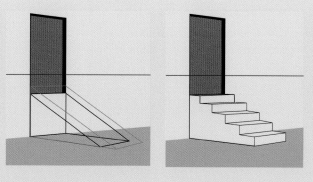

WHOOPS!

Look out for that first step—it's a killer! For safety's sake, we might have built our stairs a little differently, something like this.

Make the initial wedge one step higher and one step longer. Now a person coming through the door and down the steps has a better chance to avoid breaking his neck.

REFLECTIONS OF REFLECTIONS

Reflections faithfully follow the rules of linear perspective, as we saw in chapter nine. So do reflections of reflections. You might at first think that a reflection could not itself have a reflection (a little like Dracula), but it can. And why not? Like any object we see, a reflection is a source of light—an indirect source, but a source nonetheless.

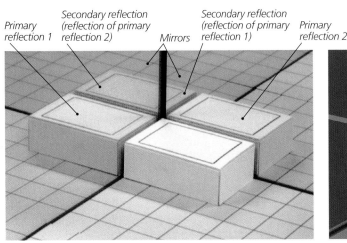

Primary reflection 1 | Secondary reflection (reflection of primary reflection 2) | Mirrors | Secondary reflection (reflection of primary reflection 1) | Primary reflection 2

FLOOR

Joints between mirrors | Mirrors | Reflection of mirror joint | Joint between mirrors

FLOOR

Tub Against Shiny Walls

Imagine this box is a bathtub in a room with shiny reflective walls. The tub reflects into both walls, and the reflections in turn have their own reflections. The reflection farthest back is in two parts, one on either side of the dark joint between the two mirrors. The larger part is a reflection of primary reflection 2, not 1. If that seems mysterious, on the next page is a little exercise you can try yourself to see what's going on.

Tub, Shiny Walls, Shiny Floor

Here's the same tub on a shiny floor. Using a mirror for the floor introduced a lot of distracting reflections of the studio surroundings, so I doctored the photo to get rid of them. From our one bathtub we now have the illusion of eight (you can see only seven).

TRY THIS

1 Using two mirrors, fasten one in an upright (vertical) position and hold the second upright, parallel to the first one. Place an object between the two mirrors and position your eyes just above the second mirror so you can see reflections in the first mirror. You'll see an "infinite series" of reflections of reflections.

2 Turn the second mirror just slightly so it's not quite parallel to the first and the series of reflections will curve!

3 Place an object between the mirrors that has an obvious right side and left side (such as a cup with a handle) and notice that the image reverses itself in every other reflection (handle on right, handle on left)

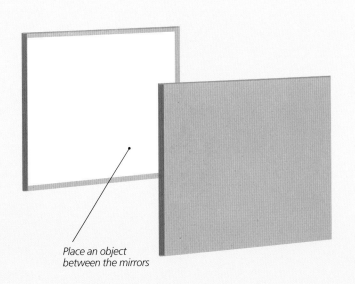

Place an object between the mirrors

LEAH'S LAW

Artist Leah Henrici points out that the reflection of a dark object is lighter than the object and the reflection of a light object is darker than the object. There may be exceptions to that law, but I haven't found any. In the tub photograph, the two primary reflections of the light tub are darker than the tub; further, the secondary reflections are darker than the primary reflections.

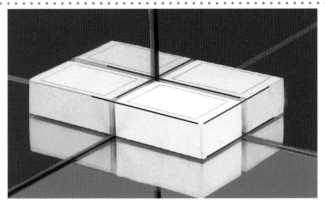

Reflections in Perspective

The tub and all its reflections are in perfect linear perspective.

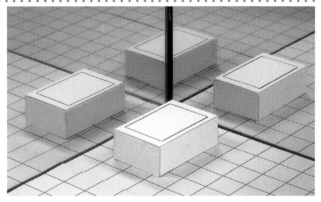

Tub Away From Shiny Walls

If the tub is set back from both walls, we see reflections of faces that are not visible in the actual tub. All the images, as usual, are in linear perspective.

TRY THIS

In chapter nine we used a flat mirror to investigate reflections on a horizontal surface. Now add two more mirrors at right angles to each other and to the horizontal mirror to view some unexpected reflections. All you need are three flat mirrors (no frames and no bevels) that you can find at craft stores.

1 Place a variety of objects, both rectangular and nonrectangular, on the horizontal mirror in several positions and observe what happens to their reflections.

2 Elevate an object to observe the reflection of its bottom.

3 Block out portions of reflections in one of the upright mirrors to see what happens to the secondary reflections in the other mirror.

MIRROR 1

MIRROR 2

Place an object in the corner

MIRROR 3

EXTREME VIEWS

Occasionally you deal with perspective from a very high or very low eye level. Sometimes such views look unreal, but if you place your trust in the rules of linear perspective, the results will be accurate. Whether the results are *appealing* is a different story.

BIRD'S-EYE VIEW

If you imagine yourself floating high above the landscape (or standing and looking directly down at a still life), your eye level is extremely high. Don't forget: eye level doesn't have anything to do with whether you're looking up or down, it has to do only with a horizontal plane (that is, a plane parallel to the earth's surface) passing through your eyes. If, as you float, you look straight ahead instead of down, you will see the horizon in the distance; that's where eye level is.

Roof From Directly Above
Here's how a building might look from directly above. The roof edges A and A' and B and B' are pairs of parallel edges receding from us, so they converge, but so slightly as to be unnoticeable. The other edges don't converge at all.

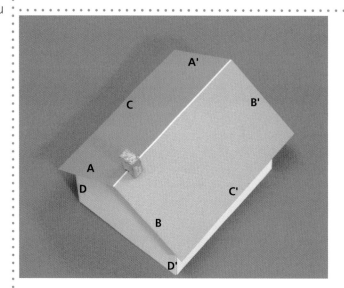

Roof From a High Angle
Another view from above, but this time a little at an angle. Now edges A and A' and B and B' are more definitely converging. They clearly recede from us because the peak of the roof is obviously closer to us than the eaves. Again, the convergence is slight. Edges C and C' also converge, but again only slightly. Perhaps the clearest convergence is seen in D and D', the vertical edges of the house; they converge downward.

WORM'S-EYE VIEW

A building high on a hill or a tall building whose top is far above eye level can provide some odd and interesting angles.

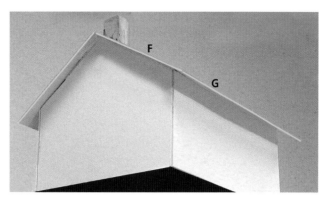

Roof Plane Viewed From Its Edge

At this angle, roof edges F and G are aligned. Sometimes a view like this is confusing and perhaps should be avoided. If eye level were a little higher, you would see part of the roof's upper surface; if lower, you would see up under the roof overhang. The vertical edges of the house converge upward.

ODD ROOF LINES

Not all roofs are straightforward symmetrical structures; they vary all over the place. Sometimes they slant in such a way as to throw off your sense of perspective. But if you rely on perspective jaws (page 101) to get the slopes and angles right, your building will look right.

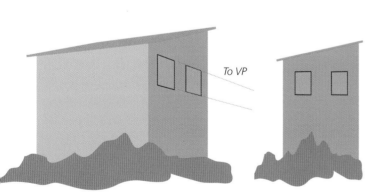

To VP

Shed Roof

Something seems weird here. The windows in the side of the building slant down, indicating a low eye level, but the roof slants up. It makes sense, of course, once you see the shape of the building from the side.

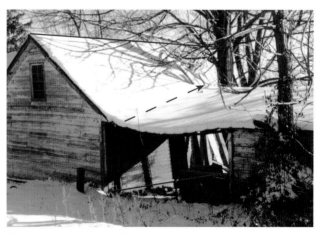

Slanted, Sagging Roof

Linear perspective in this shed is shown by the solid lines. At first glance, it looks as though the dashed line contradicts the solid lines, but the dashed line is not really a perspective line—it's the slant of the flat roof. That roof is slanted so water will run off. Obviously, snow doesn't run off well, hence the sag in the roof.

HILLY STREET SCENES

Buildings in hilly territory may make linear perspective seem daunting, but the same old rules apply: Define the eye level and make sure each building's two vanishing points lie at that eye level. And, just like buildings on level ground, individual buildings set on hills may be turned at this angle or that, so their vanishing points may not coincide—but all their regular vanishing points will lie at eye level.

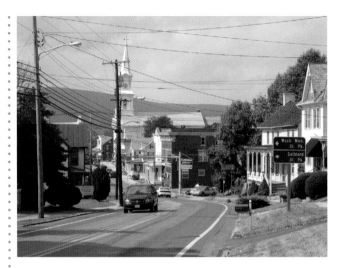

LOOKING UPHILL

Suppose we have a row of houses along an inclined street and we're looking at the scene from the downhill part of the street; that is, we're looking uphill. The street is an inclined plane, like the ramps in chapter seven, and its vanishing point will be somewhere above our eye-level. But the houses along the street all have their vanishing points, as usual, at eye level. If the houses are all facing the same way, they'll share common vanishing points; if some of them are turned in different directions, they'll have different sets of vanishing points, but all will be at eye level.

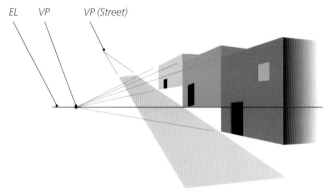

Uphill Diagram

These houses along an inclined street are all facing the same way, so they have common vanishing points. The street is an inclined ramp with a vanishing point above eye level. This is a steep incline; the doorways need steps to get to the street and the steps would need to be tapered to meet the ground. The white triangular areas under each house would be foundations: level platforms for the houses to rest on.

Uphill Photo

Here's a real street. You're looking uphill; eye level is near the bottom of the photo.

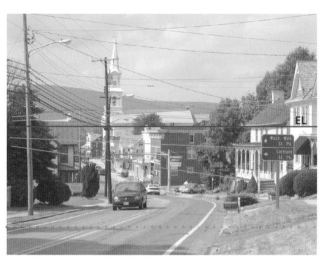

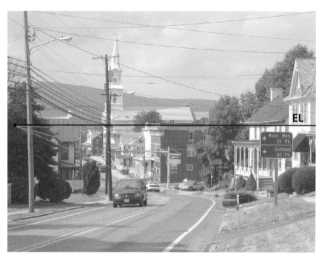

A Complex Hilly Scene, Demystified

Although this scene may be complicated by the profusion of buildings, poles, signs, cars and so on, its perspective is straightforward. The top edge of the red brick building is horizontal, so that's about where eye level is located. Other horizontal edges slant either down toward eye level or up toward eye level as they recede into the picture.

LOOKING DOWNHILL

When you look downhill, the street's vanishing point is below eye level.

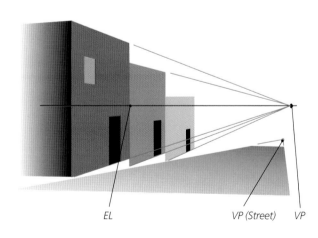

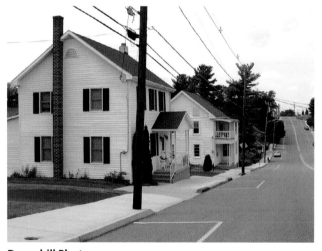

Downhill Diagram

Now we're looking at houses along a street dropping away from us downhill. The street's vanishing point would be below eye level. Contrast this scene with the uphill scene on the facing page. When using linear perspective, establishing the eye level is of paramount importance.

Downhill Photo

Here's the same street shown in the example on the facing page, looking downhill. Eye level is about halfway up the scene.

BUILDINGS NOT ALIGNED

In the examples on the previous page, all the houses were lined up in neat rows and they shared common vanishing points. If buildings in a row are turned at different angles from one another, they may no longer have the same vanishing points but they will, of course, share the same eye level.

HILLY AND CURVY

When a street is both inclined and curved, you may have to treat each building separately because each one may be angled a little differently from the others. The scene in the photo on page 196 has a sloping and curving street and is, I think, a more interesting subject than either a flat or a straight street. The rough sketch below shows another scene with slopes and curves.

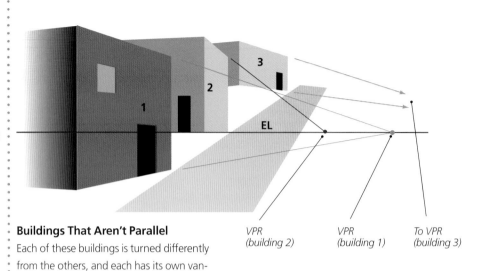

Buildings That Aren't Parallel

Each of these buildings is turned differently from the others, and each has its own vanishing points at eye level. The left vanishing points are far off the page.

VPR (building 2) VPR (building 1) To VPR (building 3)

EL

Hills and Curves

The eye-level line is as shown, more or less. Several buildings in the middle stretch are aligned, but those on either end are turned a bit to conform to the curve in the road. I've included a few construction lines to indicate how things are situated. You can see that the various sets of lines are heading for different vanishing points, but you can also see that all the vanishing points are at eye level (again, more or less). Even the stone sidewalk steps roughly behave.

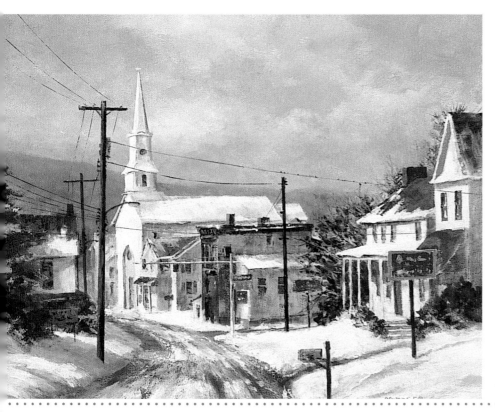

MIDDLETOWN MORNING
Acrylic on canvas
16" × 20" (40.6cm × 50.8cm)

TRY THIS

Any kids around the house? If so, maybe there are some large blocks you can use as buildings along an inclined "street." Use a board for the street and prop it up at any incline you wish. Arrange a row of block-buildings along the incline in whatever array you like. Sketch the blocks from several different eye levels and from several different vantage points, paying close attention to how their edges slope. The only critical part of the arrangement is this: To truly represent normal buildings, the blocks must be propped up so their bottom surfaces are perfectly horizontal.

Fold

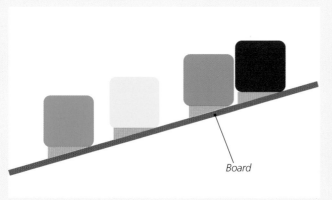

Board

Leveling the Blocks

An easy way to support the blocks is to make several identical cutouts from thin cardboard, shaped as shown here. Cut whatever angle you wish, then place the blocks on the inclined board and adjust the slope of the board to make the blocks level.

199

CONCLUSION

Once you add the perspective techniques to your bag of tricks, you'll use them pretty much automatically wherever they make sense; you won't have to make conscious decisions to use this technique or that. For this concluding picture, I deliberately used them all!

EVERYTHING BUT THE KITCHEN SINK!

Here are examples of the perspective techniques you'll find in the painting on the facing page.

- *Color recession: warm in the foreground, cool in the distance.*

- *One-point perspective: building at right.*

- *Two-point perspective: all the other buildings.*

- *Three-point perspective: roof edges converge.*

- *Sharp value contrasts: between large tree and sky; doorways and windows.*

- *Reflections: posts are pushed back as reflections come forward.*

- *Diminishing sizes: fence posts and spaces between them diminish as they recede.*

- *Blurred edges: distant treeline.*

- *Overlap: foreground tree overlaps other objects.*

- *Atmospheric perspective: distant blue hills.*

- *Cast shadows: from buildings, post, tree.*

- *Shading: on sides of buildings, trees, posts.*

- *Circles in perspective: elliptical hoops around silo.*

- *Detail: more up close than in the distance.*

A Favorite Subject
I've drawn and painted this scene in a variety of ways over the last couple of years. This farm is one of those beautiful spreads that has the misfortune to be stuck in the middle of urban sprawl. It's been sold to a developer, who will now "improve" it with condominiums and houses. This pencil drawing is a fairly faithful representation of the cluster of buildings; I transplanted the tree and snow fence from another area.

Getting Carried Away

All right, I admit it: Cramming all the perspective techniques into one painting is overkill, but it seemed a good way to wrap up the book! The picture might be a little better if I hadn't stuck in those puddle reflections (too tacky?), and I could have left out the road and posts entirely (I do use the road device too frequently). But there you have it. In your pictures, please use a little more discretion. Happy drawing and painting!

CHARLIE CROWN'S FARM
Watercolor on 300-lb. (640gsm) Arches cold-pressed paper
15" × 22" (38.1cm × 55.9cm)

ANGLE OF INCIDENCE: The angle at which a beam of light strikes a reflecting surface.

ANGLE OF REFLECTION: The angle at which a beam of light bounces away from a reflecting surface. When a reflection occurs, the angles of incidence and reflection are equal.

ANGULAR PERSPECTIVE: *See* Two-point perspective.

ATMOSPHERIC PERSPECTIVE: The tendency of distant objects to appear paler and cooler than they are, caused by a veil of impure air between the object and the viewer.

BROKEN REFLECTION: A reflection on a surface that is not smooth, especially a surface in motion, such as a river or ocean.

CAST SHADOW: An area receiving less light than surrounding areas because an object is blocking light from reaching that area.

CENTER OF INTEREST: The part of a picture the artist intends as the main focus for the viewer. A picture may have more than one center of interest, but usually one will be primary.

CENTRAL PERSPECTIVE: *See* One-point perspective.

COLOR WHEEL: An arrangement of colors around a circle, with primary colors (red, yellow, blue) equally spaced and secondary colors (orange, green, purple) also equally spaced,

each secondary color being halfway between two primary colors.

COMPLEMENTARY COLOR: The color directly opposite another color on the color wheel; red is the complement of green, blue is the complement of orange, and so on.

CONE OF VISION: The cone-shaped space in front of a person's eyes considered to be the area most accurately seen; outside the cone, one's vision becomes increasingly distorted. The cone's spread is considered to be about 60 degrees. The rules of linear perspective are most applicable within the cone.

CONSTRUCTION LINE: A straight line drawn toward a vanishing point.

CORE SHADOW: *See* Crest shadow.

CREST SHADOW: On a curved object, the narrow area on the shadowed side of the object adjacent to the lit area; also called the *core shadow* or the *shadow accent*.

DIFFRACTION: In art, the slight blurring of light as it passes by the edge of an object.

DORMER: A vertical window, or the structure containing the window, built into a sloping roof. In drawing, a dormer may be seen as a small rectangular structure joined at right angles to a larger structure.

DRAWING THROUGH: Drawing the hidden (unseen) parts of an object as an aid to rendering the visible parts correctly. Drawing through is especially helpful when drawing curves

such as ellipses because continuing the sweeping drawing motion of completing the curve helps make the ends of the curve smooth rather than pointy.

ELLIPSE: A circle viewed in perspective. If you turn at any angle the flat surface on which a circle is drawn, the circle appears as an ellipse.

EL: *See* Eye level.

EYEBALLING: Estimating the relative sizes of objects visually, without the use of any tools.

EYE LEVEL: An imaginary plane parallel to the earth and passing through a viewer's eyes. If the plane were extended far enough to where sky and earth meet, it would coincide with the horizon. In linear perspective discussions, eye level and horizon are synonymous. Eye level has nothing to do with the tilt of the head up or down—eye level is still a horizontal plane through the eyes.

FORESHORTENING: Drawing receding lines shorter than they really are to present an illusion of depth.

GABLE: The triangular section of the end wall of a building that has a pitched roof.

HIGHLIGHT: The brightest spot on the curved surface of an object; it is the reflection of the light source.

HORIZON: The imaginary plane where earth and sky meet. As you change position from low to high, the horizon you perceive also changes: the higher you rise, the farther you

Horizon
The horizon is clearly visible.

WINTER SURF
Watercolor on 140-lb. (300gsm) Arches cold-pressed paper
18" × 24" (45.7cm × 61cm)

bases parallel to the earth, but over long distances the earth is curved, not flat. When the earth's curvature comes into play, linear perspective cannot account for it.

MAJOR AXIS: The greatest dimension of an ellipse from end to end.

MINOR AXIS: The shorter of the two axes of an ellipse; the longest distance across the ellipse perpendicular to the major axis.

MODELING: Giving a shape on a flat surface the illusion of depth by showing contrasting areas of light and shadow on the object; shading.

OBLIQUE PERSPECTIVE: *See* Two-point perspective.

ONE-POINT PERSPECTIVE: A special example of linear perspective in which all receding parallel lines meet at a single point.

OVERLAP: The placing of one object in front of another so that the front object partially obscures the rear object. This technique introduces depth, or perspective, into the scene by making it clear that one object is closer to the viewer than the other object.

PARALLEL LINES: Lines that lie in the same plane, but never meet. Parallel lines *seem* to meet, however, if

see around the earth's curvature. In linear perspective, horizon and eye level are synonymous. The reason we usually use the term *eye level* instead of *horizon* is that it's always certain where your eye level is, but the horizon may be obscured by objects such as buildings or mountains.

INDIRECT CAST SHADOW: A shadow cast by reflected light rather than by light coming directly from a primary source. For example, a house blocking sunlight causes a cast shadow of the house; at the same time, light reflected from the bright side of the house, although not as strong as the original sunlight, might be strong enough to cause objects in its path to cast shadows.

JAWS: *See* Perspective jaws.

LIGHT: The part of the electromagnetic spectrum that enables us to see. Ordinary white light (daylight) is a combination of lights of various colors, typically described in terms of the so-called "rainbow" colors: red, orange, yellow, green, blue, indigo and violet. Actually, the number of colors is huge because there are countless shades of color formed by mixing varying amounts of the different wavelengths of light.

LINEAR PERSPECTIVE: A system of representing a three-dimensional scene on a two-dimensional surface, based on the observation that as parallel lines recede they appear to converge at a point in the distance. Early ideas about linear perspective go back to ancient Greece and Rome and the later work of an Iraqi called Alhazen (ca. 965–ca. 1040) who did pioneering studies in optics. But it was the Italian architect Filippo Brunelleschi who, early in the 1400s, formulated the mathematical laws of perspective. In 1436 Leon Battista Alberti put the ideas of perspective in writing, especially for painters, and the subject has been explored and enlarged ever since.

The rules of linear perspective are accurate within the human cone of vision and over relatively short distances. We base linear perspective on rectangular objects sitting flat, their

Overlap
The shed overlaps the distant barn.

SHED AND BARN
Watercolor on 300-lb. (640gsm) Arches cold-pressed paper
14" × 22" (35.6cm × 55.9cm)

they recede, that is, if the lines begin close to you but end up far away from you. This seeming convergence is the way humans see things and is the basis for linear perspective.

PERSPECTIVE: The technique of drawing three-dimensional scenes convincingly on a two-dimensional surface. Often, people use the term to mean *linear perspective*, but linear perspective is only one kind of perspective.

PERSPECTIVE CENTER: The point to which the center of a shape migrates as the shape is put into perspective. The true center of a square, for example, is where the square's diagonals cross; but when the square is tilted and seen in perspective, its center shifts to where the diagonals of the perspective square intersect.

PERSPECTIVE JAWS: Two hinged strips of material, such as cardboard, used to measure angles accurately. The artist holds the jaws at arm's length, adjusts the jaws to duplicate an angle in the subject, lowers the jaws to the drawing paper and copies the angle.

PICTURE PLANE: The surface of a picture. When discussing various aspects of design, it's helpful to have a frame of reference and often that is the picture plane. For example, in a landscape one might describe a road as either receding from the picture plane (that is, aiming off into the distance) or remaining in the picture plane (traveling right to left across the picture).

PLUMB LINE: A vertical line perpendicular to the earth's surface; a vertical line (real or imagined) on a picture's surface used to check the alignment of objects such as second-floor and first-floor windows.

PRIMARY COLORS: In painting, the colors red, yellow and blue. Other colors (except white) result from various mixes of the primary colors.

RECEDING LINE OR EDGE: Any line or edge that does not lie in the picture plane but is at an angle to the picture plane.

REFLECTED LIGHT: Light that strikes a surface and bounces away in a different direction.

REFLECTION: An image caused by light that reaches a viewer indirectly, by first bouncing (reflecting) from some surface.

REFRACTION: The redirection of the path of a light ray as it passes from one substance (such as air) into another of different density (such as water or glass) at an angle.

RELATIVE SIZE: The comparison between the sizes of two or more objects without regard to their actual sizes. Saying one line is twice the length of another is an expression of relative size without regard to units of measure such as inches or centimeters.

SCALE: Any indicator of the relative sizes of objects in a picture, usually some object common enough that its size is known and understood by everyone.

SECONDARY COLORS: In painting, the colors orange (red plus yellow), green (yellow plus blue), and purple (blue plus red).

SHADING: The darkened side of an object away from the light source.

SHADOW: General term for any area receiving less light than adjacent areas. There are two types of shadows: cast shadows and shading.

STAGING: Building a picture in successive visual layers—usually background, then middle ground, then foreground—with the aim of introducing depth.

THREE-POINT PERSPECTIVE: Linear perspective in which, in addition to vanishing points at eye level, there are one or more vanishing points above or below eye level. Such vanishing points are the result of receding parallel lines that are not horizontal, that is, not parallel to the earth.

THUMB-AND-PENCIL METHOD: A technique for comparing sizes of objects in order to represent those sizes on a drawing. Holding a pencil (or other straight tool) at arm's length and closing one eye, align the tip of the pencil with one end of an object, such as a fence post; slide your thumb along the pencil to where you see the other end of the object; that length of pencil represents the length of that object. Now align the tip with an end of a second object, such as a tree, and estimate how the first length compares with the length of this second object; that is, see how many fence-post-lengths fit into the tree's height.

TONE: See Value.

TWO-POINT PERSPECTIVE: A view of a rectangular solid in which the bottom of the object is parallel to the ground and two sides of the object are visible. The parallel horizontal edges of each of the two visible sides of the object appear to recede and meet in the distance at points that are at eye level. There are two such meeting points, called *vanishing points*, so this perspective is called two-point perspective.

UNDERPAINTING: A preliminary coat of paint underlying the main painting.

VALUE: The degree of lightness or darkness of an area; light areas are said to be high in value and dark areas are low in value. The highest value is white; the lowest, black.

VANISHING POINT: An imaginary point at which receding parallel lines meet. In one-point and two-point perspective, the vanishing points are at eye level; in three-point perspective, some vanishing points fall either above or below eye level.

VIEWFINDER: Any aperture, such as a hole in a piece of cardboard, through which one may view a scene to help focus on a particular part of the scene while blocking out the rest.

VP: Vanishing point.

VPL: Vanishing point at the viewer's left.

VPR: Vanishing point at the viewer's right.

Reflection
The lily is reflected in the still water.

LILY PADS
Watercolor on 140-lb. (300gsm) Arches cold-pressed paper
14" × 22" (35.6cm × 55.9cm)

Expand your art skills with these other North Light Books!

These books and other fine North Light titles are available at your local fine art retailer or bookstore or from online suppliers.

Don't let the title of this book fool you. Whatever your medium, you'll find plenty of usable information for painting with depth and realism. Unlock the mysteries of linear perspective, size and space variations, overlapping, aerial perspective and more. With easy-to-understand explanations and step-by-step demonstrations, it's simpler than you might think to put your paintings into perspective.

ISBN-13: 978-0-89134-880-1
ISBN-10: 0-89134-880-8
Paperback, 128 pages, #31358

With the invaluable instruction in *Pencil Magic*, you'll improve your artistic skills with just two simple tools: pencil and paper. Inside you'll find instruction on basic pencil strokes, drawing styles, and strategies for capturing perspective and proportions. Ten step-by-step demonstrations make it easy to master the fundamentals of drawing.

ISBN-13: 978-1-58180-584-0
ISBN-10: 1-58180-584-5
Paperback, 216 pages, #33045

Every practicing artist needs *The Artist's Illustrated Encyclopedia*! Over 1,000 art terms, materials and techniques are defined in this easy-to-reference volume. Packed with hundreds of photos, paintings, demonstrations, diagrams and drawings, *The Artist's Illustrated Encyclopedia* is the most comprehensive and visually explicit artist's reference available.

ISBN-13: 978-1-58180-023-4
ISBN-10: 1-58180-023-1
Paperback, 512 pages, #31677

Before you can draw like an artist, you need to see like one. *Drawing With Your Artist's Brain* offers an unusual, interesting and proven approach to maximize your powers of seeing. Use the exercises, checklists, technique summaries and step-by-step drawing demonstrations within, and unveil the secrets to creating better art!

ISBN-13: 978-1-58180-811-7
ISBN-10: 1-58180-811-9
Hardcover, 128 pages, #33494

Great artwork starts with great drawing. Get a glimpse inside the minds of over 100 skilled artists in this gorgeous and informative full-color book! Browse page after page of exceptional drawings in a variety of mediums, accompanied by insightful comments from the artists. Whatever your skill level, you'll find something within these pages to inspire you and sharpen your skills.

ISBN-13: 978-1-58180-861-2
ISBN-10: 1-58180-861-5
Hardcover, 144 pages, #Z0271